CAPTURE *THE* MOMENT

A BRIDE'S AND PHOTOGRAPHER'S GUIDE TO CONTEMPORARY WEDDINGS

PUBLISHED BY AVA PUBLISHING SA

rue du Bugnon 7

CH-1299 Crans-près-Céligny

Switzerland

Tel: +41 786 005 109

Email: enquiries@avabooks.ch

DISTRIBUTED BY THAMES AND HUDSON

(EX-NORTH AMERICA)

181a High Holborn

London WC1V 7QX

United Kingdom

Tel: +44 20 7845 5000

Fax: +44 20 7845 5050

Email: sales@thameshudson.co.uk

www.thamesandhudson.com

DISTRIBUTED BY STERLING PUBLISHING CO. INC.

IN USA

387 Park Avenue South

New York, NY 10016-8810

Tel: +1 212 532 7160

Fax: +1 212 213 2495

www.sterlingpub.com

IN CANADA

STERLING PUBLISHING

c/o Canadian Manda Group

One Atlantic Avenue, Suite 105

Toronto, Ontario M6K 3E7

ENGLISH LANGUAGE SUPPORT OFFICE

AVA PUBLISHING (UK) LTD.

Tel: +44 1903 204 455

Email: enquiries@avabooks.co.uk

ISBN 2-88479-015-2

10 9 8 7 6 5 4 3 2 1

DESIGN BY DEEP CREATIVE LIMITED

PRODUCTION AND SEPARATIONS

BY AVA BOOK PRODUCTION PTE. LTD., SINGAPORE

Tel: +65 6334 8173

Fax: +65 6334 0752

Email: production@avabooks.com.sg

Printed in China

STEPHEN SWAIN

CAPTURE *THE* MOMENT

A BRIDE'S AND PHOTOGRAPHER'S GUIDE TO CONTEMPORARY WEDDINGS

AVA Publishing SA
Switzerland

Sterling Publishing Co., Inc.
New York

ACKNOWLEDGEMENTS

This book is dedicated to Marija, Alfi and Tobi for their love and understanding.

A very big thank you to Natalia Price-Cabrera at AVA for her support, understanding and encouragement of this project, and for making it such a pleasant task. To Brian Morris at AVA for his faith, commitment and enthusiasm, and Carolyn Milne and Tessa Blakemore for their enthusiastic support. Also a very large thanks to Bill Hemsley for his time, thoughts and consideration.

Also a big thank you to Loredana Serra and Grant Bowden at Deep Creative for their beautiful and creative design work. Thanks to Paul Hanson at Camden Camera Centre, along with clever Paul and Gil. Thanks to Amanah and all at Sky Photographic Ltd., and to Christine Hayes, Carol Herning and all at Wedding and Home magazine for their kindness and support. Thank you to Vikki Hume and also to Jane Bruton, to Trevor Miller (Millhook Video), and to Henry Wells and Juliette for their encouragement and advice. Also thanks to Neil Ward, to Laurence Mongredian for his help and encouragement during my early years as a freelance photographer, and to Polly Jarvis and all at Fuji Film UK Ltd.

And, of course, the biggest thanks goes to all the brides, bridegrooms, bridesmaids, page-boys, ushers, bestmen, parents of the bride and groom, and guests included in this book. Also to all the florists, make-up artists and hairstylists who have all helped to create the photographs I have included.

Finally, I would also like to thank the couples whose weddings I have photographed, but been unable to squeeze into this publication.

Stephen Swain June 2002

FOREWORD

'If the couple has a great day, the photographer should get great photographs.' Stephen Swain

Today's modern couple want beautiful wedding photographs without any interference to their wedding day. The modern wedding photographer's daunting task is to capture the moments of the day as they unfold, whether it is the bride and groom exchanging rings, having a first kiss or cutting the wedding cake. This book will show the bride and groom how to choose the right photographer, so that they can relax and enjoy the day, and it will show the photographer how to capture the moments of the wedding day as they take place.

Wedding photography has gone through a major change over the recent years. A short while ago staunch formal photographs and rather hazy looking photographs of the couple superimposed on to wine glasses were acceptable. Not so today. Couples want sharp black-and-white and colour images that would quite easily sit in a fashion spread of a magazine, or the editorial section of a newspaper. Images caught as they actually happen, which will contain far more romance, emotion and humour than the re-created or posed image. The couple expect the same standard of photography that they are seeing in magazines and the media that surrounds them, and should accept no less.

This is a book concerned with getting great pictures; it is not a technical guidebook for the photographer. Whether you are shooting on film, or with digital cameras, it is the image captured that this book is all about. The book will help show the photographer where to be at the right time, when and when not to step in and pose a shot, and how to develop a sixth sense of what will happen next. It will teach him or her that it is not just a question of running through a set list of shots, but to treat each wedding as an individual event. This way he or she will be able to enjoy photographing weddings year after year.

Obviously, many of the events I capture on film are the same as wedding photographers have been capturing for years. All of these events are quite beautiful moments; the difference is that to stop the proceedings and start rearranging the couple into specific poses can often spoil otherwise spontaneous moments. It doesn't matter if the bride isn't looking directly at the camera lens, what the contemporary photographer is looking for is a feel/emotion of that specific time. Posed photographs will always be remembered as posed shots, whereas candid shots will be remembered as the real thing. Family portraits are still part of the contemporary wedding day, but have become a far less important part of it. These days couples just want everyone to look happy and for the whole procedure to be over relatively quickly so that they can get on and celebrate their day.

This book will help show the photographer and the soon-to-be-married couple that a wedding can be a great and rewarding day for everyone, with the photographer capturing fantastic images — images that people who don't even know the couple will enjoy looking at!

028 *098*

146

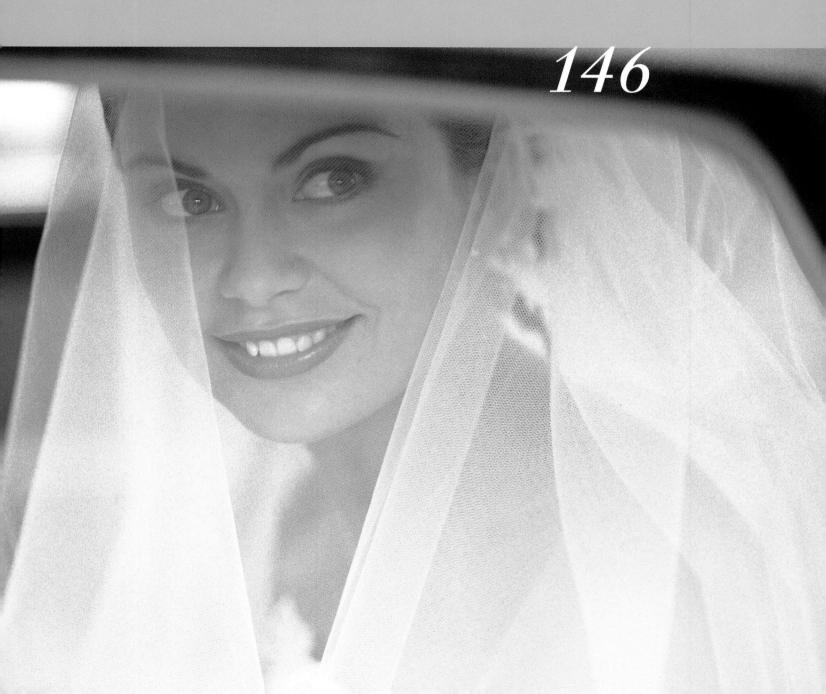

> *THE*CONTENTS

008 THE INTRODUCTION *012 EQUIPMENT 014 SELLING YOURSELF 016 BOOKING YOUR PHOTOGRAPHER* **020** BEFORE THE WEDDING *022 THE BRIDE PREPARING 028 DETAILS 036 THE BRIDESMAIDS* **042** THE WEDDING *044 THE ARRIVAL 052 THE CEREMONY 058 OUTSIDE THE CHURCH 064 LEAVING THE VENUE* **072** THE RECEPTION *074 PORTRAITS OF COUPLES 080 GROUP SHOTS 086 THE GUESTS 092 THE FLOWERS 098 THE CAKE 102 THE SPEECHES 106 THE DANCING* **110** WEDDING ALBUMS *112 MIRANDA AND GABBI 118 FLEUR AND RICHARD 122 FRANCESCA AND TONY 128 RIANDA AND SEAMUS 132 JAYNE AND SIMEON 138 HELEN AND DOMINIC 142 MICHELLE AND SACHA 146 AMANDA AND MIKE* **152** PRESENTING YOUR IMAGES **156** GLOSSARY **158** WEBSITES

❯ *THE*INTRODUCTION

FORESIGHT IS THE KEY TO CONTEMPORARY WEDDING PHOTOGRAPHY – WHERE TO
BE AT THE RIGHT TIME – AND TO CATCH THE EVENT IN A NATURAL MANNER AS IT
ACTUALLY HAPPENS.

❯ As a photographer, the foresight of positioning yourself will grow with experience. You will think more about the situations arising and what angle they would best be photographed from, discreetly manoeuvring yourself so that this can happen.

This experience increases the chances of what some critics may call a lucky shot, making it in fact a very hard-earned photograph. The skill comes in making it all seem so effortless, and not allowing the photography to interfere with the wedding.

Any reasonable photographer can take one or two great pictures at a wedding if they are present for the whole of the wedding day. The modern wedding photographer's job is to supply more than just the odd good picture from a single wedding, giving the customer good reason to choose a professional photographer rather than a friend or guest who happens to have an eye for a good picture.

The married couple have usually spent two weeks on their honeymoon re-living and remembering how spectacular and special their wedding was, and the photographer is usually their first port of call on their return. In some ways it is the wedding photographer's job to make their wedding look better than it really was, thus living up to these high expectations.

❯❯ Planning is the key to a relaxed wedding, as an informal wedding does not mean a chaotic wedding. To allow your photographer to catch the great moments of the day, you still need to make some kind of timing structure for events.

A timing structure will mean that you will not have important decisions to make on your actual wedding day, which will free up your time, and in turn, will mean you are stress-free and happy. This will, of course, reflect in the photographs.

A good toastmaster can be invaluable in keeping things together and making the day run smoothly, failing this, a designated guest to act as master of ceremonies can be a help.

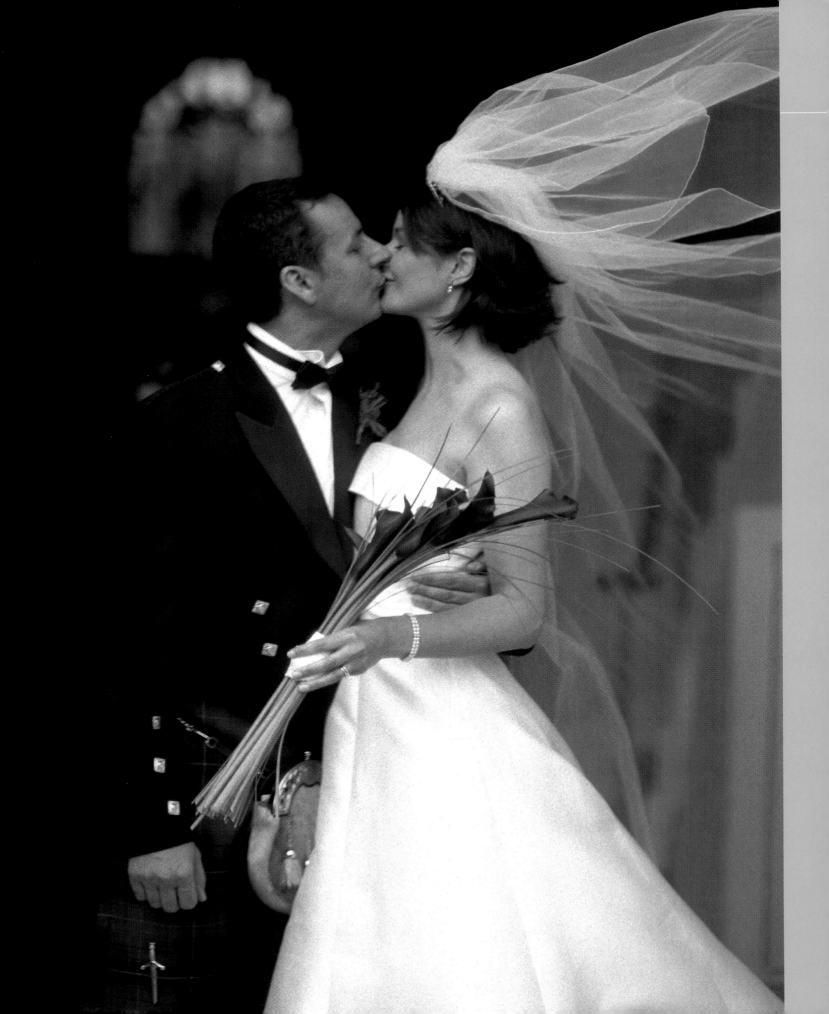

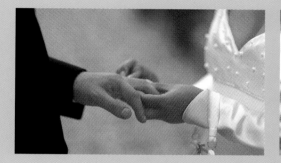

> Experience will teach you key moments to look out for. Such moments as the first time the bride and groom can steal a few private words together (usually after just signing the registry book), or the bride's first glimpse of her bridegroom as she enters for the ceremony (and vice versa). These are just two of the events I have learnt to watch for over the last few years; you will find your own moments to watch for, and thus become unique in the art of wedding photography.

As I work alone, i.e. without an assistant, much of the advice is for photographers in the same position. However, many of the tips are relevant, or can be adapted to the photographer who is working with an assistant(s). The comments regarding individual photographs are written in retrospect. At the actual time of taking the photograph often events were happening so quickly that all I was concerned with was catching a great image on film, and then moving on to the next photograph.

IN MY RUCKSACK I CARRY:
2 X NIKON F5 CAMERA BODIES
1 X NIKON 85MM f1.4 LENS
1 X NIKON 20–35MM f2.8 ZOOM LENS
1 X 105MM NIKON MICRO LENS
1 X NIKON 50MM f1.4 LENS
1 X NIKON 28MM f2.8 LENS
2 X NIKON SB 26 FLASHGUNS

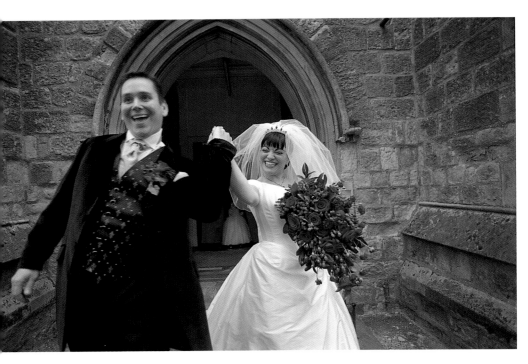

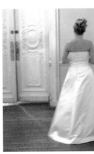

LEFT

This was taken with the lens (20–35mm zoom) set at about 24mm. The wide-angle lens adds a surreal feel to the image, it also gives the feeling that you are right in amongst the action (which indeed you have to be if working with this lens). The same picture taken with a standard or portrait lens from further away would have a different perspective, and lose some of the dramatic effect.

EQUIPMENT

> All of my camera equipment fits into one Lowepro camera rucksack. It has actually been designed for wildlife photographers (100% water-proof), and the fact that all my gear can be slung over my shoulder as I jump into a cab (which I often need to do if covering an inner city wedding) makes it an important piece of kit.

Another reason for the rucksack is that it will flip open and allow everything to be displayed and accessed immediately, without needing to rummage around in search of the right piece of equipment.

Mobility is essential when photographing a wedding. The bride and bridegroom will often exit the church, and after a quick chat and hug with friends and family, get in the car and leave for the reception. To keep up with them, you do not want to have to push back through the congregation to fetch the rest of your gear (or worse still, find the vicar has locked the doors, with your bag still inside the church as he heads off home). So keep your cameras/lenses close to you at all times.

If you are working at any location that the general public has access to (registry offices, hotels, for example), the concern of theft is also a good reason to keep all equipment to hand.

I sometimes carry a **Nikon FE or an old F2**, as a different camera can often inspire me, giving me a fresh outlook on a familiar subject.

I also carry plenty of film, a lens cleaning cloth and spare batteries (the cameras have re-chargeable Nicam batteries). I allocate one of the rucksack pockets to exposed films only. And for safety's sake, I transfer all exposed film to the pocket as soon as possible.

In the front pocket of the bag I carry any specific instructions for the day, a small umbrella, and paracetamol. I do not carry a tri-pod.

I use **Nikon cameras** simply because my first camera (after a Zenith E) was a **Nikon FM**, and as my collection grew, compatibility became a big issue.

I usually switch between aperture priority and programme modes on both **(F5) cameras**. One will be loaded with black-and-white film, the other with colour.

Far more important than the body is the lens. Buy the best you can afford. An aperture of **f1.4** will allow you to work in a dark church without flash, which you are often required to do. The **85mm lens** listed is what I use as a standard lens (see below left).

The zoom lens I carry **(20–35mm)** is not as fast, but I find the focal length very useful. This allows me to carry one lens instead of three. As you can hand-hold with a wide-angle lens at a slow shutter speed without camera shake, this was the option I took (see far left).

The **105mm lens** is for candid and portrait shots. I usually use it at the reception and sometimes for photographing flowers, jewellery and details during the preparation stage of the wedding.

The **28 and 50mm lenses** are for back-up. The **50mm** sometimes comes out of the bag for the family portraits, and if I am working into the evening they sometimes get chosen as they weigh considerably less than others.

My flashguns (see below) are always set to **TTL (through the lens)** metering. And, as you will see from some of the photographs, I will often use the rear curtain sync setting. This enables the photographer to expose the film for background light, and then fires to light the foreground subject just as the shutter curtain closes. This can result in some motion blur, but can be used to great effect, for example during the first dance.

The colour film I use is **Superia (Fuji Film UK Ltd.)** – from **100 to 400 ASA** – because it produces very warm tones. The lab I use print on **Kodak paper**, and this combination gives me the result I am looking for.

For black-and-white images I opt for **Ilford and Fuji film** – from **50 to 1600 ASA**. The choice of speed depends on the effect for the final print I am looking for, and, of course, the lighting conditions. I hand-print my standard black-and-white prints on **resin-coated Ilford paper** (this is for speed and convenience), occasionally using **Kentmere (Art Classic) paper**, or various fibre-based papers.

BELOW

The very shallow depth-of-field obtainable with this lens (working at f1.4) allowed me to focus on the flowers and throw the bride slightly out of focus.

BELOW

This was taken using the rear curtain sync button on the camera (or flashgun). The orange glow of the background is held, and the small amount of motion blur adds to the atmosphere of the photograph. I was working on the

aperture priority/auto setting on the camera at f2. The exposure was 1/8 of a second, and I was working with 200 ASA film, which I prefer to work with when using a flashgun as it allows me to work at a wider aperture.

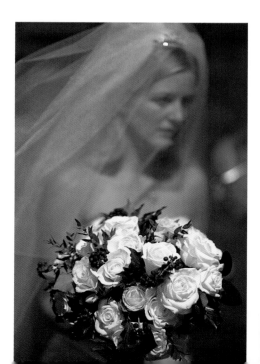

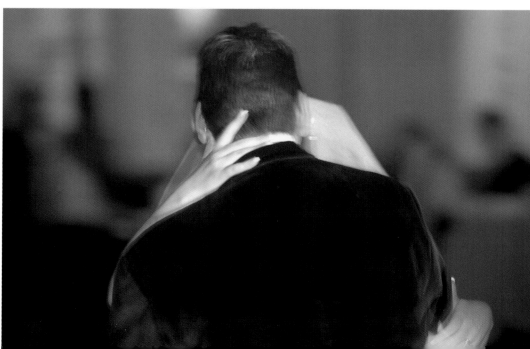

SELLING*YOURSELF*

> **HOW I STARTED**

In 1994 I was commissioned to photograph a wedding by Wedding and Home magazine. This came about when the picture editor of the magazine saw the work in my fashion and editorial portfolio, which I was touting around various fashion magazines (with very limited joy). The brief was to photograph a wedding in an editorial style; they were not interested in family portrait pictures or the standard cutting the cake shot, but in a more stylised and relaxed approach. The photographs were a success with the couple and the magazine, which made me decide it was time to make a small career move.

I had photographed a few friends' weddings before being commissioned by the magazine, so I did have a few shots to show the magazine and gain the commission. When photographing friends' weddings, I made sure I was the only professional photographer, so I was not interfering or in competition with another wedding photographer.

If you are thinking of practicing wedding photography at a friend's wedding, then please ask the couple to check if it's all right with the photographer they have commissioned. You could spoil the photographs by being in the way without even realising it. A better way is to phone around and try to find a job assisting a photographer.

WHERE TO ADVERTISE

I took the risk from the very beginning of not trying to catch passing trade. I was far more interested in targeting the kind of person (bride-to-be) who I thought would be interested in my work. I kept away from advertising in phone directories and local papers, as they were too general-purpose for what I was offering. Instead I advertised in publications such as Wedding and Home magazine, where I knew the advert would reach my target audience.

I kept the advert simple, with text only. Later, as the business grew, I included a photograph in the advert. The more successful I became the larger the classified advert became, and sometimes I would place an advert in the editorial section of the magazine too. The main difference (apart from cost) in advertising in the editorial pages of a magazine rather than the classifieds is that with a classified advertisement you reach the customers searching for a definite product. With a larger advert in the main body of the magazine, everyone who reads the magazine will see it, which will create some word-of-mouth advertising.

Nowadays, I also use advertising in the wedding press to direct customers to my website.

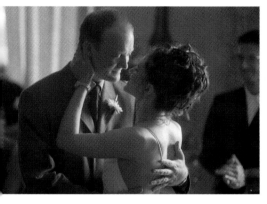

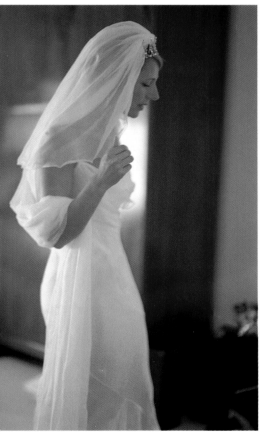

THE WORLD WIDE WEB

The www is the perfect place for a photographer to advertise. Your whole portfolio can be placed on a website for the world to see at the click of a button.

Before putting together your website or briefing a design company on building a site for you, think about how you want the site to look and what you would like it to achieve. For example, you may want it to feature everything about your business, or you may want it to contain just enough information to entice the customer to contact you.

For design ideas look at the magazines your future customers are buying and reading, the Vogues and the Elles etc. Look at the photographs, the way they are displayed, and the typefaces that have been used (this especially includes the advertisements).

Make your site look as contemporary as possible, without being unnecessarily flashy or complex. I find that good photographs attract customers, so display what you feel are your very best shots so as to get their attention from the beginning. Information such as terms and conditions and prices can be provided once the customer has contacted you, alternatively you may wish to display all details on your site, eliminating time spent answering questions on the telephone or at a meeting.

I use my website as a kind of filter. If the customer calls or telephones after they have viewed my site, then I know they like the photographs and have a basic understanding of the kind of service I provide. If they do not like the photographs on the site, then they can cross me off their list. This means far less time is spent on unsuccessful appointments, which is good for both parties involved.

To promote your website make sure to include the site address in all your advertisements, as you will still have to point people to your site. Also include the address in all letterheads and on your outgoing answer-phone message.

You may wish to advertise with a larger website such as confetti.co.uk, who for a fee will provide a link directly to your site. You can also submit your site information to the various search engines (Yahoo!, Lycos etc.), that will then list your site (amongst others) once people have typed in a few key words.

MEETING THE COUPLE

The meeting is a chance for the couple to see face to face who will be taking their wedding pictures, and to ask more detailed questions (see pages 016–019).

The first thing I do at the meeting is to confirm the date, time and location of the wedding. I also establish a rough arrival and departure time at this point, which provides a kind of framework for the rest of the meeting.

I then explain how I work throughout the day and offer the couple the chance to ask questions. For this I find it helps to establish a list of set rules for yourself (i.e. how late you are prepared to stay, will you view the location before the wedding day etc.), and then you can bend your own rules for individual customers if you wish to.

Be 100% open with the customer from the beginning. The meeting is for the benefit of the photographer as well as the couple, and the photographer being vague about how he/she works can lead to the couple making wrong assumptions, which in turn can lead to larger problems at a later date. Ask the couple to read your terms and conditions, and to ask questions if they do not understand any of the points.

Next I show the customer everything they will receive for their money. I leave nothing to their imagination, as this again can often cause problems at a later date. Contact sheets, preview/proof albums and portfolios are all scrutinised at this point.

I sum up by asking if the couple has any more questions, and that to call or post a deposit if they would like me to confirm the date as booked. The whole meeting usually lasts about 45 minutes.

Experience makes me advise that a photographer should not count the booking as confirmed until a deposit has been paid. Saving dates without taking a deposit can cause confusion all round, usually with the photographer losing work in the end.

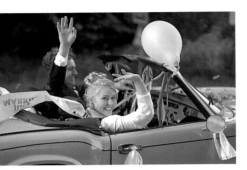
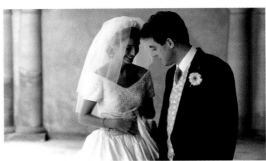

BOOKING *YOUR* PHOTOGRAPHER

>> There are two main ways to find a wedding photographer: through advertising and through recommendation. As soon as you have confirmed/booked your wedding and reception venue it is time to start looking for a photographer.

The obvious thing to do is ask friends and work colleagues and see if they can recommend a photographer, but do remember, their taste may be somewhat different to your own. If they can recommend someone, ask them if you can have a look through their own wedding album.

If you are impressed with the results, give the photographer a call and ask for some details (most photographers will have a brochure and price list to send out). Once you have received the details, view some other photographers' images, on the internet for example, just so you have a comparison, picture- and price-wise. The next step is to arrange a meeting. Failing no personality clashes – it is important that you get on as they will have a ringside seat at your wedding – and you are happy with the prices, my advice is to book the photographer, as good photographers will get booked up to two years in advance.

If you have not been impressed by any of your friends' wedding photographs, or simply do not want the same photographer as them, then it is time to flick through the classified adverts in the back of the bridal magazines. You may amass plenty of these as your wedding approaches. Pick a few of the ads that catch your eye and simply call and ask to be sent information. Most photographers will have website addresses advertised. This means you can view their photographs before you contact them, so at least you will know if they can supply the style of picture you require right from the start.

If you like the website, and get on well with the photographer over the telephone and via email, you may even be happy to book your photographer without actually meeting up.

If you cannot, or do not feel happy about booking a photographer without a face-to-face meeting, then make a short list of your favourites.

Once you have made a list, it is time to arrange some meetings.

WHEN THE TIME COMES TO SEE WHAT YOU WILL PHYSICALLY RECEIVE FOR YOUR MONEY THE THINGS TO CHECK ARE:

· How are the proofs presented?
· What size are the proofs?
· Are the proof prints presented in print format or on contact sheets?
· Are the proofs stamped with a copyright mark?
· Can the proofs be kept or are they returnable?
· How many photographs or rolls of film will the photographer take and are these included in the fee?
· How is the final selection of prints presented?
· How much do reprints cost?
· How long does the photographer hold the negatives?
· Will the photographer sell the negatives?
· Does the price include sales tax?
· Are there any travel costs?
· Are there any postage and packing costs?

There are no correct answers to these questions, but as long as you are content with the answers you are given, any possible confusion or disagreement at a later date can be avoided.

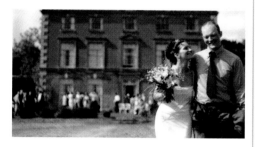

Note: Proof prints are the initial prints your photographer will produce after your wedding. They will have a reference number on the front or reverse side: proof prints that are to be returned are usually defaced in some way so that they cannot be copied and are useless to keep.

Contact sheets are all of the photographs taken on a single roll of film displayed on a single sheet of photographic paper. The frame numbers run underneath the relevant pictures. These are more common with black-and-white photographs, and as well as serving a practical purpose, can look fantastic mounted and placed in a frame.

If your photographer is working with digital equipment many of the questions and points in this section are still relevant. Of course, the issue of black and white and colour can be decided at a later time.

AT THE MEETING:

On average the meeting with a photographer will last about 45 minutes. You can ask many of the questions below over the phone. What the appointment is primarily for is to see (and feel) what you will receive for your money (albums, presentation boxes etc.), and to meet your photographer face to face. Some photographers will travel to your home, bringing their portfolios and information, but with the majority you will be visiting them at their studio or office. Below is a list of the most common questions I am asked at meetings, along with my replies. Obviously the answers will differ from photographer to photographer, but these can serve you as a guideline. Over the telephone you will have already established availability of the date, the initial charge for photographing the wedding, whether your photographer is willing to travel the distance to your venue, and you will have viewed a few of their photographs in a brochure or on a website.

HOW AND WHEN DO WE PAY THE PHOTOGRAPHER?
Usually you will have to pay a deposit before a photographer will book you in for a certain date. The photographer may hold a date out of courtesy for a short while for you without taking a deposit, but a deposit makes your booking definite. You may be requested to fill in a booking form or sign a contract at this point as well, giving details and contact phone numbers and saying that you agree to the photographer's terms and conditions. When the remaining balance is paid differs from photographer to photographer, but usually it is between two weeks before the wedding day and the wedding day itself. You should always receive a receipt/confirmation of your booking in writing.

CAN I SEE SOME MORE PHOTOGRAPHS?
When viewing a photographer's work, it is a good idea to ask if you can see a selection of prints from two or three weddings, as well as the best pictures from a selection of weddings. Obviously, in the sales brochure and on the website, the very best pictures from many different weddings are chosen to grab the customer's attention. It is relatively simple for a photographer to take one good photograph at a wedding, so look at proof prints and albums of weddings the photographer has completed in the past. This will give you some idea as to whether the photographer is consistent.

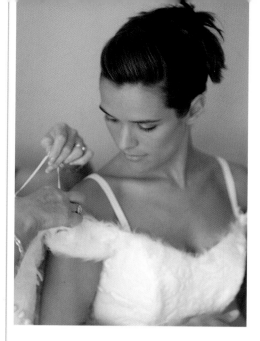

HOW MUCH WILL REPRINTS COST?
This will differ greatly between photographers. Some photographers will charge you a smaller fee for actually photographing the wedding and have slightly higher reprint prices. Others will have a much higher fee on the day and a more reasonable reprint price, and, of course, some will have a high fee for the day and high reprint prices!

Also, some photographers may sell the negatives to the customer, which could be a good deal in the long run. On average a 10x8 inch reprint from a wedding photographer costs much more than having it printed yourself.

HOW ARE THE PHOTOGRAPHS PRESENTED?
Leather-bound albums, embossed albums, presentation box sets, bound books with text, mounted prints and framed prints: photographers will have many individual ways of displaying the final selection of prints. If you have strong ideas about presenting your photographs in a certain way, then choose an option from your photographer that takes this into account, possibly including more enlargements in the fee rather than an album. Also you may want to add an album to your wedding gift list.

HOW MUCH WILL IT COST?
You will be aware of the photographer's prices before the appointment. The fees for the day's work can range from £500.00 to £3,000.00, but as a photographer's 'options' will vary so much in what they contain, and as already mentioned, in the time they attend the wedding, it is impossible to compare like for like by price alone.

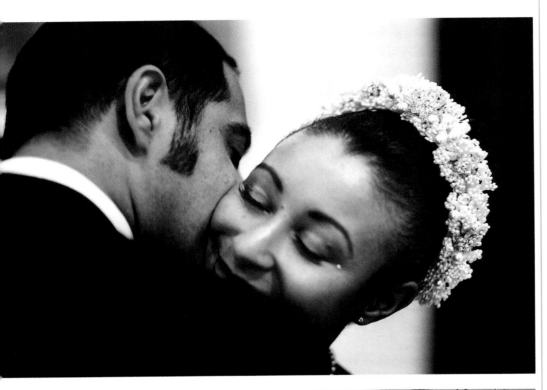

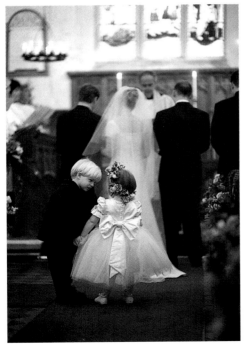

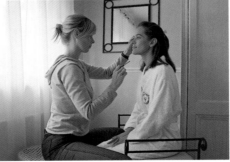

*AT WHAT TIME WILL THE PHOTOGRAPHER ARRIVE,
AND AT WHAT TIME WILL HE OR SHE DEPART?*

The majority of modern style wedding photographers are with you for the day and some of the evening. They want to capture the hustle and bustle of events leading up to the ceremony, and stay to photograph the humour and emotion of the speeches and dancing. Generally the photographer will arrive at the bride's preparation venue two hours before the ceremony. So for a 2.00pm wedding the photographer will arrive at 12.00pm latest, and then leave for the ceremony venue half an hour before the bride sets off. This is to allow time for the photographer to park, to photograph the venue flowers, to photograph the bridegroom and ushers (if they venture out of the pub early enough), and guests arriving, and, most importantly, to be ready for the arrival of the bride.

Obviously this means you will not have photographs of the bride leaving the house (unless your photographer has an assistant with another vehicle), however, it is far more important for your photographer to be waiting as you arrive for the ceremony itself.

The finishing time will vary from photographer to photographer. Some will finish when you sit down to eat, others will stay through the speeches, some for the first few dances, and some to the very end. As a rule, the later your photographer stays into the evening, the more expensive it will cost (due to time and film used).

*HOW MUCH TIME SHOULD WE ALLOW
FOR PHOTOGRAPHY?*

As modern wedding photographers are far more interested in capturing the events of your wedding as they unfold, I shouldn't worry about allocating time for photography too much. As long as you supply a list of more 'formal' type pictures for your photographer – see list on page 083 – allowing about 20 minutes out of your reception for these, plus maybe ten minutes for some photographs or portraits of the bride and bridegroom alone together. The rest of the time allows your photographer to wander around the wedding capturing candid and informal moments.

*I DO NOT LIKE HAVING MY PHOTOGRAPH TAKEN;
WILL THIS BE A PROBLEM?*

If the photographer is capturing the events as the day unfolds, you will be doing very little posing, and you will soon be unaware of their presence. The photographer will be more interested in capturing you laughing with your friends, or smiling at your new husband. This will make a far more natural photograph, and as no posing is necessary for this type of picture the question should not be an issue.

BASIC INFORMATION YOUR PHOTOGRAPHER WILL REQUIRE FROM YOU
RELEVANT TELEPHONE NUMBERS FOR BRIDE AND BRIDEGROOM
TELEPHONE NUMBER OF BRIDE'S DEPARTURE ADDRESS, WEDDING VENUE AND RECEPTION VENUE
MAPS AND DIRECTIONS FOR ABOVE LOCATIONS
CEREMONY TIME AND OTHER RELEVANT TIMINGS
YOUR PREFERENCE BETWEEN COLOUR AND BLACK-AND-WHITE PHOTOGRAPHS (IF APPROPRIATE)
DRESS CODE FOR WEDDING (I.E. LOUNGE SUIT, BLACK TIE, MORNING SUIT)

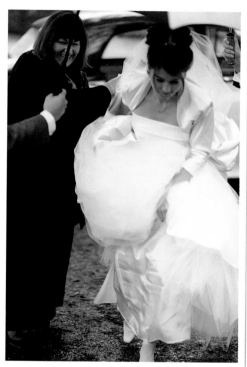

WE HAVE SOMEONE PROFESSIONALLY VIDEOING THE DAY; WILL THIS INTERFERE WITH THE PHOTOGRAPHY?

No, this shouldn't be a problem; the only time it can be of consequence is if the person videoing starts to arrange things or set things up, disturbing the natural flow of events. But if you have chosen a photographer with the style of photography illustrated in this book, the chances are your choice of videographer will be similar, thus avoiding any problem.

WHAT HAPPENS IF THE PHOTOGRAPHS DON'T COME OUT?

This is one for the insurance companies to sort out. Read the photographer's terms and conditions as well, as they may contain information relevant to the above question.

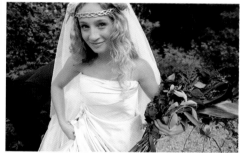

WILL THE PHOTOGRAPHER VISIT THE VENUE BEFORE THE WEDDING?

Some photographers will, while others will not find it necessary. Personally I prefer to visit the reception and venue (unless there is a great distance between all three locations of the wedding) before I arrive at the bride's preparation venue on the morning of the wedding. This way I am aware of the weather situation whilst looking around. However the main purpose for me doing the 'recce' is so that I know the driving routes from venue to venue, and where to park the car etc. This allows me to concentrate on the photography and not how to get from A to B.

WHAT HAPPENS IF IT RAINS ON THE DAY?

The chances of it raining for the whole of your wedding day are not that high, but it does happen. The main thing is to try and not let it get you down too much. You can still go outside for some photographs; a newly wedded couple huddling up under an umbrella in the pouring rain can look very romantic. The weddings I have photographed where it has rained all day have still been great occasions. Check with your venue if they have contingency plans for rainy weddings, such as an extra room for some family photographs etc. The contemporary wedding photographer will not worry about the weather too much as they are simply telling the story of the wedding through photographs, and the rain will simply be a part of that story.

WHAT HAPPENS IF THE PHOTOGRAPHER IS ILL?

If you have hired a photographer from a firm or a team, then this is not such a problem. The company can simply send another photographer (if one is available at short notice) that is on their books. This is the advantage a team or company will have over an individual trading as a photographer.

If you have hired an individual photographer to provide a more personal service, then they will probably have a list of photographers who can be called in an emergency. They may have a competent assistant that could step in for the day, but the process of finding a replacement may not be as simple as it will be for a large company.

No professional photographer that I know of would pull out of a wedding without a very good cause. If it is just a question of a headache then of course they will turn up. It will have to be a pretty serious illness (or a booking mistake) for them to fail to show up.

If your photographer is insured then the insurance company will sort out the financial arrangements that will arise from such situations. You can also insure your own wedding against such disasters.

> BEFORE*THE*WEDDING

BEFORE THE WEDDING IS A FANTASTIC OPPORTUNITY FOR YOUR PHOTOGRAPHER TO
CAPTURE MOMENTS ON FILM THAT WILL BEGIN THE STORY OF YOUR WEDDING DAY.

> For the photographer, this is a great opportunity for pure reportage photography. I usually arrive two hours before the ceremony time, which allows about an hour for pictures. You will be surprised at how soon you become invisible, and will be able to photograph the build up to the wedding in a natural way. Watch out for cuddles, tears, and portrait opportunities. You will get a feel for the atmosphere of the wedding (hopefully relaxed and fun) and will be able to establish a working relationship with the bride and her family that will last the day. This is much harder to do if you only start work at the wedding venue, as 101 people will all want to chat with the couple and the photographer will not be top of the list.

If the atmosphere is very tense and things aren't going to plan for the bride, start off by photographing the details – such as the flowers, shoes, and hair accessories – but take it from there. I have no set picture agenda for the period at the bride's house (I may take two photographs, I may shoot two rolls of film), but I always set off for the wedding venue a good half an hour before the bride is set to leave.

> > For the bride, photographs of her getting ready may be the last thing she wants, however, it isn't just the bride the photographer will want to capture on film. There are the flowers, the shoes, the dress hanging in the room, the flower girls causing havoc etc. All of these things make the day what it is, and I feel should be photographed for posterity's sake. Having photographs taken at this point in time will also enable you to establish a working relationship with the photographer and give you time to get used to having the camera lens pointed in your direction, which will give you one less thing to worry about when you arrive at the wedding venue.

CAMERA	Nikon F5
LENS	85mm
FILM	Fuji Superia 400 ASA
FOCUS	Auto
FLASH	No
CAMERA SETTINGS	Aperture priority f1.4

TECHNICAL INFO FOR MAIN PICTURE >

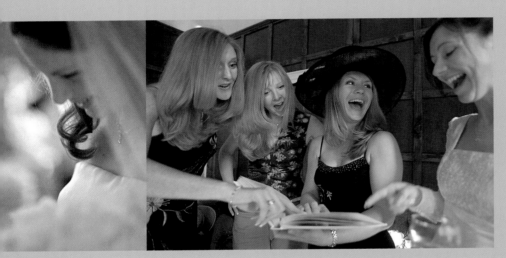

RIGHT
This image was taken as the bride was being dressed. I was waiting for a moment when none of the other four people in the room were in the frame. In fact, you can still see an arm to the far right. If I had asked anybody to move, the bride would have become aware she was being photographed and possibly become self-conscious.

LEFT
Just before the wedding the bride and her friends view the hen night photographs. They were all so focused that they didn't pay any attention to me, even right up close with a wide-angle lens.

FAR LEFT
The bride does not have to be looking happy or into the lens for a great picture, capturing a moment of reflection before the main event is just as important to me.

*THE*BRIDE*PREPARING*

> I always try not to put the bride under any pressure to be ready by a certain time before the wedding itself. I may shoot two frames, I may shoot two rolls, it depends on the atmosphere and how stressed the bride is. If she is very stressed then I will concentrate on photographing details – such as flowers, shoes and hair accessories – and assess the situation. The one thing I will do is stick to my own schedule, and if the bride is running late, I will still set off for the venue at my set time.

>> It is a good idea to have your photographer around before the wedding, as you will get used to the lens being pointed in your direction, and it will be one less thing to think about later. Do not worry about being self-conscious; you will be surprised how soon he or she blends into the woodwork.

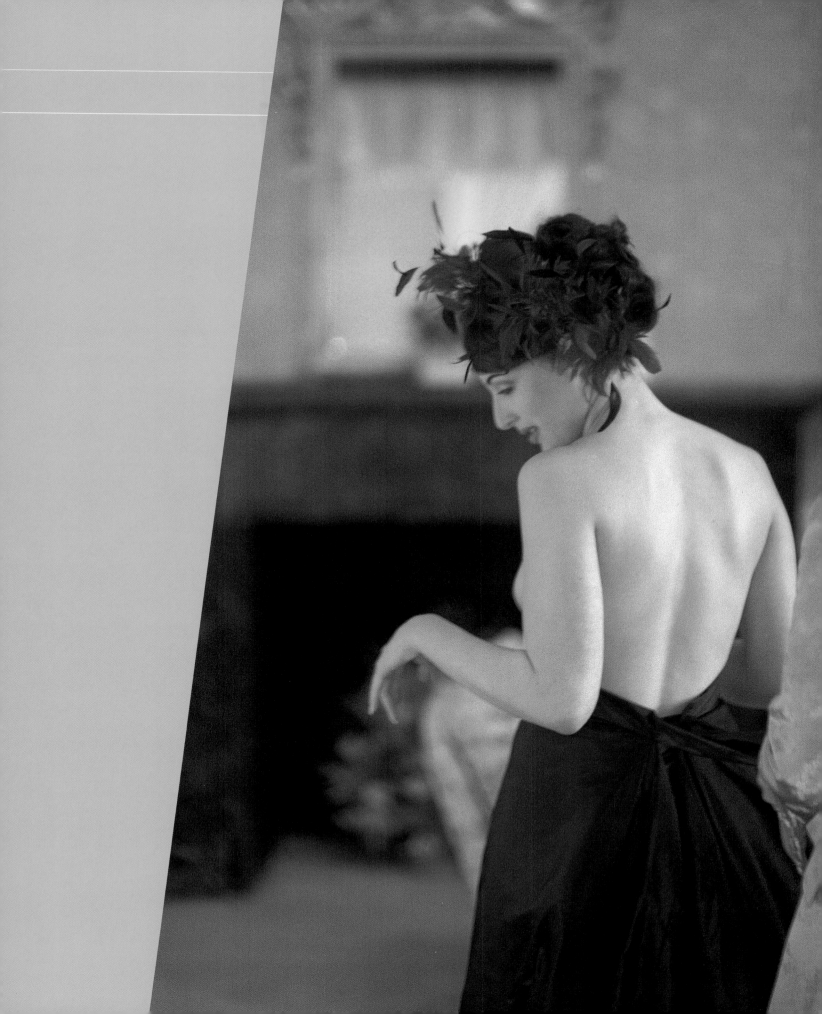

TECHNICAL INFO FOR MAIN PICTURE	
CAMERA	Nikon F5
LENS	105mm
FILM	Fuji Superia 400 ASA
FOCUS	Auto
FLASH	No
CAMERA SETTINGS	Aperture priority f3.5

RIGHT

The bride was being made up opposite a beautiful big window, so the natural light was flooding into the bedroom. I only take one or two of the make-up being applied, as it is not fair to get in the way of the make-up artist, and not fair to the bride to have too many pictures taken without make-up!

LEFT

A beautiful bride in a beautiful dress on a beautiful day – sometimes the pictures are handed to me on a plate. I didn't need to pose anything as the bride was relaxed and having a good time. If I had stepped in and started to arrange the shot it would have spoilt the atmosphere.

FAR LEFT

It is the formation of the girls and the way they are linked together that makes this shot so powerful.

{ YOU DO NOT NEED ESPECIALLY STRONG MAKE-UP FOR PHOTOGRAPHS. IF YOU LOOK GREAT IN THE MIRROR YOU WILL AUTOMATICALLY FEEL RELAXED AND CONFIDENT, WHICH WILL MAKE FOR EQUALLY GREAT PHOTOGRAPHS.

> This is a great time for real fly-on-the-wall photography, usually with plenty of excitement, or otherwise calm anticipation in the air. Whatever the mood, try and pick up on it and capture it on film, do not try and create a mood by arranging people or rooms too much. If the room is in a mess, leave it in a mess (as the mess will be relevant to the wedding), as it is all part of the story.

>> Allowing plenty of time is the key to keeping this part of the day relaxed and enjoyable. Estimate a time for your hairdresser to start, and then move it forward an hour just to make sure. If you don't have adult bridesmaids, ask a good friend to come round for moral support as the more relaxed you are, the better the photographs will be. You do not need especially strong make-up for photographs, if you look great in the mirror you will automatically feel relaxed and confident, which will make for equally great photographs.

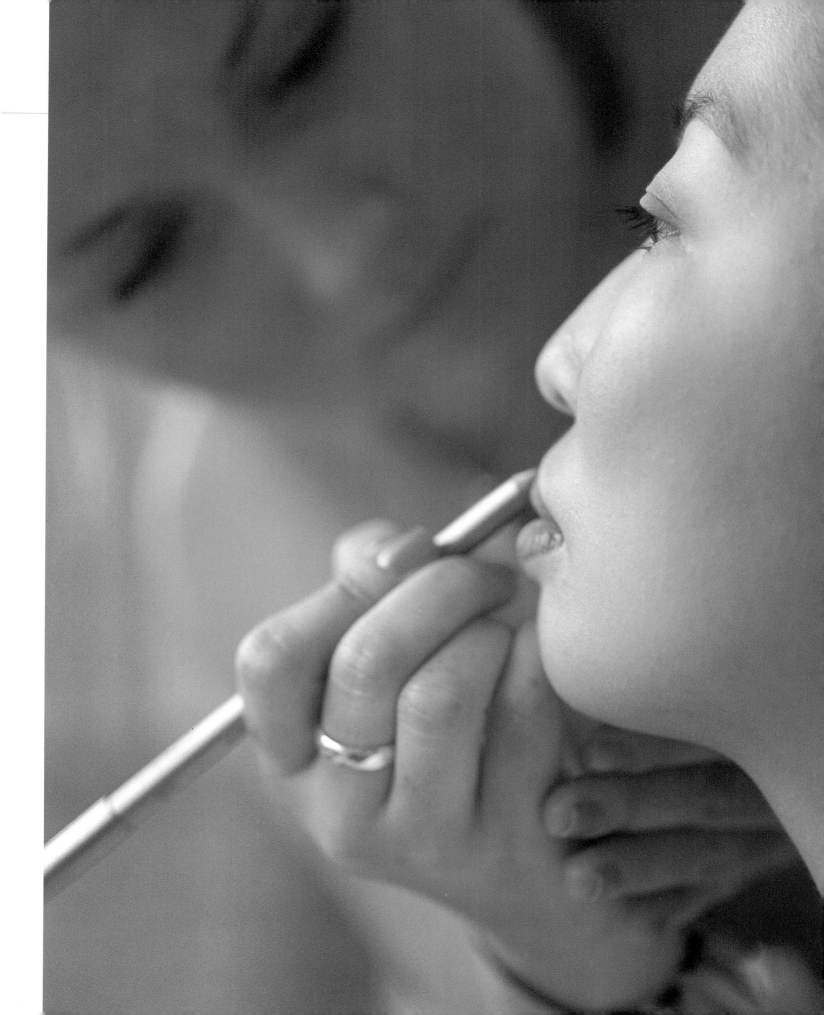

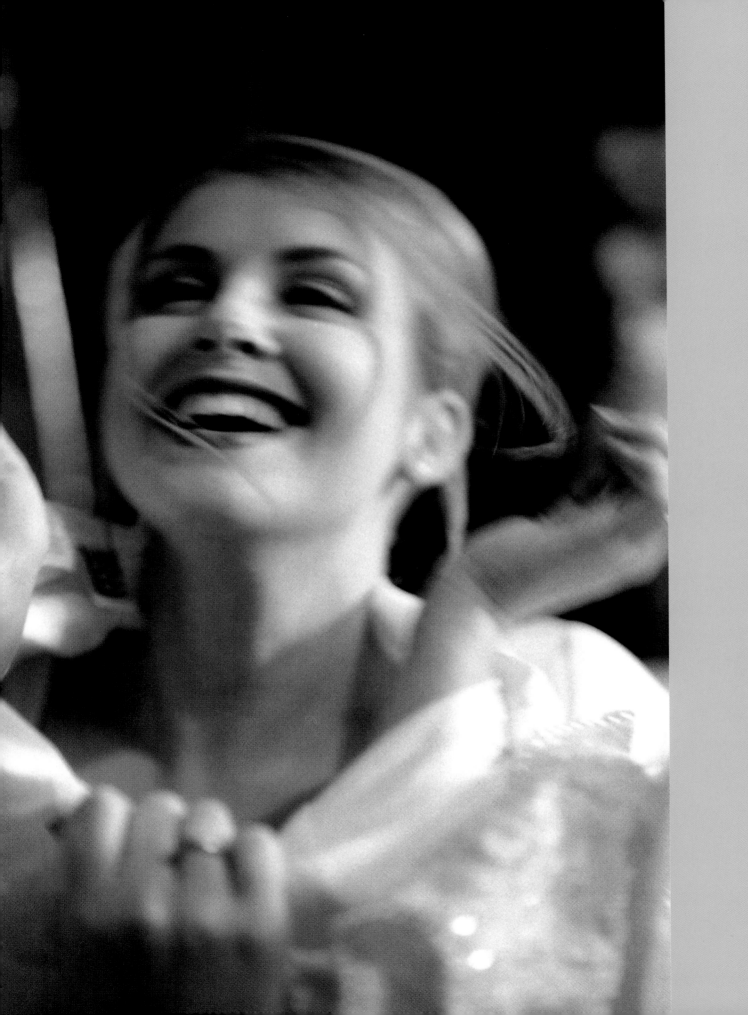

CAMERA	Nikon F4
LENS	85mm
FILM	Ilford HP5 400 ASA
FOCUS	Auto
FLASH	No
CAMERA SETTINGS	Aperture priority f1.4 at 1/15sec

‹ TECHNICAL INFO FOR MAIN PICTURE

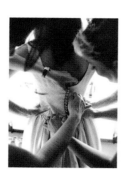

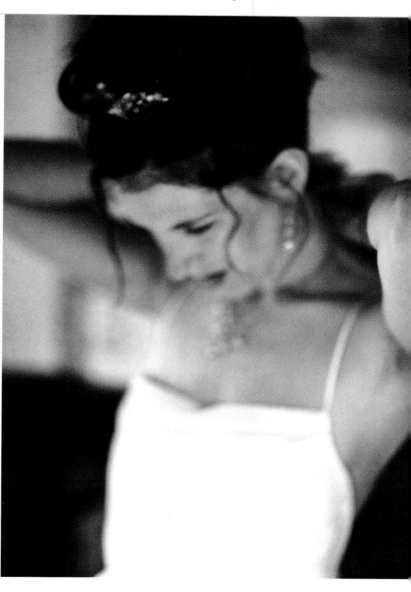

ABOVE
Many hands make light
work! The dress is fastened
by the bridesmaids; a
wide-angle lens (20mm)
amplifies the effect of
this picture.

LEFT
The bride's head and hands
pop through her dress as she
is fitted by her bridesmaids.
The room was dark, but I
avoided using flash, which
created the beautiful
movement in this picture.

RIGHT
The bride fastens
her necklace.

{ TRY AND INVOLVE THE PHOTOGRAPHER IN THE EVENTS LEADING UP TO THE CEREMONY ITSELF. THIS WAY YOU WILL NOT ONLY BECOME MORE COMFORTABLE IN FRONT OF THE LENS, BUT WILL ALSO HAVE A PHOTOGRAPHIC RECORD OF AN OFTEN MEMORABLE STAGE IN THE DAY.

> If you look hard, even what seems the most mundane event can sometimes be worth capturing. Always be on the look out for these types of images, and the more you look the more you will see.

CAMERA	Nikon F5
LENS	85mm
FILM	Ilford HP5 400 ASA
FOCUS	Auto
FLASH	No
CAMERA SETTINGS	Aperture priority f1.4 at 1/30sec

TECHNICAL INFO FOR MAIN PICTURE >

DETAILS

> Brides put a lot of work into co-ordinating the details for the wedding, not to mention the expense of what are often very beautiful things, so some good photographs of them will be very much appreciated. Sometimes I will move things to where there is some natural light, but quite often things are fine as I find them.

>> Ask your photographer to photograph the details that you have put so much effort into choosing. One day you may wish to show your children or grand children the type of shoes or jewellery you wore on your wedding day.

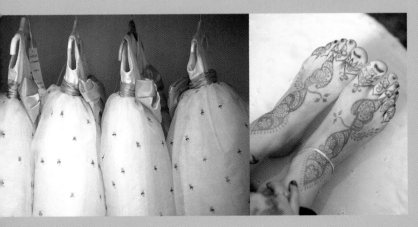

RIGHT
Always be on the look out for new ways of photographing things. It doesn't always work, but when it does, as in this picture, the effect can be very powerful.

LEFT
The henna dye (used at some Asian weddings) on hands and feet is painlessly (and patiently) applied and is for decorative purposes only.

FAR LEFT
The bridesmaids' dresses hang in the wardrobe. The electric light of the hotel room provides a warm glow.

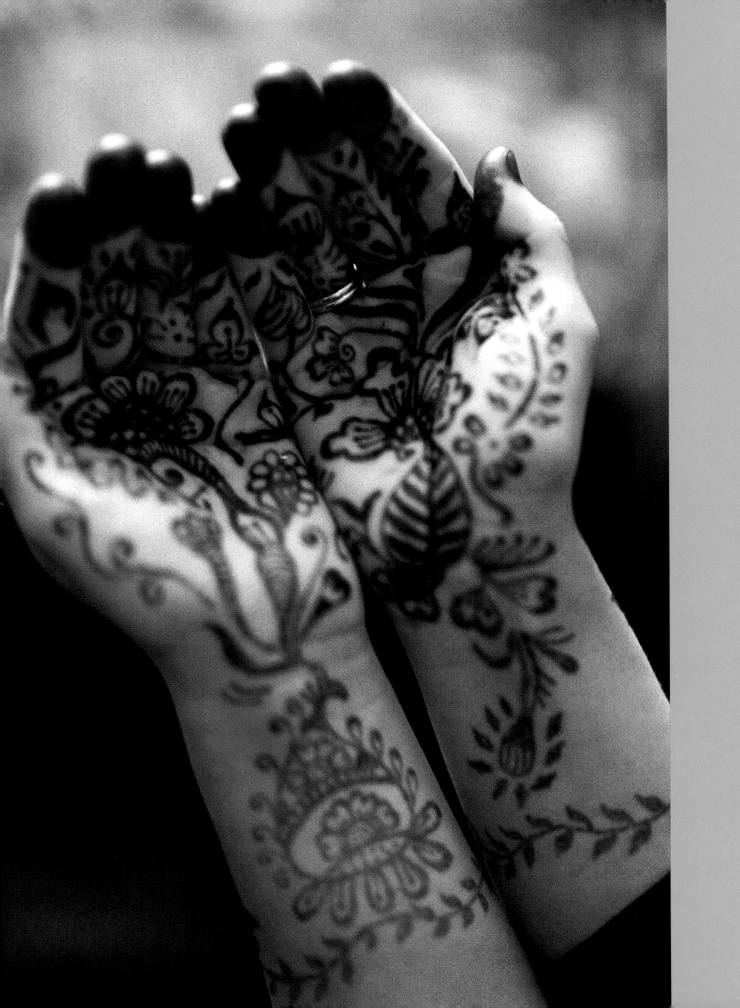

CAMERA	Nikon F5
LENS	85mm
FILM	Ilford HP5 400 ASA
FOCUS	Auto
FLASH	No
CAMERA SETTINGS	Aperture priority f1.4 at 1/30sec

‹ **TECHNICAL INFO FOR MAIN PICTURE**

RIGHT

I didn't even have to move these shoes, they are just as I found them!

LEFT

Henna-dyed hands. The henna is applied through a paper cone (similar to ones used for cake decoration) to hands that have been coated with clove oil. When it has dried, lemon juice is gently applied to stop any cracking that may occur. The effect can last between six and eight weeks. This is a tradition that originates from a prophet's wife, who decorated her hands, feet, and especially nails this way.

{ TRY AND HAVE A QUIET ROOM TO YOURSELF TO GET READY. ASK SOMEONE TO DEAL WITH ALL PHONE CALLS. ALLOW PLENTY OF TIME, ESPECIALLY IF YOU WOULD LIKE PHOTOGRAPHS IN YOUR WEDDING DRESS AT HOME, AS YOUR PHOTOGRAPHER NEEDS TO BE AT THE VENUE WELL BEFORE YOU.

› I use natural light where possible with nearly all the photographs taken before the wedding (I don't even fit the flash to the camera at this stage). Movement and a shallow depth-of-field can add to the atmosphere of the photographs. Flash (even a minimal amount) can be too harsh and create unwanted shadows. Also, it is a lot easier to remain 'invisible' and be unobtrusive without your flashgun firing every ten seconds.

 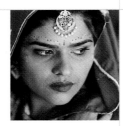

ABOVE LEFT
The bride slips decorative
bangles over her wrist.

ABOVE
Here it is the bride's
beautifully painted face
and headdress that
caught my attention.

RIGHT AND FAR RIGHT
Decorative feathers
placed in these brides'
hair provided me with
interesting focal points.

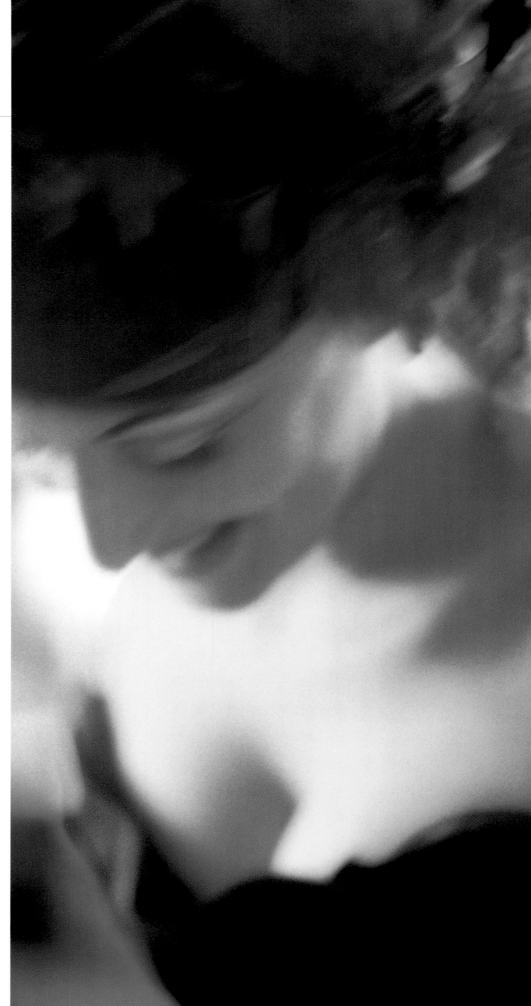

TECHNICAL INFO FOR MAIN PICTURE	
CAMERA	Nikon F90
LENS	85mm
FILM	Fuji Superia 400 ASA
FOCUS	Auto
FLASH	No
CAMERA SETTINGS	Programme f1.4 at 1/15sec

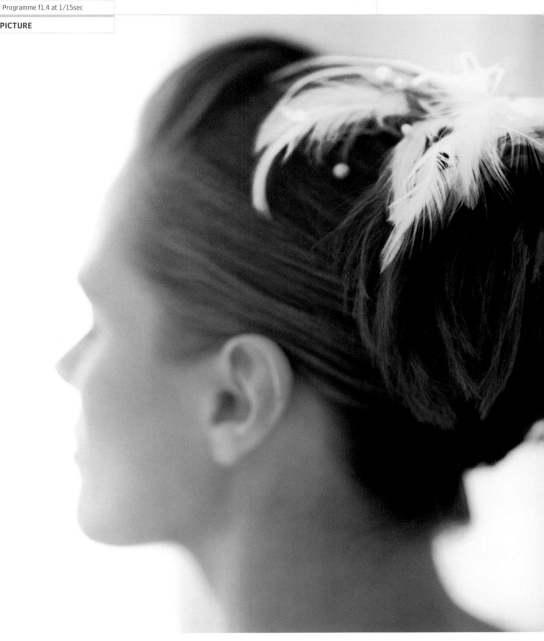

{ OFTEN PEOPLE ARE QUITE OBLIVIOUS TO BEING PHOTOGRAPHED –
THIS MAKES FOR SOME BEAUTIFULLY NATURAL, AND OFTEN
UNUSUAL PHOTOGRAPHS.

>> By allowing your photographer to work before the wedding you will get used to them snapping away, and you will soon forget that they are present. This always helps to produce natural wedding photographs throughout your wedding day.

CAMERA	Nikon F5
LENS	85mm
FILM	Fuji Superia 400 ASA
FOCUS	Auto
FLASH	No
CAMERA SETTINGS	Auto/aperture priority f1.4 at 1/30sec

TECHNICAL INFO FOR MAIN PICTURE >

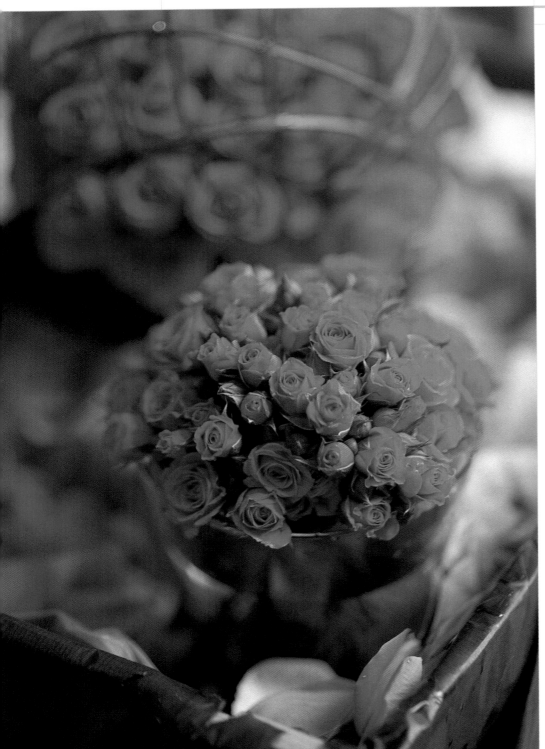

LEFT
The bridesmaid's bouquet.
Sometimes I will move
the box the flowers are
presented in to a window
making use of the natural
light. Here the crêpe paper
supplied by the florist
becomes an attractive
background.

RIGHT
This is how the flowers were
positioned as I entered the
room. When photographing
weddings you will often find
that things do not need to
be arranged, or if they do
only slightly, as they look
gorgeous exactly as they
have been placed, in a
natural manner.

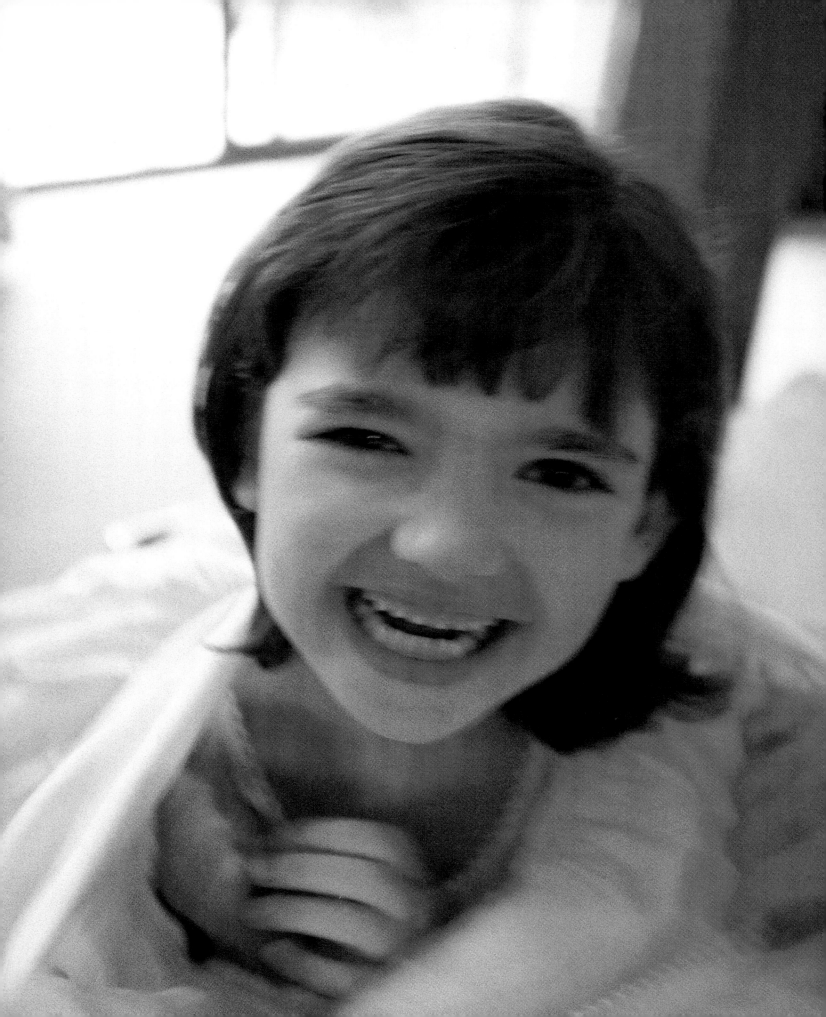

CAMERA	Nikon F5
LENS	20–35mm
FILM	Neopan 400 ASA
FOCUS	Auto
FLASH	No
CAMERA SETTINGS	Programme f2.8 at 1/15sec

‹ TECHNICAL INFO FOR MAIN PICTURE

LEFT
This bridesmaid struggles into her dress, with a little help from mum.

BELOW
Some children love the camera, as is evident here with these two little girls.

*THE*BRIDESMAIDS

> Be patient with children, if they won't smile for you don't worry, just keep an eye on them throughout the day and you will catch them at some point.

> > I find children wonderful to photograph. There are the obvious pros and cons to having children at your wedding, but as a photographer I think that they make for great characters in wedding pictures. As a bride, it is a way of involving younger members of the family too.

CAMERA	Nikon FE
LENS	28mm
FILM	Neopan 1600 ASA
FOCUS	Auto
FLASH	No
CAMERA SETTINGS	Aperture priority f2.8 at 1/250sec

TECHNICAL INFO FOR MAIN PICTURE >

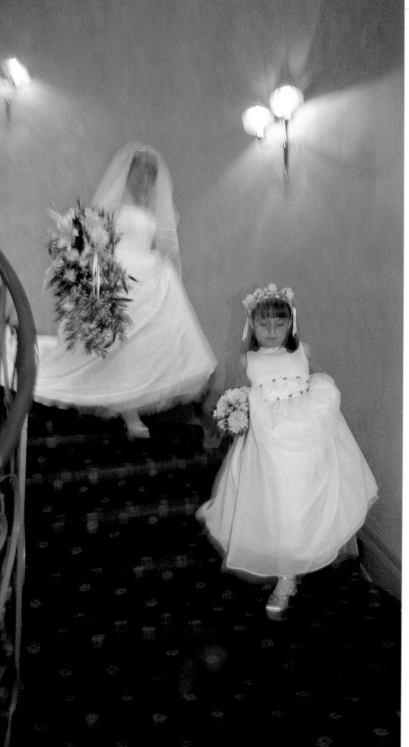

{ SOME OF MY FAVOURITE PHOTOGRAPHS ARE THOSE TAKEN WHILE EVERYONE IS GETTING READY. THEY MANAGE TO CATCH SOME REALLY TENDER AND TOTALLY NATURAL IMAGES.

RIGHT

This is the first frame of the first wedding I was commissioned to undertake (back in 1994).

LEFT

I used a slow shutter setting and the rear shutter sync on the flashgun to capture and add movement to this shot. I panned down slightly and the bridesmaid's face has held. The shots either side of this did not work, as they were too blurred.

ABOVE

This was taken just after a slightly more formal photograph, the bride is laughing with someone off-camera, but I still have the attention of two of the bridesmaids. When working with a very wide-angle lens (20–24mm), people towards the sides of the frame fail to realise that they are still in shot. This can be used to good effect. In this picture the bride is assuming that I am photographing the two bridesmaids in the foreground.

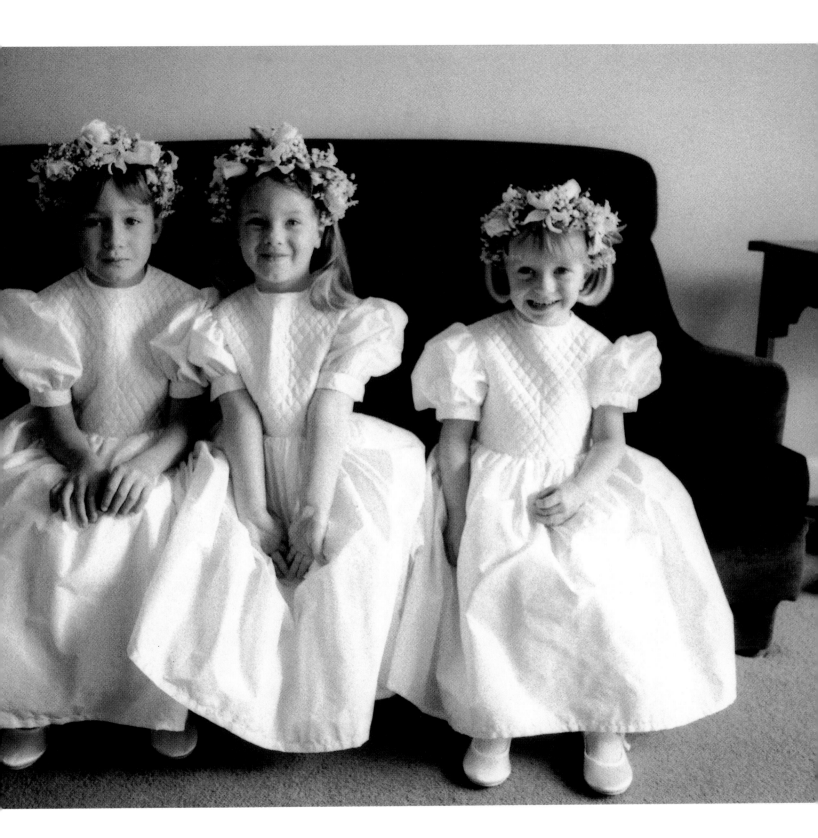

CAMERA	Nikon F5
LENS	85mm
FILM	Ilford FP4 125 ASA
FOCUS	Auto
FLASH	No
CAMERA SETTINGS	Programme f2.8 at 1/500sec

TECHNICAL INFO FOR MAIN PICTURE >

ABOVE
The photo shoot is finished, so these two make
their way to see the bride.

RIGHT
A slight breeze at the right time makes this picture.
The bridesmaid had come to watch me photograph
the bride and groom, away from the other guests,
when I took this photograph of her.

FAR RIGHT
The bride and bridesmaid go for a stroll before they set
off to the wedding. This shot is set up to a degree, I just
asked the bride and bridesmaid to stroll along together
and the rest fell into place.

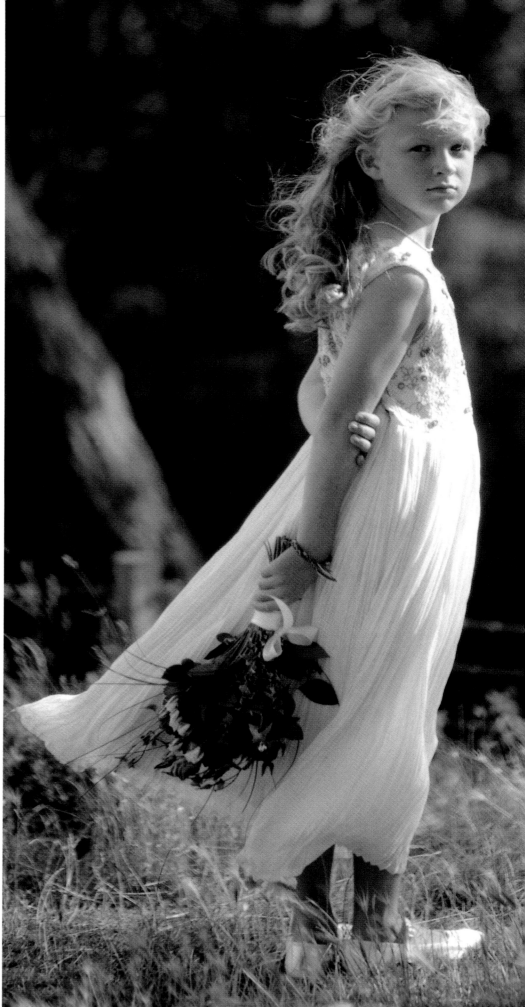

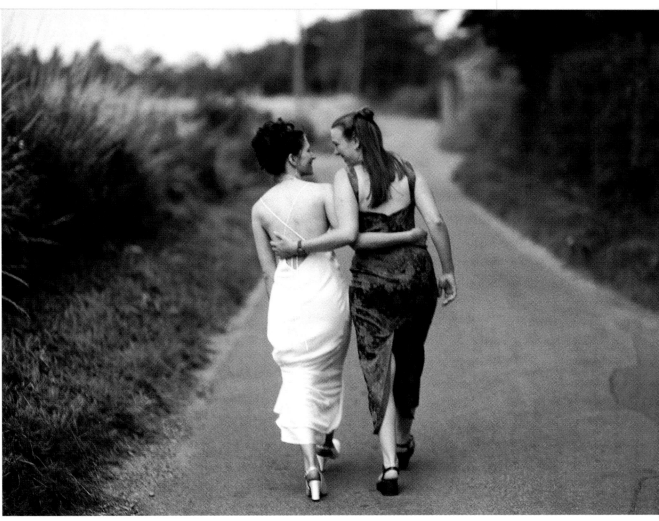

{ TRY TO CAPTURE IMAGES WHICH SHOW MOVEMENT, AS WELL AS THE MORE STATIC POSES, AS THIS WILL ADD TO THE OVERALL DYNAMISM OF A COLLECTION OF PHOTOGRAPHS.

> In some cases I will set up a shot and work within that scenario in a reportage style. This is not true reportage photography, but I find it is sometimes necessary to 'step in' in order to create a great image. On average 80 per cent of the photography I complete at a wedding is pure reportage, the remainder of the photography I have controlled to a greater or lesser degree.

> *THE* WEDDING

I TRY TO ARRIVE AT THE WEDDING VENUE HALF AN HOUR BEFORE THE CEREMONY IS DUE TO COMMENCE AND BEGIN BY PHOTOGRAPHING THE FLOWERS IN THE CHURCH OR CEREMONY ROOM.

> Next I photograph guests as they arrive (whoever captures my eye really). Usually the groom and the best man are next to arrive, followed by the bridesmaids and bride's mother, and finally the bride and her father (or companion).

The only instruction I give the bride at this point is to not rush. I simply photograph things as they happen. I do not arrange things at all at this point, although I will give advice if asked. What I am trying to capture is the feeling of the moment — apprehension, excitement, nerves, and tension, all mixed with joy.

You may or may not be permitted to photograph during the actual wedding ceremony, but I always ask, as I feel it is the very crux of why I am present. If allowed, I always work without flash during the ceremony. If not, then I simply work within the boundaries I have been given.

>> As the bride, your arrival at the venue is a beautiful moment and should never be rushed, even if you are arriving late! The contemporary wedding photographer will not hassle you to pose for endless photographs at this time (maybe a quick pose with whoever has arrived with you), but will photograph you naturally as events unfold. This event is visually stunning enough without a photographer stepping in to arrange the poses, someone issuing commands will simply take away emotion from the event rather than add anything to the occasion. Leave it to your photographer to be in the right place at the right moment.

CAMERA	Nikon F4
LENS	85mm
FILM	Ilford HP5 400 ASA
FOCUS	Auto
FLASH	No
CAMERA SETTINGS	Programme f2 at 1/125sec

TECHNICAL INFO FOR MAIN PICTURE >

*THE*ARRIVAL

> This is a very 'delicate' part of the day. Try and capture the moment without interfering. Before I leave for the wedding venue, I always ask the bride to take it slowly as she arrives for the ceremony. What you are after is to catch some of the poignancy of the moment, and not the bride and bridesmaids posed and smiling falsely at the camera before they make their entrance.

>> Try and enter the ceremony venue as slowly as you can; it is worth having a practice walk with whoever is giving you away. This will not only allow your photographer time to get some great pictures, but give you the opportunity to look around and absorb the atmosphere, so that you remember this moment.

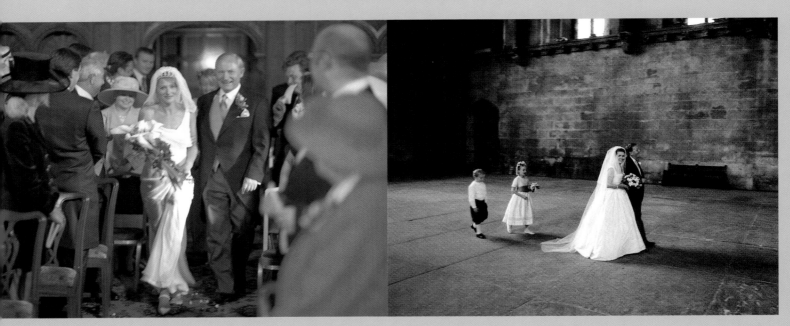

ABOVE LEFT
This is one of a short series of pictures taken of the bride entering for the ceremony with her father. The registrar was very helpful, which is not always the case, and allowed me to shoot over her shoulder. This was my favourite of the selection, as I like the flow of the dress, the visible shoe, and the fact that I have caught the first glance of the day at her husband-to-be.

ABOVE RIGHT
To catch the splendour of the bride walking through this great hall, I used a very wide-angled lens (20mm).

RIGHT
The bride receives a few last minute instructions from the vicar just before entering the church. Strong backlight often occurs in these situations. Rather than switch to spot metering, I leave the metering system on general (matrix metering) and use the exposure lock button, having taken a reading from close-up to the bride. I find this faster than changing the settings on the camera and also I may forget, and leave the metering switch on the wrong setting.

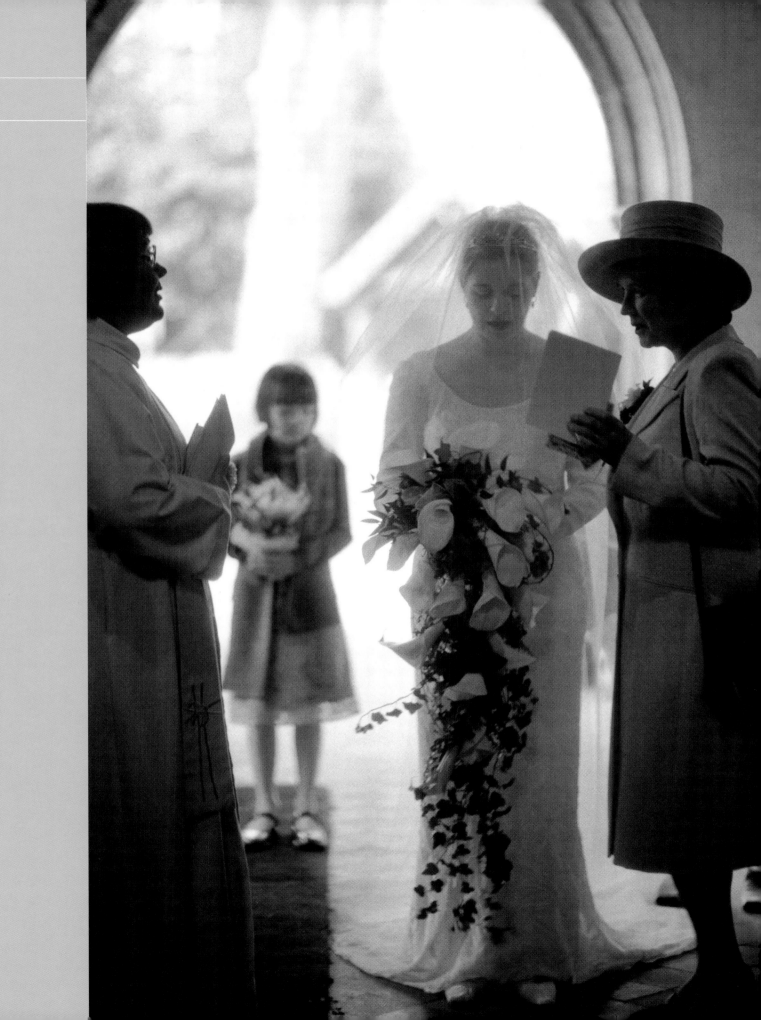

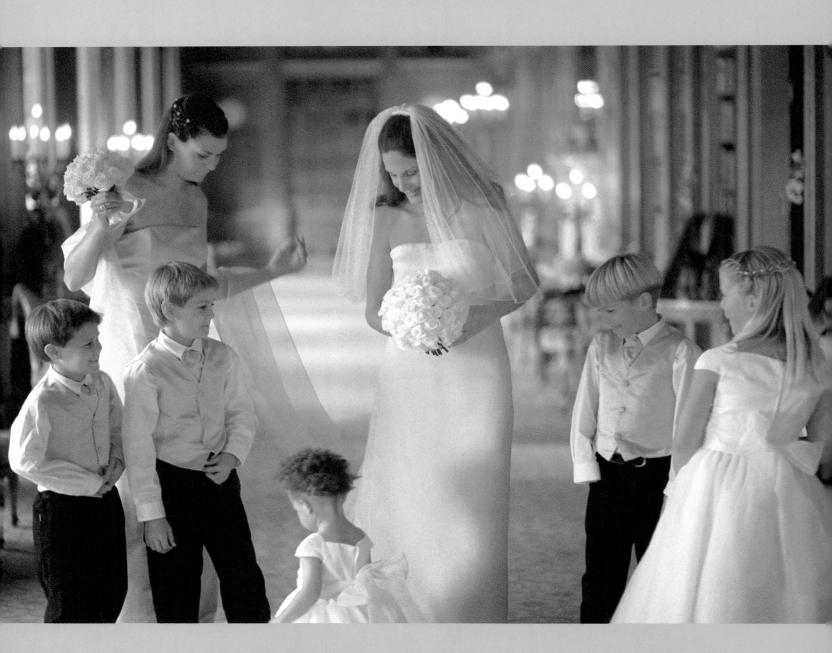

CAMERA	Nikon F5
LENS	85mm
FILM	Fuji Superia 400 ASA
FOCUS	Auto
FLASH	No
CAMERA SETTINGS	Auto/aperture priority f1.4

TECHNICAL INFO FOR MAIN PICTURE

LEFT

This shot was taken just after a more formal grouping. After photographing a posed shot, always be ready to catch the group as they relax afterwards. It doesn't always work, but can often lead to a better shot than the initial formal photograph.

RIGHT

Even if you are unable to work during the church ceremony, you can usually take this kind of photograph of the bride walking up the aisle with her father. It is a good way of catching the back of the dress (often requested) in a natural manner. Limited natural light in the church can lead to some motion blur, which creates a nice dream-like quality.

FAR RIGHT

It is always good to get a record of the bridesmaids as they walk down the aisle too. Often the bride and bridegroom are so nervous they take in little of what is going on around.

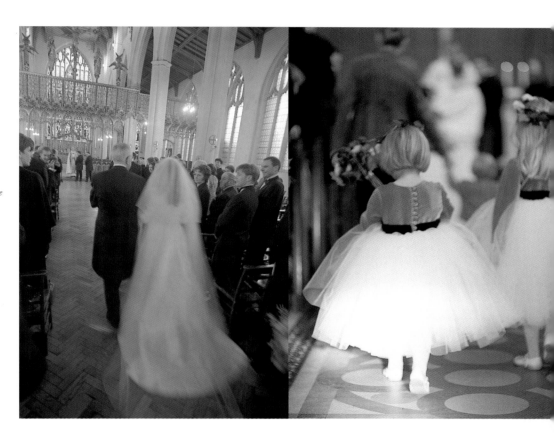

{ FIND OUT WHETHER PHOTOGRAPHY IS PERMITTED DURING THE ACTUAL WEDDING CEREMONY.

> Just before the bride is due to arrive, check how many shots you have left on your cameras (if you are working with film, of course). If you only have a few frames left, sacrifice them and insert a new film. It is best not to halt the proceedings of the bride's arrival to change film, as you may spoil the mood of the occasion, and if you run out of film at this point, you may miss a great shot.

>> Once again, my advice is not to rush, even if you are running (fashionably) late. Time usually allocated by the traditional wedding photographer for posed shots is not needed by the contemporary wedding photographer, as he or she will capture events as they happen, so use this time to relax instead.

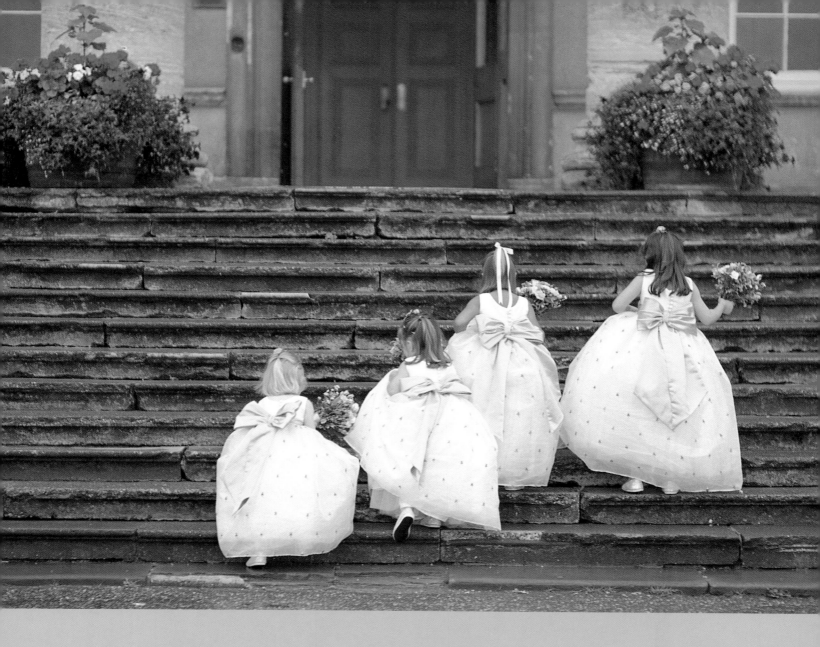

{ THINK OF WAYS TO INCORPORATE THE OFTEN BEAUTIFUL SURROUNDINGS OF WEDDING LOCATIONS INTO YOUR PHOTOGRAPHS. THIS IS FAR MORE EFFECTIVE THAN DRAGGING THE COUPLE FROM LOCATION TO LOCATION FOR VERY SIMILAR PORTRAITS WITH VARYING BACKGROUNDS.

CAMERA	Nikon F90
LENS	85mm
FILM	Fuji Superia 200 ASA
FOCUS	Auto
FLASH	No
CAMERA SETTINGS	Programme

‹ **TECHNICAL INFO FOR MAIN PICTURE**

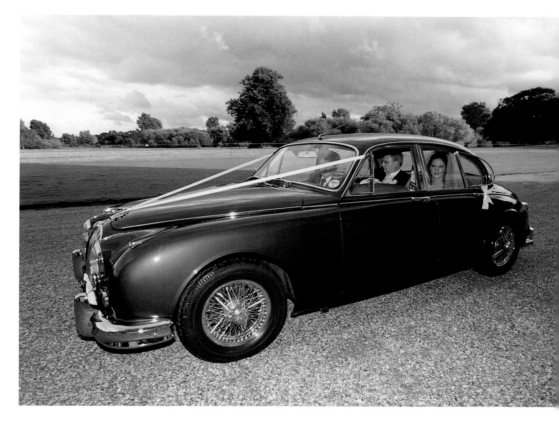

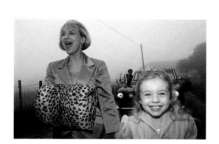

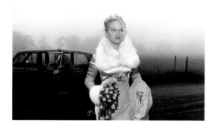

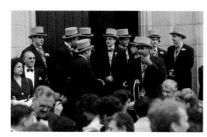

ABOVE

The bride arriving is also an opportunity to photograph the car without staging the picture. Flash helps to illuminate the car interior and reduces reflection, allowing you to see the bride.

TOP LEFT

A foggy February morning was the scene for this wedding. I walked backwards in front of the bridesmaids and caught this shot. To cut through the mist I used some flash.

A wide-angle lens is useful for candid photography. The bridesmaid to the left of the picture is unaware that she is in shot and is calling out to her friends, creating an exciting and fun image.

Usually I try and scan the shot for telegraph poles or other potential distractions in the background. Such distractions can be avoided, but had I been thinking of the telegraph pole here, I would have missed the picture and I don't really feel it detracts from the shot.

CENTRE LEFT

The fog still had not cleared as the bride arrived. This very stylish and glamorous dress created a fantastic contrast to the surrounding farmer's fields.

BOTTOM LEFT

The bridegroom (centre) and his ushers assemble on the church steps. This type of picture is a good alternative to the now dated photograph of the ushers throwing their hats into the air. The guests gathered below give bridegroom and ushers a greater sense of importance.

FAR LEFT

I envisaged this image, so it was not pure reportage. As I was waiting for the bridesmaids to arrive, I was thinking of a way I could make use of the beautiful steps. As the car pulled up and the little girls got out, I asked the mothers to hold back, allowing me to get this picture.

CAMERA	Nikon F5
LENS	85mm
FILM	Fuji Superia 200 ASA
FOCUS	Auto
FLASH	No
CAMERA SETTINGS	Auto/aperture priority f2 at 1/250sec
TECHNICAL INFO FOR MAIN PICTURE	>

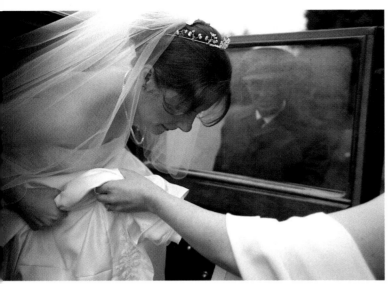

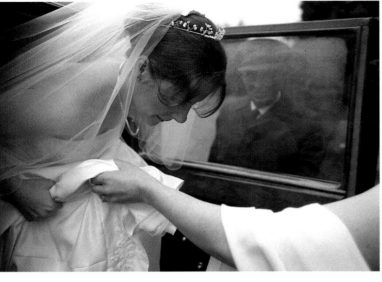

TOP LEFT

The bride alights the car, assisted by a bridesmaid, as the driver watches through a rainy window. I often prefer to work close to the subject with a wide-angle lens rather than stepping back and using a telephoto lens. The perspective is different and gives the feeling that you are in amidst it all instead of being simply an on-looker.

BOTTOM LEFT

Once again, the exposure lock on the camera was used to hold the detail in the shade for this quick portrait.

RIGHT

An usher waits for the bride to arrive. This was probably the wettest church wedding I have seen. It rained for the bride's arrival, thundered through the entire ceremony, and didn't stop until the bride and bridegroom arrived at the reception venue (it is actually very rare that it will rain for the whole day). For this picture I was holding an umbrella with one hand and operating the camera with the other, making full use of autofocus.

{ USUALLY WHEN IT RAINS EVERYTHING HAPPENS VERY QUICKLY, SO JUST BE READY TO RECORD THINGS AS THEY OCCUR. OBVIOUSLY, ALL REQUESTS THAT THE BRIDE TAKE HER TIME GET THROWN OUT OF THE WINDOW IN THIS SITUATION.

> Try and keep your equipment as dry as possible, especially the lenses. Give everything a quick wipe over at every given opportunity.

>> Make sure you and your guests have access to some umbrellas that do not have any advertising logos printed on them, as this can spoil the photographs. Good umbrellas are often provided by the reception, but do check just in case they have the name of the venue emblazoned across them.

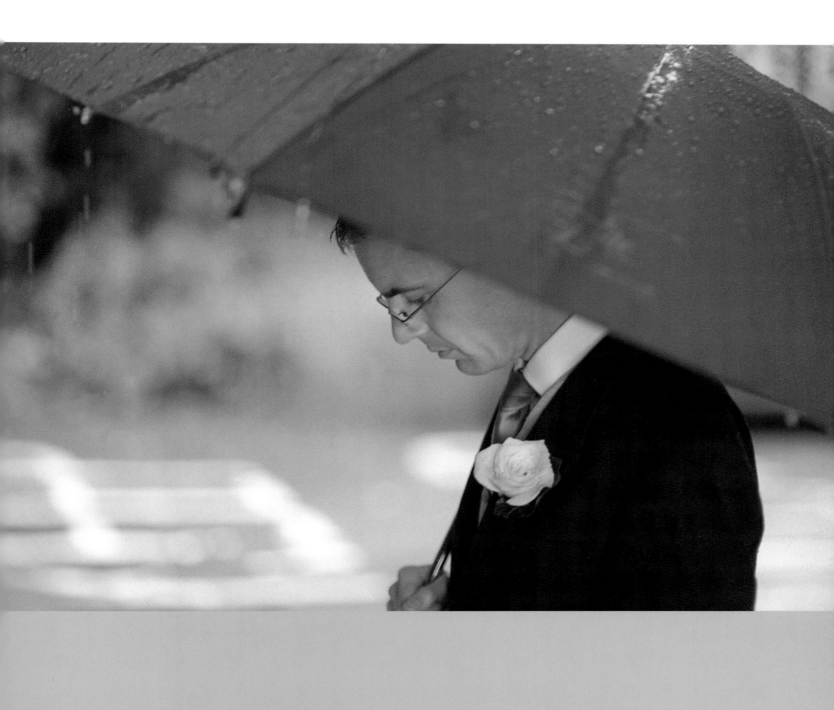

CAMERA	Nikon F5
LENS	85mm
FILM	Kodak TCN 400 ASA
FOCUS	Auto
FLASH	No
CAMERA SETTINGS	Auto/aperture priority f1.4

TECHNICAL INFO FOR MAIN PICTURE ❯

*THE*CEREMONY

❯ I prefer to position myself so that I can see the bride's face throughout the ceremony, rather than the bridegroom's. Sometimes it isn't possible due to large flower displays, video cameras or registrars/clergy, but if you can you'll get some great results. I never use flash (unless I have absolutely no choice) as I feel it is too intrusive, and by not using it I increase my chances of becoming invisible.

❯❯ As far as photography goes at this point, forget about it! Just focus on the imminent event. Your photographer will take beautifully natural pictures this way.

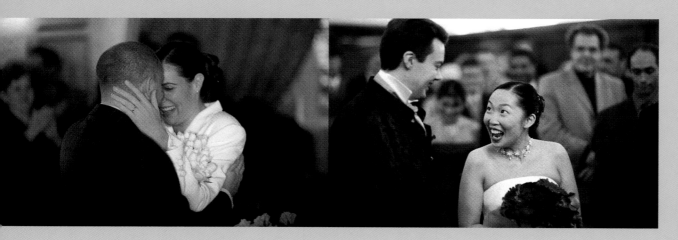

ABOVE
The pure intimacy of this photograph is what makes it so special. This is far more romantic than anything that could be posed, and exactly the type of photograph I had in mind when I started my career as a wedding photographer.

ABOVE RIGHT
Always be ready for the bride's and bridegroom's first exchange of glances and words, as you can capture some fantastic expressions.

RIGHT
During civil weddings, if you have permission to work during the ceremony, you usually end up standing fairly close to the bride and groom. This gives you the opportunity to take some very intimate photographs such as the ring being placed on the bridegroom's finger, as shown here. This could easily be mocked-up afterwards, but I feel that the photograph would then lose all sense of intimacy as it would always be remembered by the couple as being set up and not the real moment caught on film.

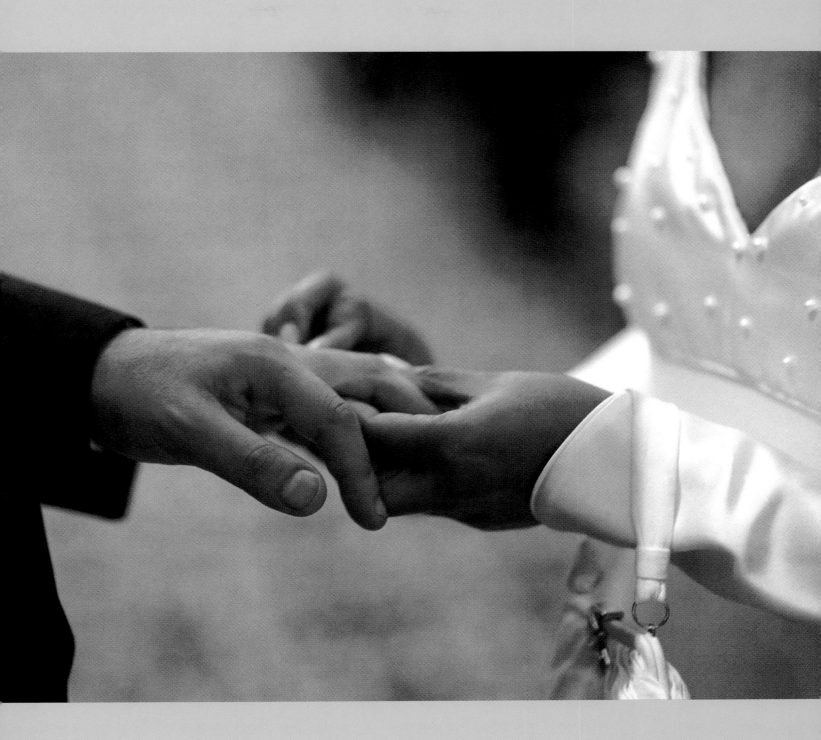

054

The wedding

CAMERA	Nikon F4
LENS	85mm
FILM	Ilford HP5 400 ASA
FOCUS	Auto
FLASH	No
CAMERA SETTINGS	Programme f4

TECHNICAL INFO FOR MAIN PICTURE >

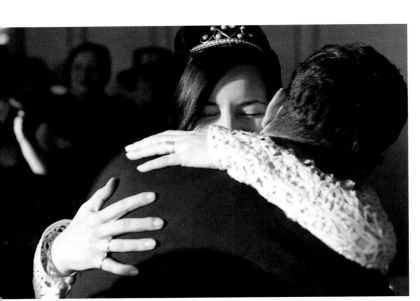

RIGHT
It is fairly unusual to be given permission to be present during the signing of the registry book, so if you do get the opportunity, snap it up immediately. This photograph holds so much more power than the couple simply holding a pen, sitting in front of the book and smiling at the camera, as once again you are photographing the actual event.

LEFT
Having the foresight to position yourself to get the best possible picture is as important as any technical knowledge of photography. With autofocus, programme facilities and compatible flashguns all coming as standard photographic equipment, the photographer can concentrate fully on composition, which is by far the most important aspect of photography.

> Every now and again buy a selection of fashion magazines, study the composition of the photographs in the fashion and editorial spreads and also the advertisements. This is a good way of learning how to compose a contemporary photograph. You will get lots of ideas and inspiration, together with knowledge of the type of image your clientele expects from a wedding photographer.

>> Tear out any photographs that you like (not just wedding photographs) from magazines that you buy. These will give your photographer an idea of the look you are after. Do not expect a carbon copy of the images you hand over, however, they will give the photographer an indication of the type of feel you would like your wedding photography to have.

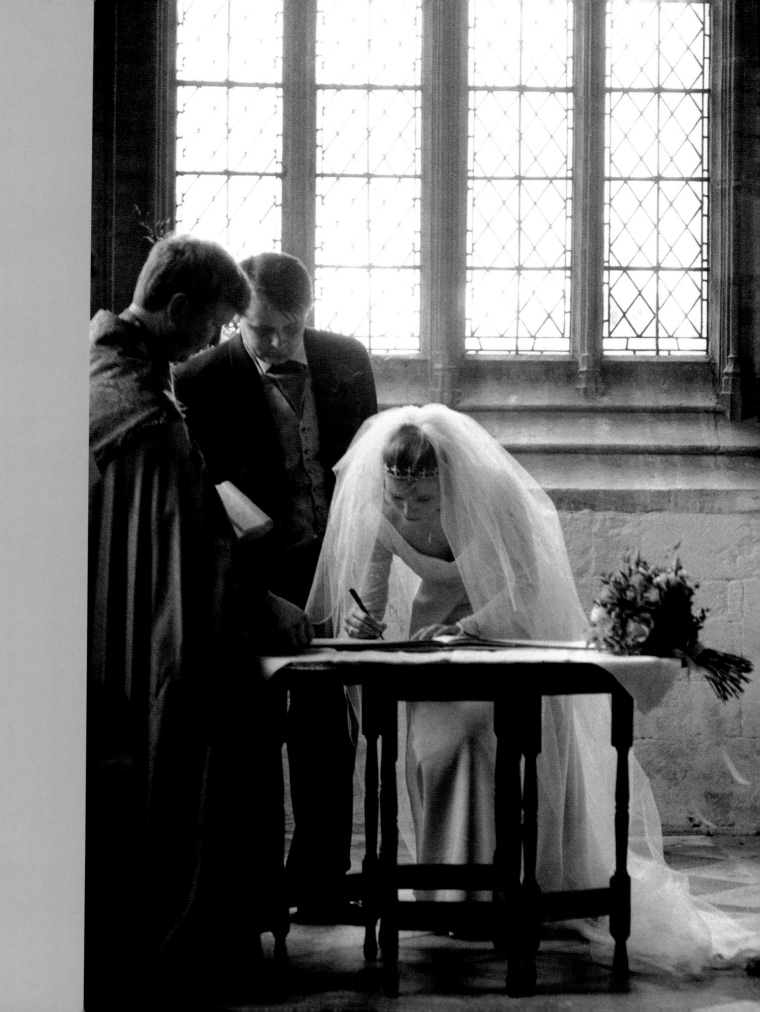

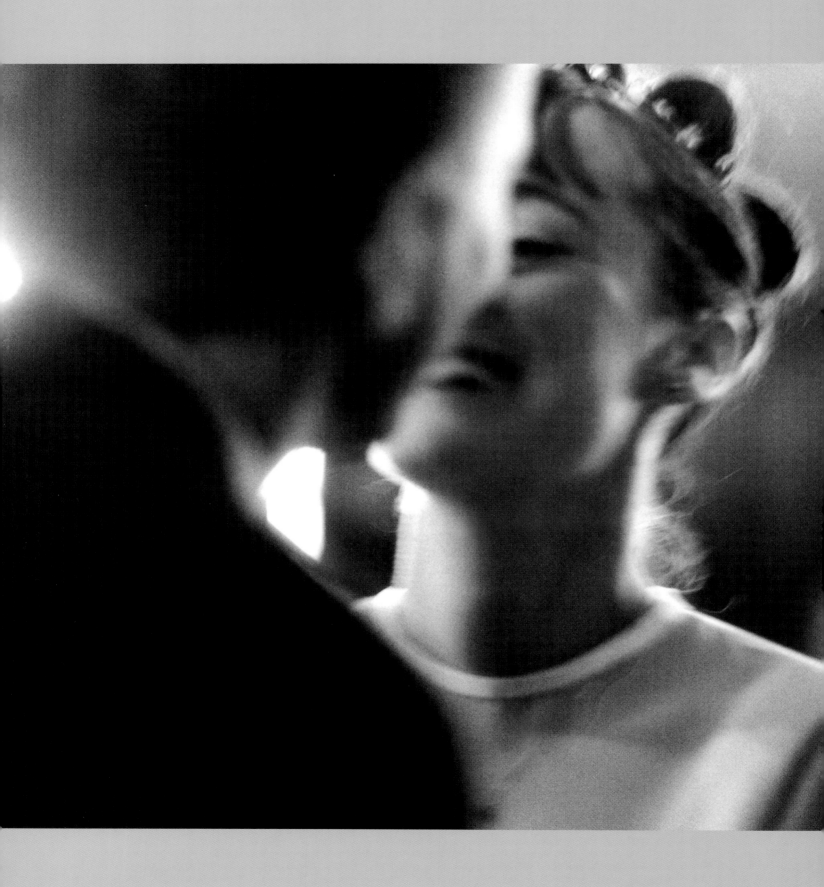

CAMERA	Nikon F5
LENS	85mm
FILM	Ilford HP5 400 ASA
FOCUS	Manual/spot metering
FLASH	No
CAMERA SETTINGS	Auto/aperture priority f2.8 at 1/30sec

< TECHNICAL INFO FOR MAIN PICTURE

LEFT

This photograph was taken during the ceremony in a very dark room with strong sunshine as backlight. The autofocus kept searching so I switched to manual focus and had to use spot metering, remembering to switch back afterwards. Even though the light conditions were poor from this position, having the bride's face in view was still my top priority.

RIGHT

You will sometimes have the opportunity to photograph some of the guests while the ceremony is in progress.

FAR RIGHT

Immediately after the ceremony, before the rest of the guests have left the church is a good time to grab a few quick shots of the couple alone together. Often it is the first time a newly married couple are away from (almost) everyone, and the first time they can give each other a quick squeeze!

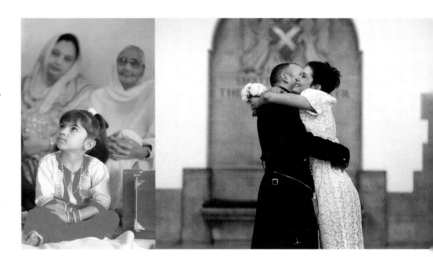

{ HAVING THE FORESIGHT TO POSITION YOURSELF TO GET THE BEST POSSIBLE PICTURE IS AS IMPORTANT AS ANY TECHNICAL KNOWLEDGE OF PHOTOGRAPHY.

> If you are photographing a wedding of a religion you are unfamiliar with it is worth finding out the events of the day that will be important to photograph, and the parts which would be inappropriate to photograph. Discuss this with the bride and bridegroom beforehand, or perhaps with the person who is conducting the ceremony.

CAMERA	Nikon F90
LENS	20–35mm (set at 35mm)
FILM	Ilford HP5 400 ASA
FOCUS	Yes
FLASH	No
CAMERA SETTINGS	Programme

TECHNICAL INFO FOR MAIN PICTURE

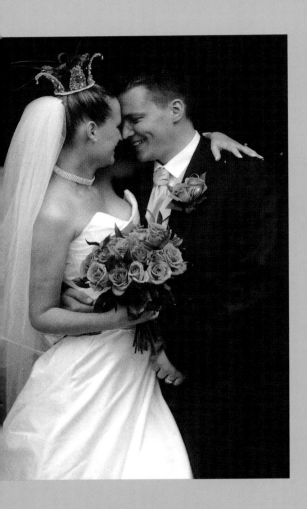

RIGHT

One of the biggest kisses I have ever photographed, just as the couple were leaving the church. Different couples react in different ways, the most some couples will want to do in front of the camera is a quick peck on the cheek, which is fine. All I do is request that the couple cuddle up together and see what happens. The slight distortion caused by the wide-angle lens helps amplify the hugeness of the kiss.

LEFT

Here is another photograph of the couple leaving the church. I usually photograph this moment in black and white; to me it just feels the right medium for the picture.

OUTSIDE *THE* CHURCH

> The couple leaving the church, as with traditional wedding photography, is still a must-have photograph. Many of the events that a modern wedding photographer catches on film are the same events that a more traditional photographer would capture, the difference being that the modern photographer will not demand certain poses. The scenario is the same (the couple are leaving the church), but the way it is handled and photographed is far less formal the contemporary way.

>> Do not be bullied or coaxed into any pose that you feel awkward about, as the same feelings of awkwardness will be reflected in the printed photograph.

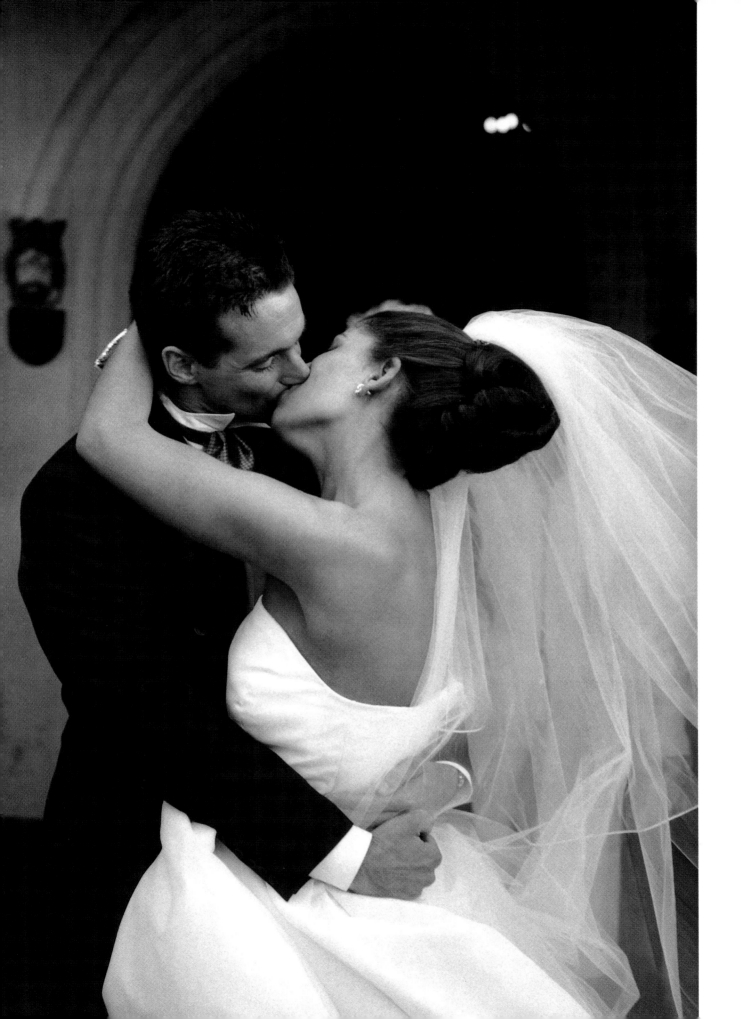

CAMERA	Nikon FE
LENS	85mm
FILM	Ilford FP4 125 ASA
FOCUS	Manual
FLASH	No
CAMERA SETTINGS	No known

TECHNICAL INFO FOR MAIN PICTURE ⟩

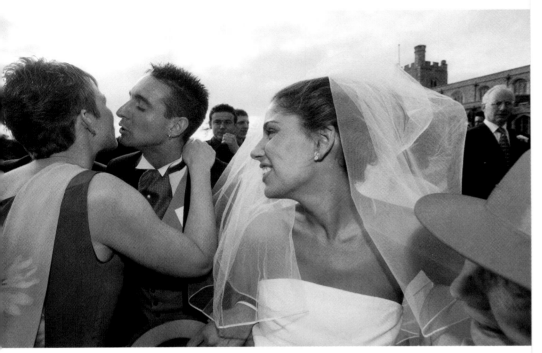

{ FIND OUT IF THE THROWING OF CONFETTI IS PERMITTED, AS THIS CAN MAKE FOR SOME BEAUTIFUL PHOTOGRAPHS.

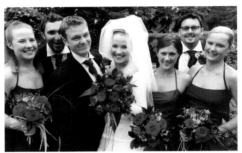

ABOVE

This is the type of group photograph I try and achieve. Everybody is happy and looking good, and the strength of the friendships show through.

ABOVE LEFT

This photograph was taken with a wide-angle lens (20mm) and once again gives the impression that the viewer is in amidst the action. The depth-of-field is almost infinite. It wasn't until I was printing this shot in the darkroom that I noticed the lady in the bottom right of the frame.

RIGHT

Confetti throwing can make a great photograph!

I do try and have some control over this event, requesting that the guests form a human aisle to throw their confetti from as the bride and bridegroom leave the church or venue. The only advice I issue to the couple is to try and keep smiling and look ahead. I walk backwards, in front of the couple, and shoot a series of pictures, as often confetti will be covering an eye or a nose etc.

⟩ Usually I will shoot any group photographs at the reception, so that uninvolved guests can get on with celebrating rather than be waiting outside the church while this task is completed. However, the advantage of taking these photographs at the church is that when you do arrive at the reception most of the hard work is done and you are free to roam and work in a documentary style.

Your decision will be dictated by such things as the amount of available light left, weather conditions (if it is getting worse, take them at the church) and available grounds to work in. If possible I choose the option that will cause the least interference to the wedding.

⟩ ⟩ If you would like a confetti shot do ask your friends and relations to bring some with them, or maybe supply rose petals or confetti in a basket, and ask the bridesmaids or flower girls to hand it to guests as they leave the venue. Sometimes confetti throwing is not permitted outside the church or venue, in which case it could perhaps be thrown as you cut your cake, perform your first dance or leave the reception.

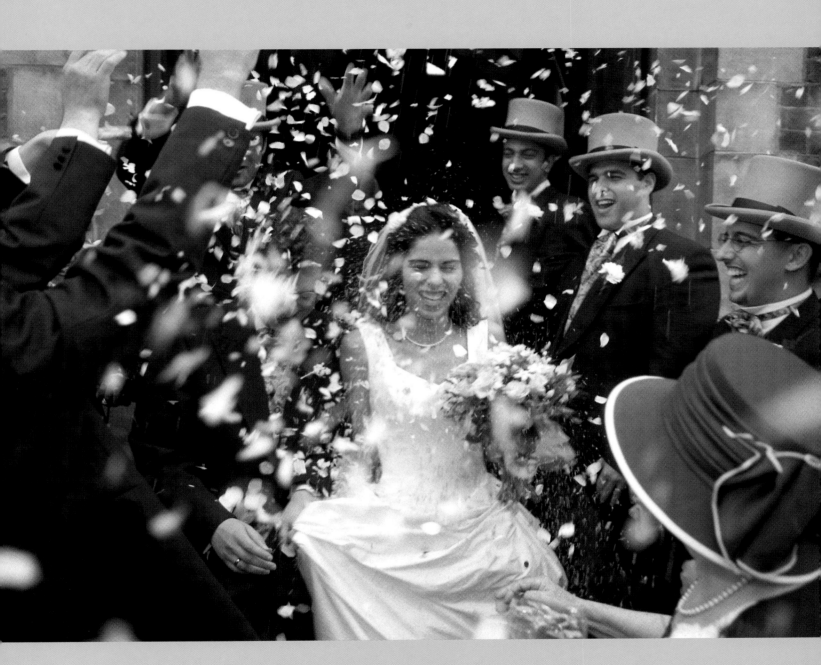

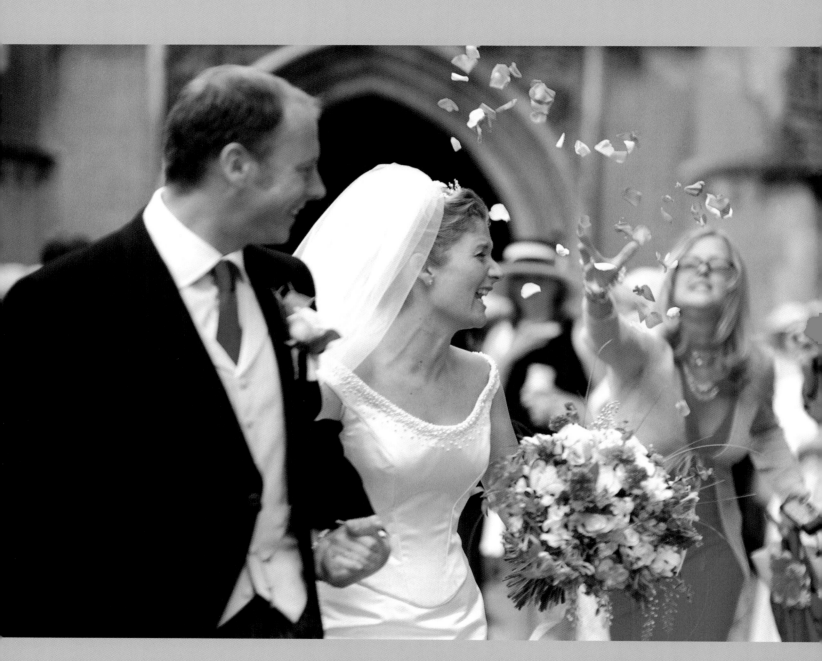

CAMERA	Nikon F90
LENS	85mm
FILM	Fuji Superia 200 ASA
FOCUS	Auto
FLASH	No
CAMERA SETTINGS	Programme f2.8

TECHNICAL INFO FOR MAIN PICTURE

The wedding **063**

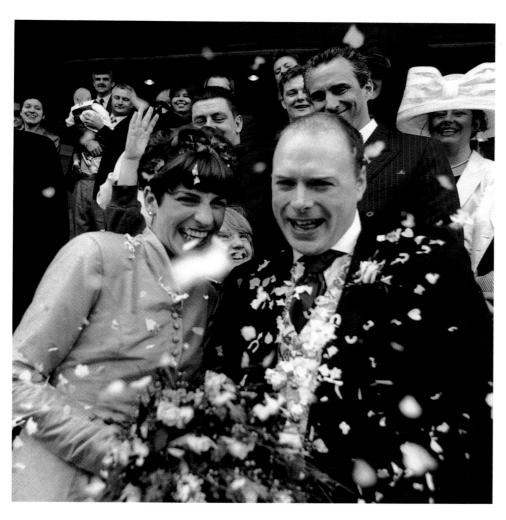

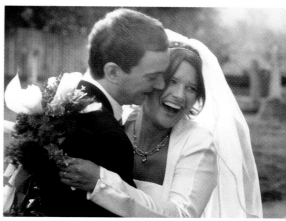

ABOVE
Here the couple hug outside the church. The bride is in fact looking at a guest's camera, but the image still seems to work from this angle.

FAR LEFT
Rose petals are thrown as the couple leave the church. The autofocus locked on to the confetti rather than the couple, which I couldn't have done if I had tried.

LEFT
This shot was taken on the steps outside the venue. A good time to take a confetti shot is just after you have photographed everybody (if this picture has been requested), as you won't have to assemble or organise guests for the confetti picture. A wide-angle lens once again helps keep a large depth-of-field, and as guests are situated behind the couple, the confetti is flowing towards the camera, increasing the dramatic effect of the picture.

{ OUTSIDE THE CHURCH OR VENUE I PHOTOGRAPH THE CONGRATULATORY HUGGING, CONFETTI THROWING, AND A FEW FORMAL PHOTOGRAPHS IF REQUESTED, AND OF COURSE, THE COUPLE AS THEY LEAVE IN THEIR CAR.

>> Many venues do not allow the throwing of confetti, but they may allow biodegradable confetti or rose petals. If you would like a picture with confetti do investigate this beforehand.

CAMERA	Nikon F5
LENS	20–35mm
FILM	Ilford HP5 400 ASA
FOCUS	Auto
FLASH	Yes (TTL balanced fill-in)
CAMERA SETTINGS	Programme

TECHNICAL INFO FOR MAIN PICTURE ›

LEAVING*THE*VENUE

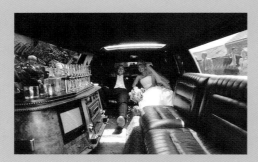

ABOVE

The bridegroom must take credit for this shot, as he had it in mind before the couple even booked me. I used flash (TTL balanced fill-in) as the car's interior was very dark, and the midsummer sun through the sun-roof created very harsh shadows. It may have also helped to make the guests visible through the tinted glass, which creates a nice effect.

RIGHT

As I photographed the couple in the car before their departure, I asked them to give me a wave through the rear window as they pulled away. I also wanted to get the church in view behind the car and positioned myself accordingly.

You only get one chance with a shot like this and sometimes it will not work as the subject will blink, but it is worth the attempt, as the couple will very much appreciate it when it does work. I used flash to light the bride through the window (you can see the reflection of the flash in the car paintwork to the right of the window).

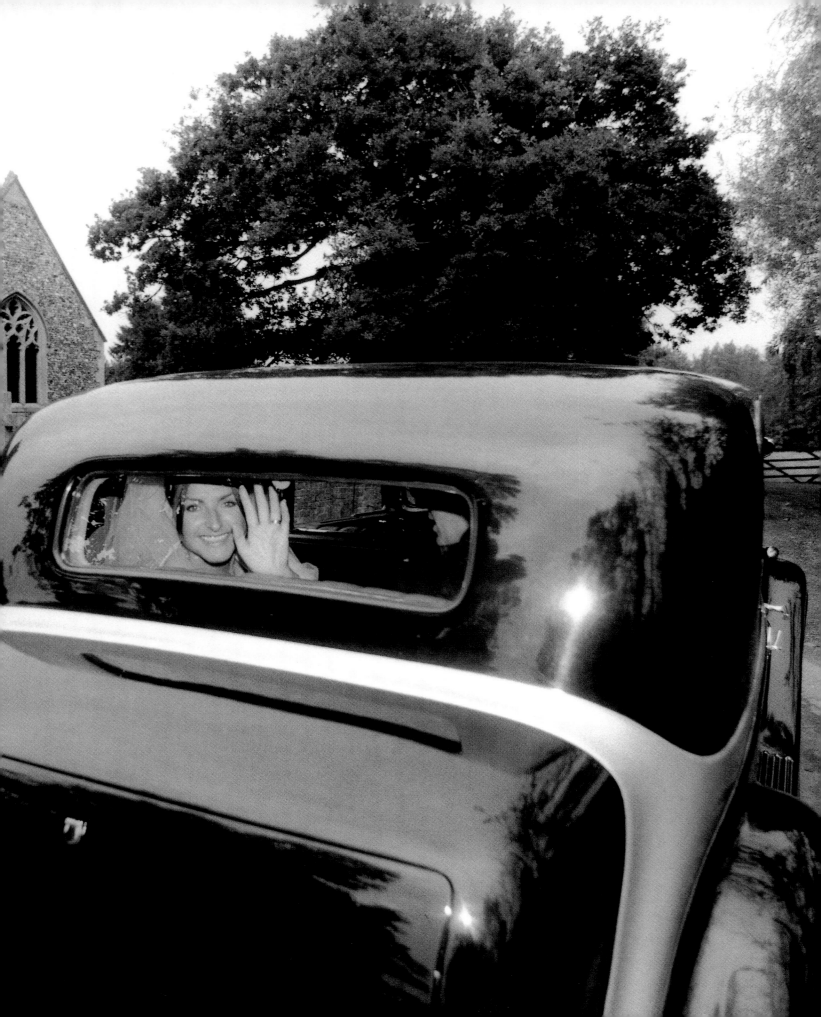

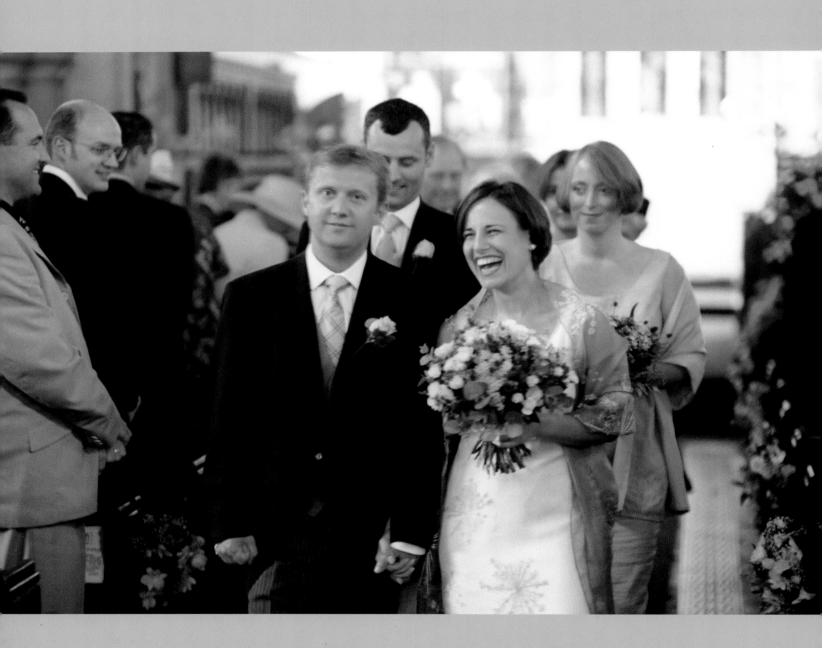

CAMERA	Nikon F90
LENS	85mm
FILM	Fuji Superia 200 ASA
FOCUS	Auto
FLASH	No
CAMERA SETTINGS	Auto/aperture priority f2 at 1/125sec

< **TECHNICAL INFO FOR MAIN PICTURE**

RIGHT

This black-and-white photograph was taken on a rooftop balcony just after the ceremony.

LEFT

As the couple depart from the church, I do not stop them, but simply take a series of photographs as they are on the move. In this church I was lucky enough to have enough natural light to work without flash.

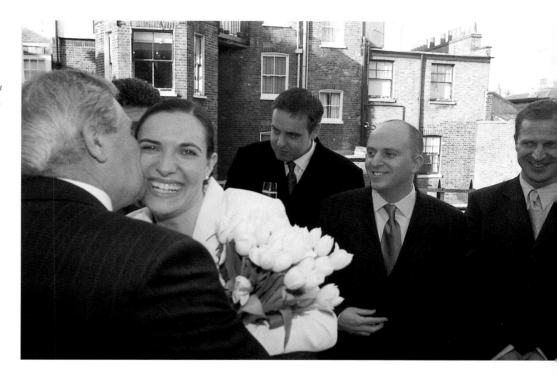

{ THE AMOUNT OF TIME SPENT OUTSIDE THE CEREMONY VENUE DEPENDS ON WHAT THE GROUNDS ARE LIKE. SOMETIMES IT'S BEST TO TAKE AS MANY PHOTOGRAPHS AS POSSIBLE AT THIS POINT AS THERE ARE NO OUTSIDE GROUNDS AT THE RECEPTION VENUE.

> Many guests will also be taking photographs at the weddings you are commissioned to photograph. This is never usually a problem, unless the guest decides that he or she wants to compete with the professional photographer for the best picture. This could mean following you to the front of the church, or working over your shoulder during the speeches etc.

This is a delicate matter as usually it is a good friend of the bride and groom who wants to present the couple with some good photographs. Even so, if they are disturbing your work, or even just your equilibrium, then have a word with them explaining that you are being paid to photograph the wedding, and that they may be interfering with you doing your job to the best of your ability. If they persist talk to the best man, tell him the situation and see if he can sort it out.

CAMERA	Nikon F90
LENS	85mm
FILM	Fuji Superia 200 ASA
FOCUS	Auto
FLASH	No
CAMERA SETTINGS	Auto/aperture priority f2.8 at 1/125sec

TECHNICAL INFO FOR MAIN PICTURE ›

{ AS THE BRIDE AND BRIDEGROOM COME BACK DOWN THE AISLE AFTER THE MARRIAGE CEREMONY I RUN OFF FOUR TO EIGHT FRAMES TO ENSURE I HAVE A GOOD IMAGE ON FILM.

BELOW
The couple relax in the back of the car before they leave for the reception.

BELOW LEFT
I swap between working landscape and portrait at this juncture in proceedings (if I have time), as both perspectives give a slightly different feel.

RIGHT
Plenty of natural light and a long aisle made this church a pleasure to work in. Try and use the altar, or the church pillars in the background of the picture to help you keep your camera square; it is easy to go slightly askew when working hand-held at this point.

> Always carry some very fast film (1600 or 3200 ASA) in your bag, as it can prove invaluable, especially at winter weddings and evening receptions.

> > If you do want your departure from the church to be photographed in good light, check on a diary for the differing sunset times through the winter months before booking your ceremony.

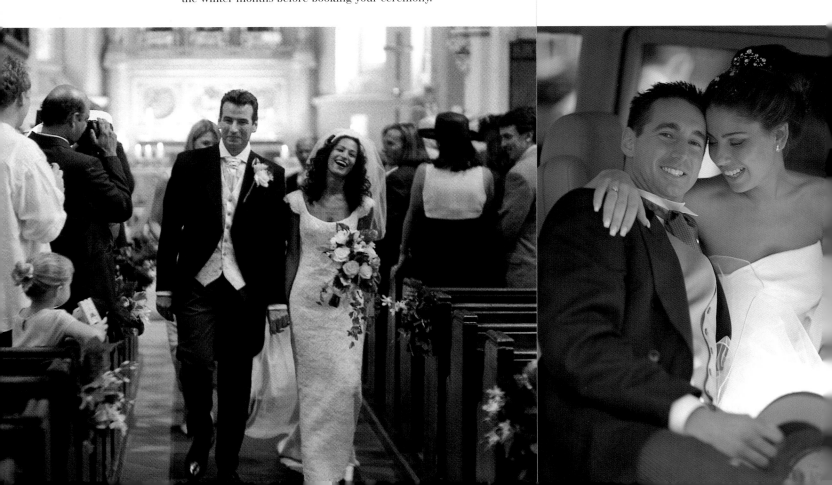

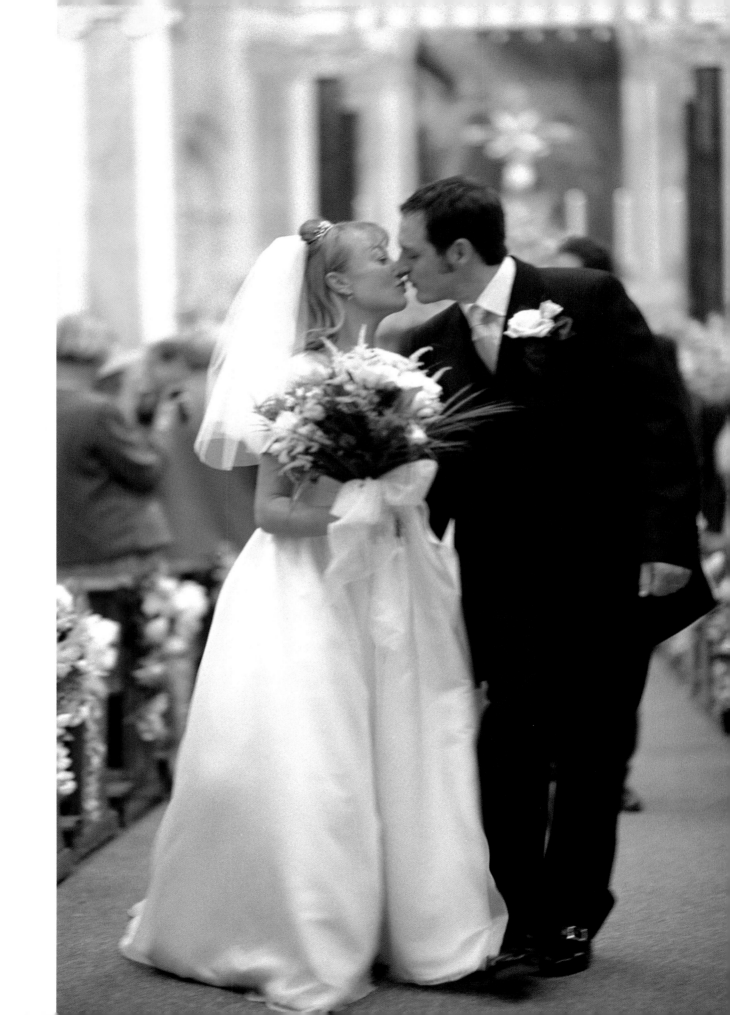

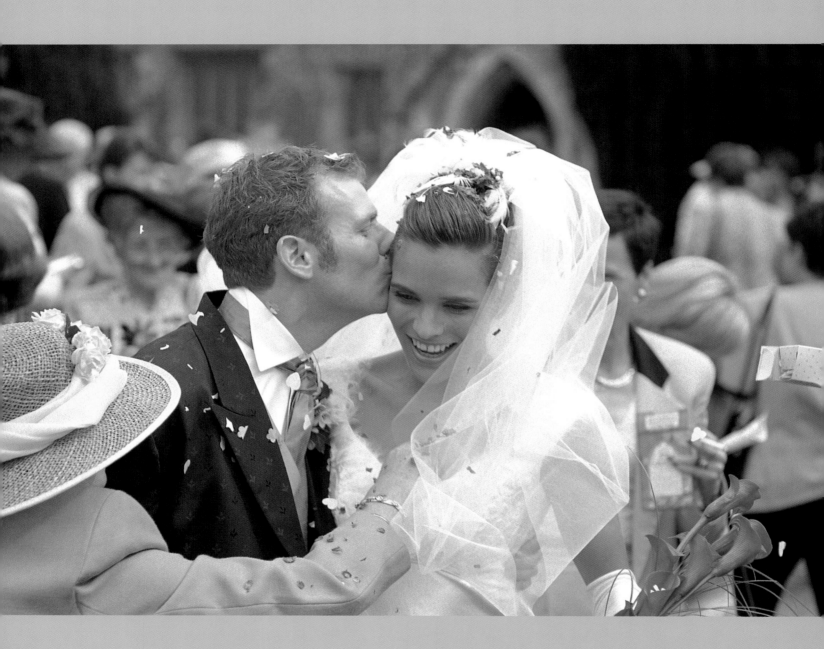

CAMERA	Nikon F90
LENS	85mm
FILM	Fuji Superia 200 ASA
FOCUS	Auto
FLASH	No
CAMERA SETTINGS	Programme

< TECHNICAL INFO FOR MAIN PICTURE

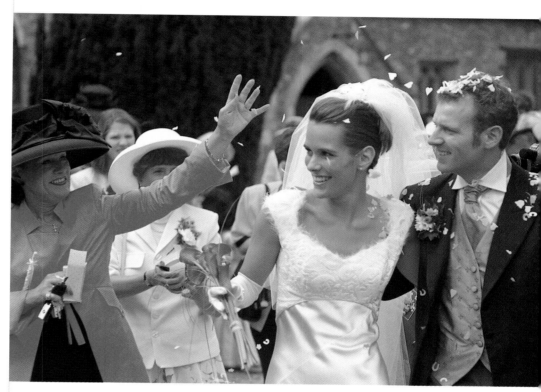

LEFT, ABOVE AND RIGHT

This sequence of pictures was taken as the couple walked from the church to the waiting car. Luckily, confetti throwing was allowed on the church premises. The shots were semi-organised in that I had asked guests to throw confetti as the bride and groom passed them, which gave me plenty of time to catch a sequence of pictures. These are the colour ones, but their was also time to shoot some black-and-white photographs with a wide-angle lens as they got close.

{ IF CONFETTI IS BEING THROWN I WALK BACKWARDS IN FRONT OF THE COUPLE AND SHOOT A SERIES OF PICTURES, AS OFTEN CONFETTI WILL BE COVERING AN EYE OR A NOSE ETC.

> *THE*RECEPTION

AT THE RECEPTION I LIKE TO PHOTOGRAPH ANY FORMAL PHOTOGRAPHS AND PORTRAITS OF THE COUPLE ALONE TOGETHER AS SOON AS POSSIBLE, AS PEOPLE CAN QUICKLY LOSE INTEREST AND START TO WANDER AROUND THE GROUNDS OF THE VENUE.

> It is a good idea to ask the couple to inform those required for family portraits when and where these will be happening before they arrive at the venue. This gives me plenty of time to wander around and capture the atmosphere of the proceedings once these shots have been taken. Inside the reception venue I like to photograph the dining room, table arrangements and cake before the guests enter the room. I check when the speeches will be (times can vary so do double check), and photograph the bride and groom as they enter the room. I photograph the cutting of the cake with the rest of the guests. I do not mind them joining in at all; it can make what can be a very predictable picture into an exciting one, with plenty of interaction between the couple and guests. Also, as contemporary wedding photography is about capturing the moment, I feel it is better to capture the real event, rather than setting it up. During the speeches I am looking for reactions to the words spoken (especially during the best man's speech), not just the people speaking. I make sure I give priority to the video at this point, keeping out of shot. After photographing the first dance (or few dances) it is time for me to depart. Sometimes I am requested to stay until the end of the evening and photograph the bride and groom leaving – this is something you will have to decide when putting together your pricing structure and when you meet the couple. The above is a general outline of events for a typical English wedding reception. You may find yourself photographing many different types of wedding receptions, so make sure you get a full brief of events and expect a late night in some cases.

> > For the bride and bridegroom, the reception should be party time. My basic advice is that if you have a great time, your photographer will take great photographs. Also, a good toastmaster can prove invaluable at this point, as even if the wedding is an informal affair, someone needs to be behind the scenes ensuring your wedding runs like a well-oiled machine. Nowadays formats are not so rigid with speeches sometimes performed before the meal, the cake cut in the middle of the reception venue or between courses and served for dessert, or canapés served instead of a sit down meal.

CAMERA	Nikon F90
LENS	20–35mm
FILM	Ilford HP5 400 ASA
FOCUS	Auto
FLASH	No
CAMERA SETTINGS	Programme f2 at 8/60sec

TECHNICAL INFO FOR MAIN PICTURE >

PORTRAITS*OF*COUPLES

> It does not take long to take a few portraits of the couple alone together, I usually take less than ten minutes. The time of day I choose for the portraits of the couple varies from wedding to wedding.

Sometimes I arrive at the reception venue with the couple and we take some pictures before the guests arrive, other times it will be as we wait for the family to arrive for the family portraits. I have no set agenda for the timing of these photographs; it simply depends on the light and a time when it seems appropriate for the couple to leave the guests for a short while.

I do prefer to work alone with the couple at this point, as they may be a little self-conscious about cuddling up surrounded by over-enthusiastic camera-wielding guests.

I tend to have already spotted the location I like and just ask the couple to ignore me and be relaxed with one another; they may talk, kiss or hug.

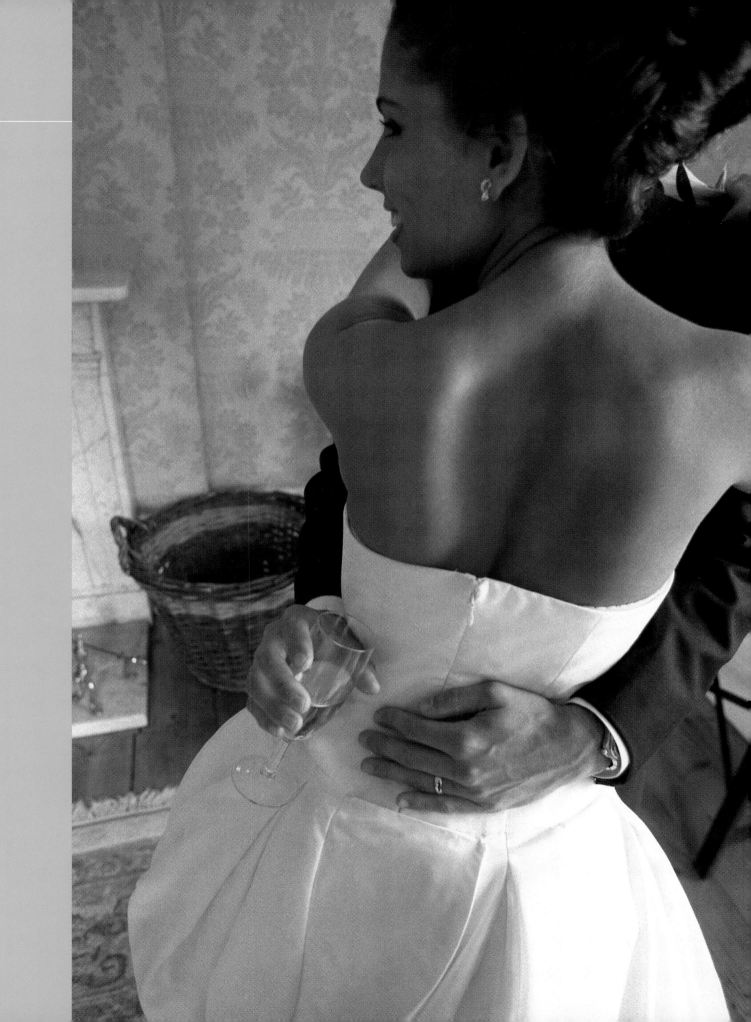

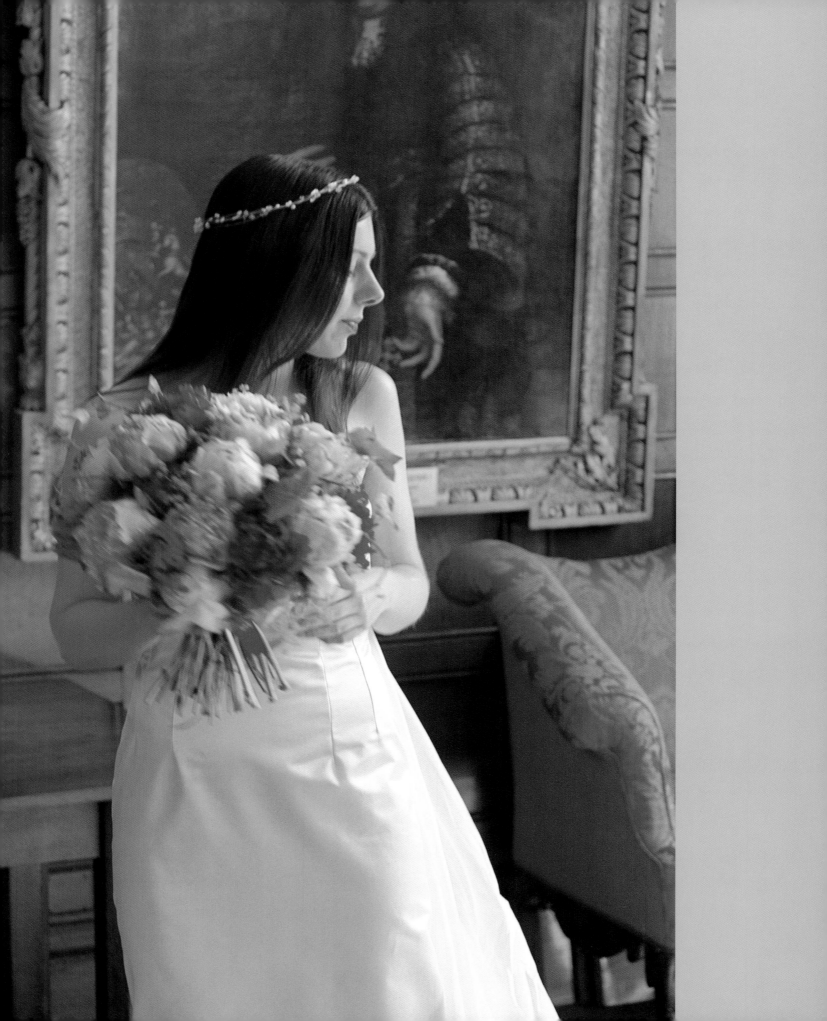

CAMERA	Nikon F5
LENS	85mm
FILM	Fuji Superia 400 ASA
FOCUS	Auto
FLASH	No
CAMERA SETTINGS	Auto/aperture priority f2.8 at 1/60sec

‹ TECHNICAL INFO FOR MAIN PICTURE

The reception

077

LEFT

This semi-posed photograph was taken in a quiet room. The bride was talking to a close friend and I just caught this angle as they were discussing the train of the dress.

RIGHT

Tell it how it is! This was not set up at all, the bride simply looked up and saw the camera as she was chatting to friends at the drinks reception. Some brides will not want to be photographed smoking, and will soon inform you of this when the camera is pointed in their direction.

BELOW

This was the very first portrait I took of the couple. Sometimes it is good for the bride and groom to take a quick break from the rest of the guests and it will reflect in the photography.

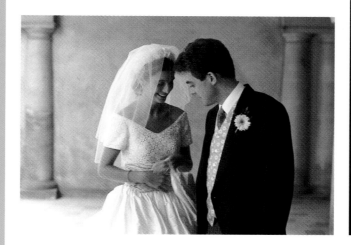

{ SOMETIMES IT IS GOOD FOR THE BRIDE AND GROOM TO TAKE A QUICK BREAK FROM THE REST OF THE GUESTS.

> As this style of photography relies on interaction between people for the majority of the pictures, I find photographing the bride alone, without it looking staged a difficult task. Sometimes I ask the bridegroom or a close friend of the bride to stand next to me, and photograph the bride as she is chatting to the person who is out of shot.

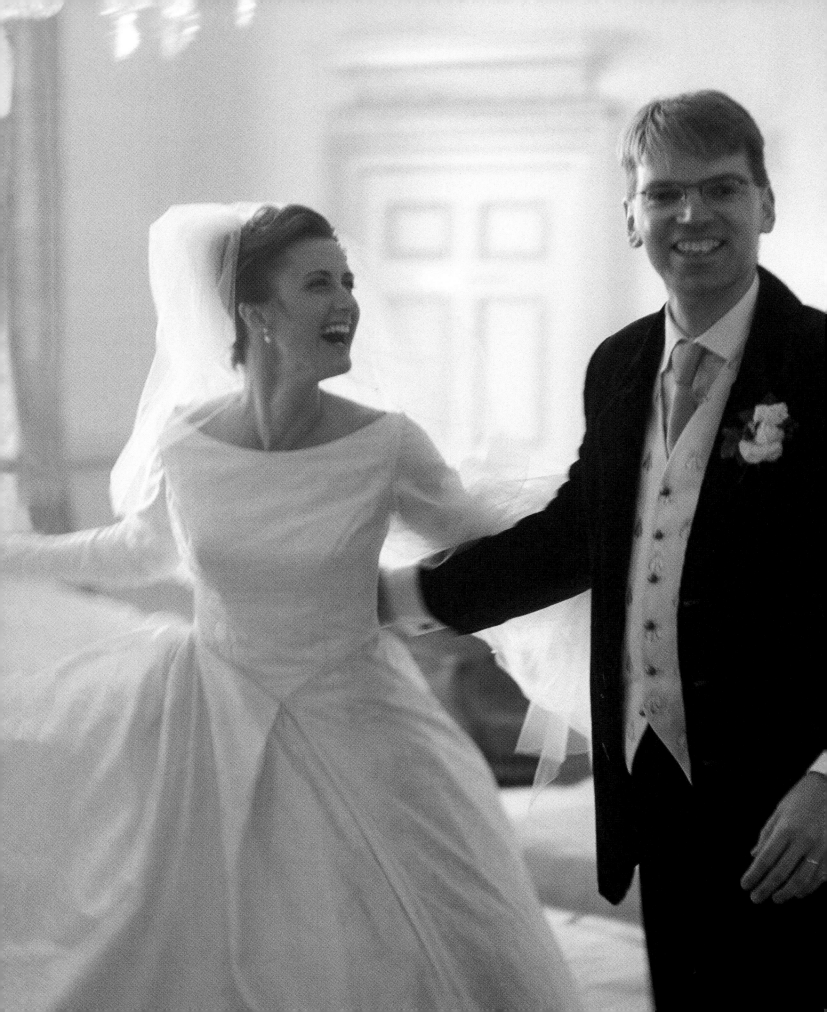

TECHNICAL INFO FOR MAIN PICTURE	
CAMERA	Nikon FE
LENS	85mm
FILM	Ilford HP5 400 ASA
FOCUS	Manual
FLASH	No
CAMERA SETTINGS	Auto/aperture priority

BELOW TOP

The couple were not leaving the venue, but they drove around this impressive driveway so that I could take this photograph of them in their car.

BELOW CENTRE

This was taken just after photographing all the guests together. I quickly asked the bride and groom to step forward as the guests were dispersing, using them as a back-ground for the picture.

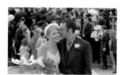

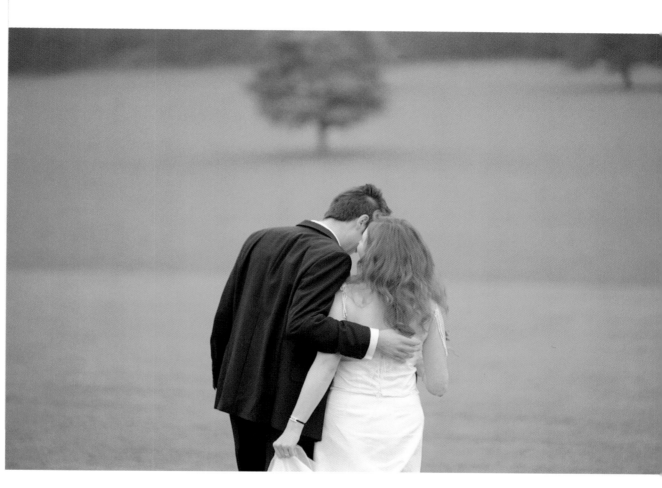

LEFT

This shot was semi-posed in the sense that the scenario was created and then I clicked away. We were doing a few portraits and the couple started dancing together, *which was when I got this shot. The weather was so good that all the guests were in the garden, so we had the beautiful lounge room to ourselves.*

>> As the day progresses and you become more and more comfortable in the presence of your photographer, so too will the resulting photographs become more natural and candid.

CAMERA	Nikon F5
LENS	85mm
FILM	Fuji Superia 400 ASA
FOCUS	Auto
FLASH	No
CAMERA SETTINGS	Auto/aperture priority f1.4 at 1/15sec

TECHNICAL INFO FOR MAIN PICTURE >

RIGHT
This was taken in a very crowded and dark room where the drinks reception was being held. I really liked the fact that the group of men surrounded the bride, as it visually confirmed the point that the bride is the centre of attention for the whole of her wedding day. Once again I chose natural light over artificial light. This kept the warm feel of the lighting in the room and stopped the attention being drawn to me. Photographs like this are hard to put into words as, to a degree I am on autopilot whilst taking them.

LEFT
After completing the photograph of everyone present at the wedding, I often move in close to the bride and bridegroom and take a few portraits, so that they are still surrounded by guests.

GROUP*SHOTS*

>> Formal portraits take time to photograph so keep the list short. Family politics can become an issue as you compile the list, causing it to grow and grow. If a family member feels left out, explain that to save time only immediate family is on the formal photograph list. Then explain that you'd much rather he or she be caught on film in a natural manner enjoying your wedding. Hopefully this will smooth things out.

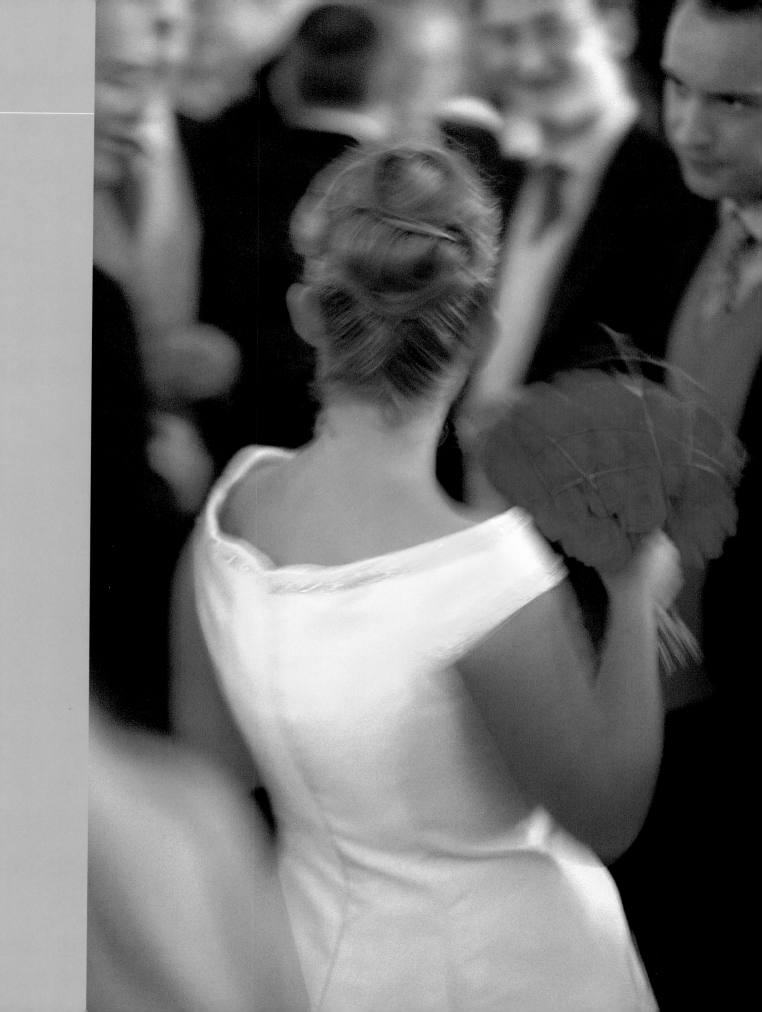

{ A PHOTOGRAPH OF THE WHOLE WEDDING PARTY MAKES
EVERYONE PRESENT AT THE WEDDING FEEL THEY HAVE
BEEN PHOTOGRAPHED WITH THE BRIDE, WHICH SATISFIES
A LOT OF GUESTS WITH JUST ONE PHOTOGRAPH.

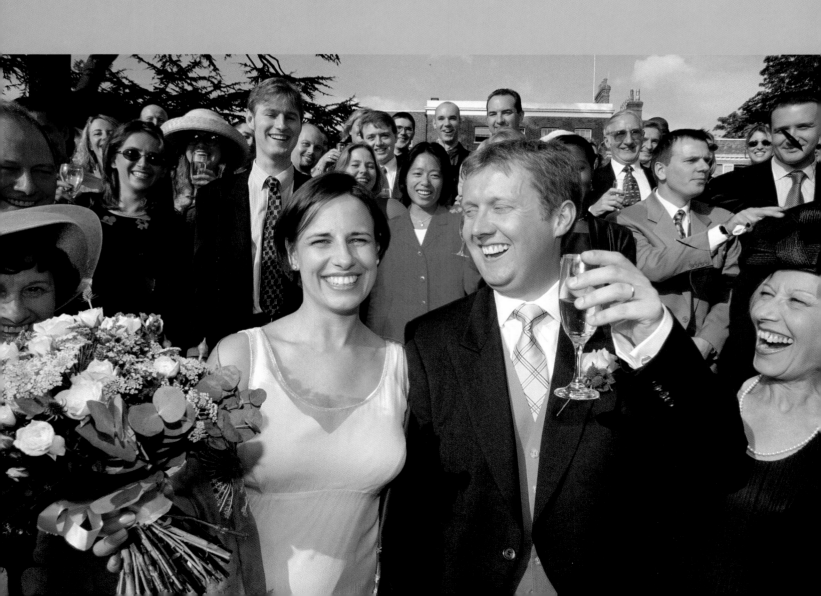

CAMERA	Nikon F5
LENS	20–35mm
FILM	Fuji Superia 100 ASA
FOCUS	Auto
FLASH	Yes (TTL balanced fill-in)
CAMERA SETTINGS	Programme f8 at 1/250sec

< **TECHNICAL INFO FOR MAIN PICTURE**

ABOVE RIGHT

This type of picture tells you much more about the family than the more conventional family portrait would have done. Obviously, the opportunity to capture a family in a situation similar to this may not always arise, but keep an eye out for such relaxed scenes during the drinks reception.

LEFT

Another group shot with the bride and groom as the main focal point. Here I had everyone's attention, as you can see by the big smiles.

> Group photographs and family portraits should be taken quickly and in a relaxed manner so that the couple and family do not get bored and have time to enjoy the wedding. If the couple do require a long list of family portraits, they should probably opt for a more traditional style of photographer, who will have a knowledge of how people should stand correctly, how to hold the flowers, where the bride's cousin should stand in relation to the bride etc. I only ask that everyone be happy (holding a drink if they wish) and relaxed. I shoot a standard eight pictures in the following order:

Bride and bridesmaids > Bride, bridegroom, bridesmaids and best man > Bride, bridegroom, bridesmaids, best man and all parents > Bride, bridegroom and all parents > Bride, bridegroom and bride's parents > Bride, bridegroom, bride's parents and bride's immediate family > Bride, bridegroom and bridegroom's parents > Bride, bridegroom, bridegroom's parents and bridegroom's immediate family

>> Then depending on how long this has taken, and what the couple want, I can add:

All of both families together > Everybody at the wedding > Bride and bridegroom with all non-family (i.e. friends)

I find this order quite quick to complete, as you are usually just adding or subtracting people to an already formed group.

I may ask for any requests, or ask if they would like any pictures with grandparents or other family members, close friends, ushers and hen-night girls. I usually photograph during the drinks reception in a more relaxed manner.

CAMERA	Nikon F90
LENS	85mm
FILM	Ilford FP4 125 ASA
FOCUS	Auto
FLASH	No
CAMERA SETTINGS	Aperture priority f11

TECHNICAL INFO FOR MAIN PICTURE >

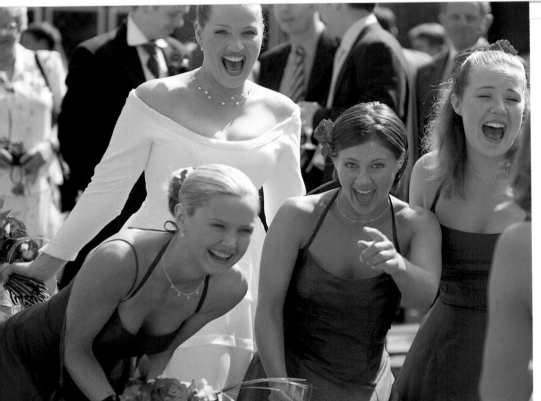

RIGHT

A photograph of the whole wedding party makes everyone present at the wedding feel they have been photographed with the bride, which satisfies a lot of guests with one photograph! I usually assemble people on steps or stairs, or look down on a group from an upstairs' window. I have also been known to balance precariously on ancient tombstones to get some height (a set of steps would be an extra item of equipment to carry around making me less mobile). I take four or five shots of the group. If people do choose to ignore me and carry on talking amongst themselves (up at the back for instance) then I just carry on regardless.

LEFT

This shot was taken just after I had photographed the bride and bridesmaids together. As I finished, a friend of the bride stepped in to take the same picture (see right of frame). A funny comment was made which I overheard, and this is why the middle bridesmaid is pointing at me. It is a great informal photograph, but would not have occurred if the more formal photograph had not been taken beforehand.

> To assemble everybody for a photograph can be quite a task. Sometimes the wedding venue is the best location as everybody is present and has not had time to wander off. I usually ask the couple to lead their guests from the ceremony venue straight to the location for the group photograph. It is useful to have the ushers at the ceremony venue exit to help guide guests in the right direction. Otherwise I take this shot at the reception asking the guests to present themselves at the given location before they sit down for the meal. The mention of food often seems to motivate people into action at this point!

> > Experienced toastmasters are very good at shifting large groups of people from one location to another in a professional manner. This can help your photographer and staff at the reception venue a great deal.

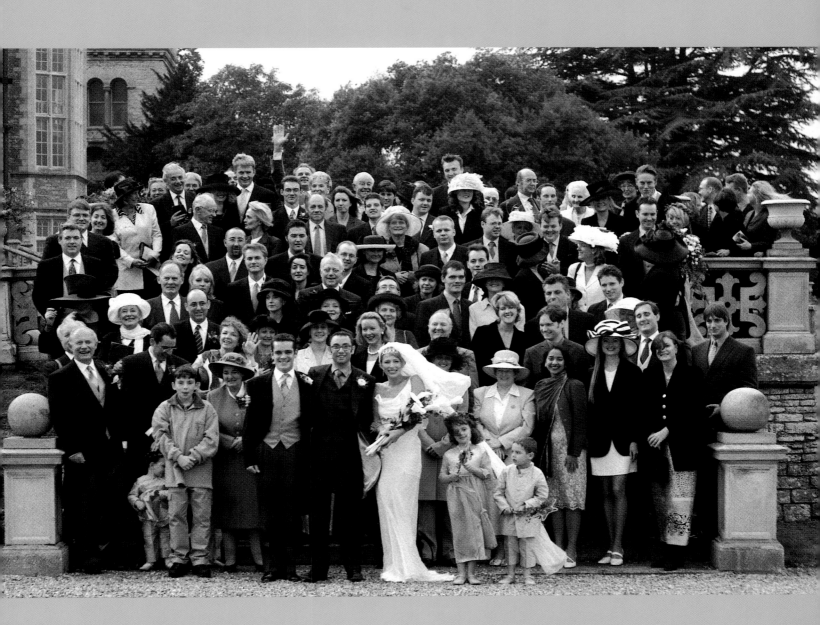

CAMERA	Nikon F5
LENS	20mm
FILM	Fuji Superia 100 ASA
FOCUS	Auto
FLASH	Yes (TTL balanced fill-in)
CAMERA SETTINGS	Programme

TECHNICAL INFO FOR MAIN PICTURE >

RIGHT
By this time you have usually taken all the essential photographs and it is time to scout around looking for pictures that capture some of the guests enjoying themselves. A low viewpoint and a wide-angle lens make this a powerful picture.

LEFT
A young page-boy wields his magic wand, causing chaos in the courtyard. I was in the process of taking some group shots when I took this, and did not have a chance to change camera settings (I was working at 1/60sec). I had to pan to keep him sharp, but the movement adds to the impact of the photograph.

FAR LEFT
These brothers were a 'must have' for everyone taking photographs at the wedding. I decided to take the picture from a different angle, and at the same time probably making a guest appearance in the background of everyone else's photographs!

*THE*GUESTS

> If it is a very large wedding be aware that the couple, who have employed you, may not want you to use your film allocation on guests they barely know. What I do is concentrate on looking for a few good images of the guests, and then I tend to concentrate on the bride or bridegroom and whoever one of them happens to be with. At my initial meeting I inform the couple that one of them will be present in 85 per cent of the photographs I take on the day.

>> If you have a large number of guests at your wedding, your photographer will probably not take an individual portrait of every person present. Do give some indication to your photographer if there are any particular guests you would like him or her to catch on film during the day.

CAMERA	Nikon FE
LENS	28mm
FILM	Ilford FP4 125 ASA
FOCUS	No
FLASH	Manual
CAMERA SETTINGS	Not known

TECHNICAL INFO FOR MAIN PICTURE	>

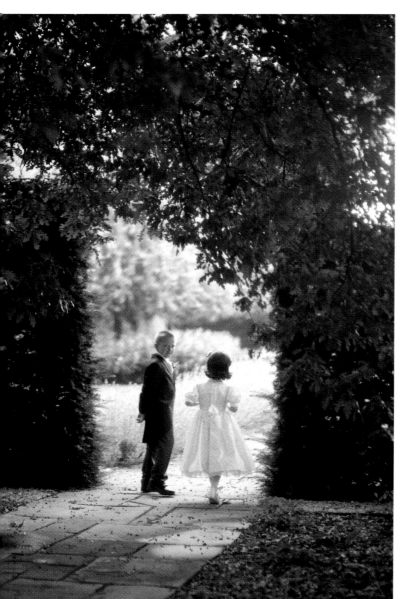

LEFT
The children were walking ahead of me to have a few portraits taken with the bride in the lavender garden. I took this shot of them while they were waiting for me to catch up with them.

RIGHT
The movement in this picture was not intentional, I must admit. I was kneeling over my kit bag changing the film in my second camera, when I noticed the bridesmaids chasing each other out of the corner of my eye. I simply grabbed the camera with film in and started taking pictures. I took about four shots, the others have too much motion blur, but I really liked this image.

In some rare cases when you see an image you like, you have to just grab it as quickly as you can before the moment is gone. The point being that if I hadn't reacted and taken the picture, knowing the camera wasn't set right, I would not have caught this image on film.

BELOW
Some guests chatting over a fence at the wedding reception.

> As a general rule, if people are crying at a wedding and they are shedding tears of joy, I will record it on film. An example of this would be tears of joy from a bride or bridegroom during the ceremony. If, however, they are shedding tears of sadness, I tend to pull back and stop photographing for a while. Tears during the speeches due to the mention of a recently departed relative would be an example of this.

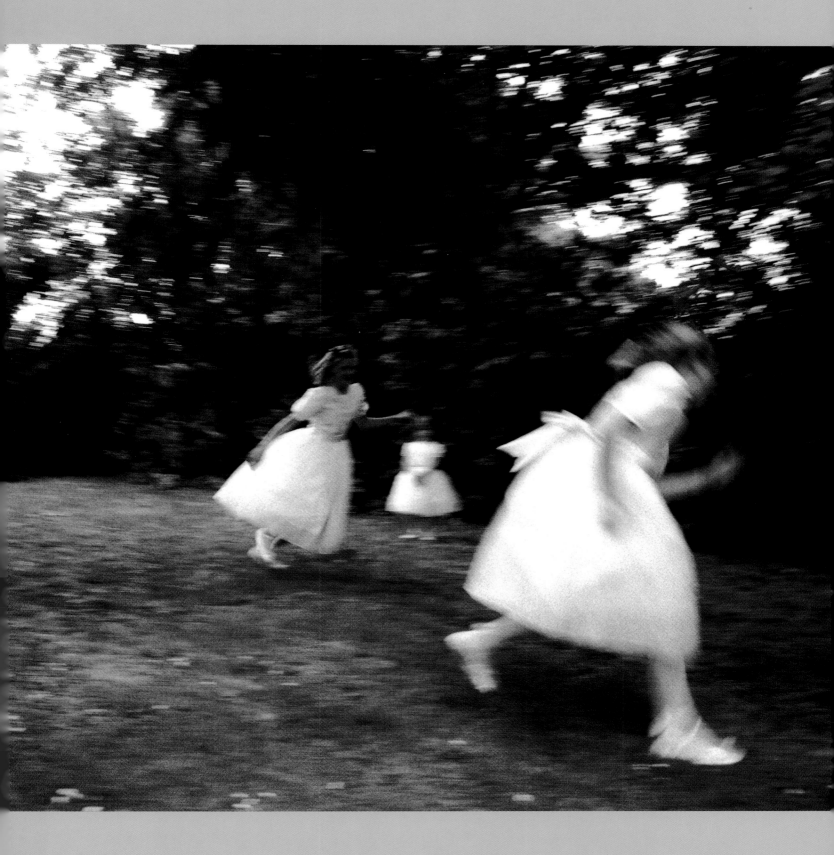

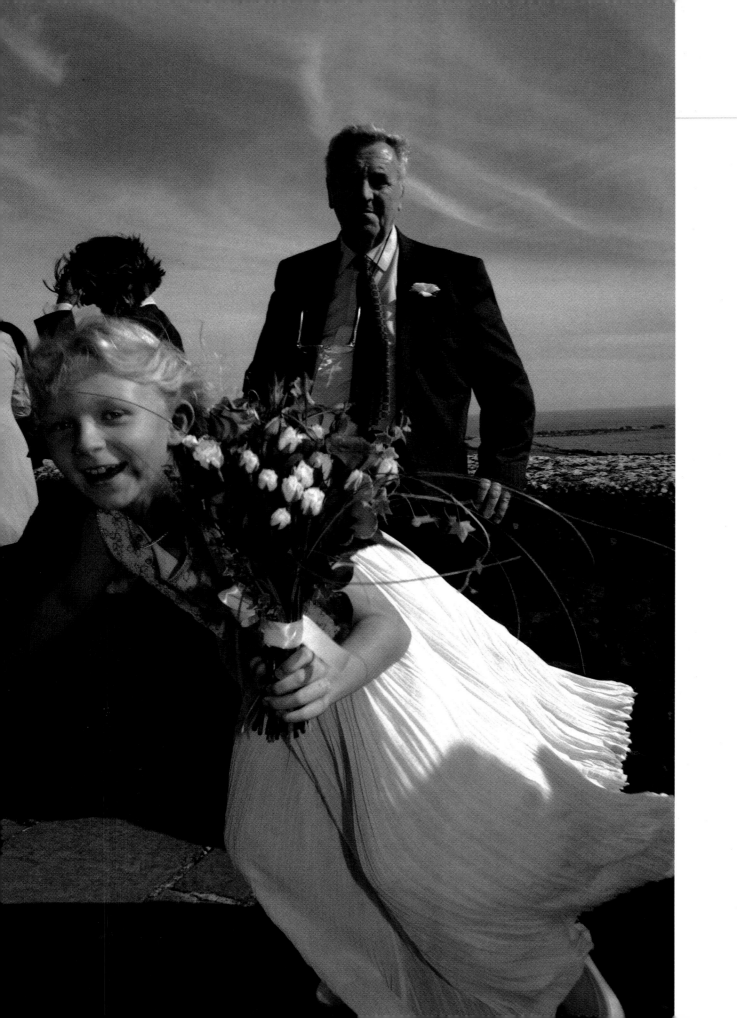

CAMERA	Nikon F5
LENS	20–35mm
FILM	Ilford FP4 125 ASA
FOCUS	Auto
FLASH	Yes
CAMERA SETTINGS	Programme

‹ TECHNICAL INFO FOR MAIN PICTURE

The reception

091

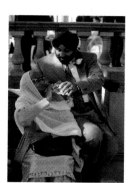
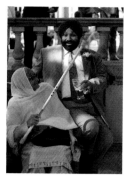

{ YOU CAN OFTEN GET SOME VERY FUNNY MOMENTS ON FILM BY WANDERING AROUND AMONG THE GUESTS.

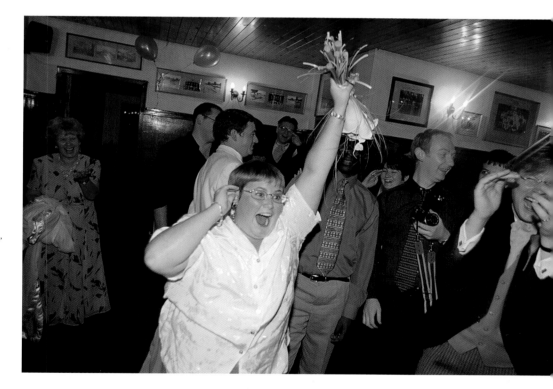

ABOVE

I captured this short sequence as I wandered amongst the guests. The gentleman was jokingly offering his beer to the lady, who dishes out a swift punishment with her walking stick.

RIGHT

I don't think I have ever seen a guest more elated at catching the bride's bouquet. For this type of shot I usually stand between the bride and the expectant group of young ladies, and move in for a close-up as the bouquet is caught to capture people's reactions.

FAR LEFT

This camera-shy bridesmaid was trying to escape my lens when I took this photograph. If she had been very shy of the lens I would have left her alone, but it seemed to be more of an escape-the-photographer game, so I followed her for a while, and caught this shot with the bride's father standing behind her.

> In sunny conditions I tend to use fill-in flash constantly when working with a wide-angle lens. The extra light the wide-angle lens takes in from the sky seems to help the meter counter and illuminate the subject a little.

>> Some brides will throw one of their bridesmaids' bouquets as a substitute, as they wish to keep their own to have dried or pressed. The throwing of the bouquet often takes place at the very end of the wedding when the couple leave the reception venue, but some couples arrange for the event to occur while their photographer is still present.

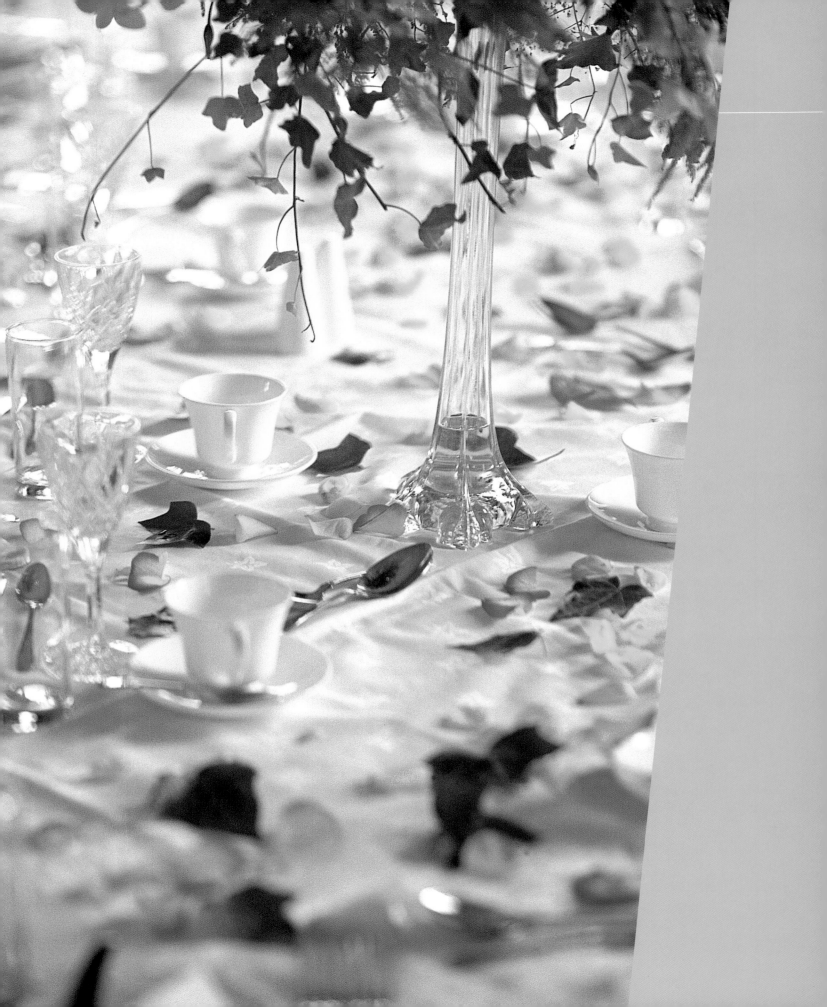

CAMERA	Nikon F5
LENS	85mm
FILM	Fuji Superia 200 ASA
FOCUS	Auto
FLASH	No
CAMERA SETTINGS	Programme f2

‹ TECHNICAL INFO FOR MAIN PICTURE

The reception 093

THE FLOWERS

> As many brides spend a lot of time choosing and colour co-ordinating their flowers, I make a point of getting as good a photograph of them as possible. Usually I work with a portrait lens at full open aperture, which creates a beautiful soft look. When photographing flowers I always use natural light. For very close-up work I use a macro (micro) lens.
>
> I photograph the bouquets at the beginning of the day, and the dining tables at the reception as soon as they are ready, making sure any table candles are lit first. This is also the time to photograph any other details in the dining-room such as the cake, or spectacular food displays.

>> Flowers are such a personal taste that I have no advice about your choice of flowers. As a photographer I prefer bold colours, with bouquets of deep reds and purples etc. Use your flower choice to create splashes of colour throughout the wedding photographs.

CAMERA	Nikon F5
LENS	105mm micro
FILM	Fuji Superia 400 ASA
FOCUS	Auto
FLASH	No
CAMERA SETTINGS	Auto/aperture priority f3.5 at 1/30sec

< TECHNICAL INFO FOR MAIN PICTURE

{ FLOWERS ARE A GREAT WAY TO ADD VIBRANT
COLOUR TO YOUR WEDDING PHOTOGRAPHS.
IT IS PERHAPS WORTH BEARING THIS IN MIND
WHEN CHOOSING YOUR FLOWERS.

FAR LEFT
Moving in close for this photograph of the bride's
bouquet makes a powerful composition.

BELOW, RIGHT & LEFT
I also try and photograph the flowers in the hands
of the bride at some point during the day.

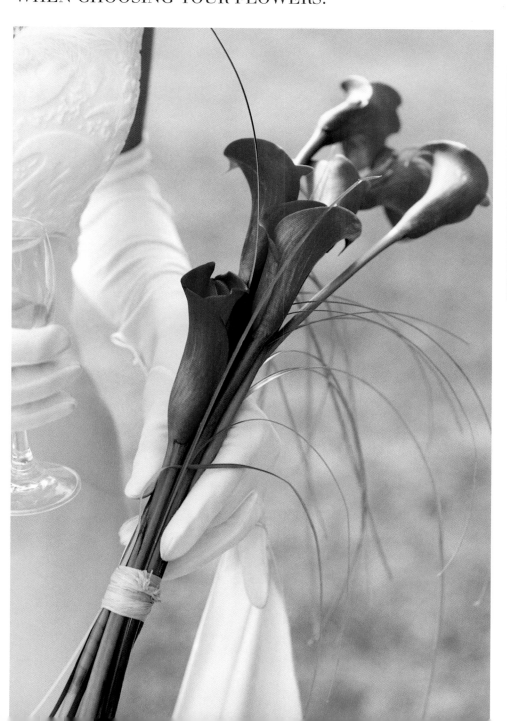

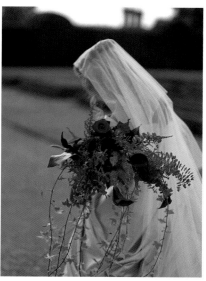

CAMERA	Nikon F5
LENS	20–35mm (set at 20mm)
FILM	Fuji Superia 200 ASA
FOCUS	Auto
FLASH	Yes (TTL balanced fill-in)
CAMERA SETTINGS	Auto/aperture priority f2.8
TECHNICAL INFO FOR MAIN PICTURE	>

RIGHT
Here a wide-angle lens has helped to capture the splendour
of the whole room.

BELOW
The micro (or macro) lens is a very useful piece of equipment
for photographing individual flowers.

{ I ALWAYS TRY AND PHOTOGRAPH THE DINING-ROOM BEFORE
GUESTS SIT DOWN TO EAT SO AS TO CAPTURE THE FULL IMPACT
OF THE TABLE ARRANGEMENTS.

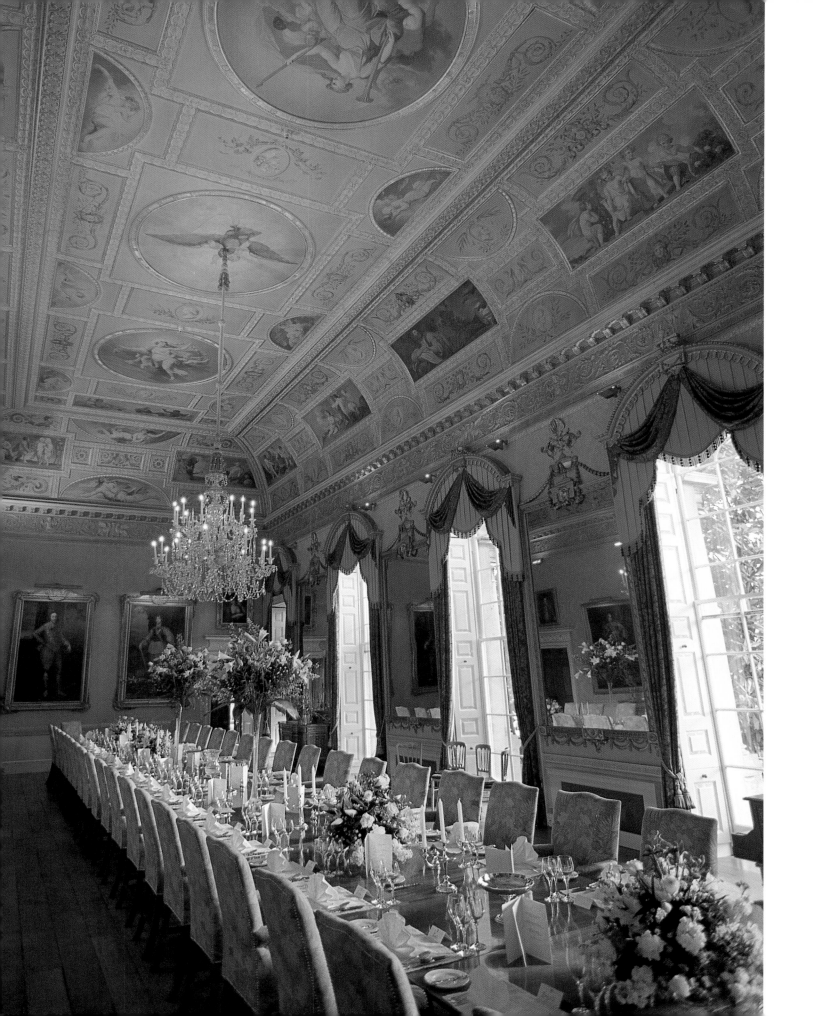

CAMERA	Nikon F5
LENS	85mm
FILM	Fuji Superia 400 ASA
FOCUS	Auto
FLASH	No
CAMERA SETTINGS	Auto/aperture priority f1.4 at 1/30sec

TECHNICAL INFO FOR MAIN PICTURE >

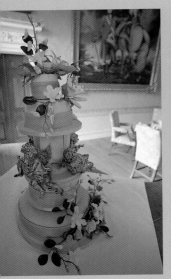

RIGHT
I always photograph the cake on its own, so the couple have a record of it. When I photograph the actual cutting of the cake I am concentrating on photographing the couple and their guests, not necessarily getting a good shot of the cake.

LEFT
Having taken the couple posing I sometimes move around and capture a close-up of the knife slicing through the cake.

*THE*CAKE

> If you find the cake has been poorly positioned, try and have it moved for the actual cutting; into the middle of the dance floor with all of the guests gathered around, for instance. If you are posing the cutting of the cake photograph you will probably be able to lose or hide any distractions through your choice of the couple's position and the angle you take the photograph from.

>> You have usually spent a lot of money on your wedding cake so make sure it gets the attention it deserves. I would recommend that you determine its position in the dining-room. Often the staff at your reception will inadvertently place it somewhere surrounded by distractions such as under an emergency fire alarm switch, next to a fire extinguisher, under a hotel direction sign or green exit sign, or in front of a large mirror. All of these detract from the cake being the focal point and will be very apparent in the final image.

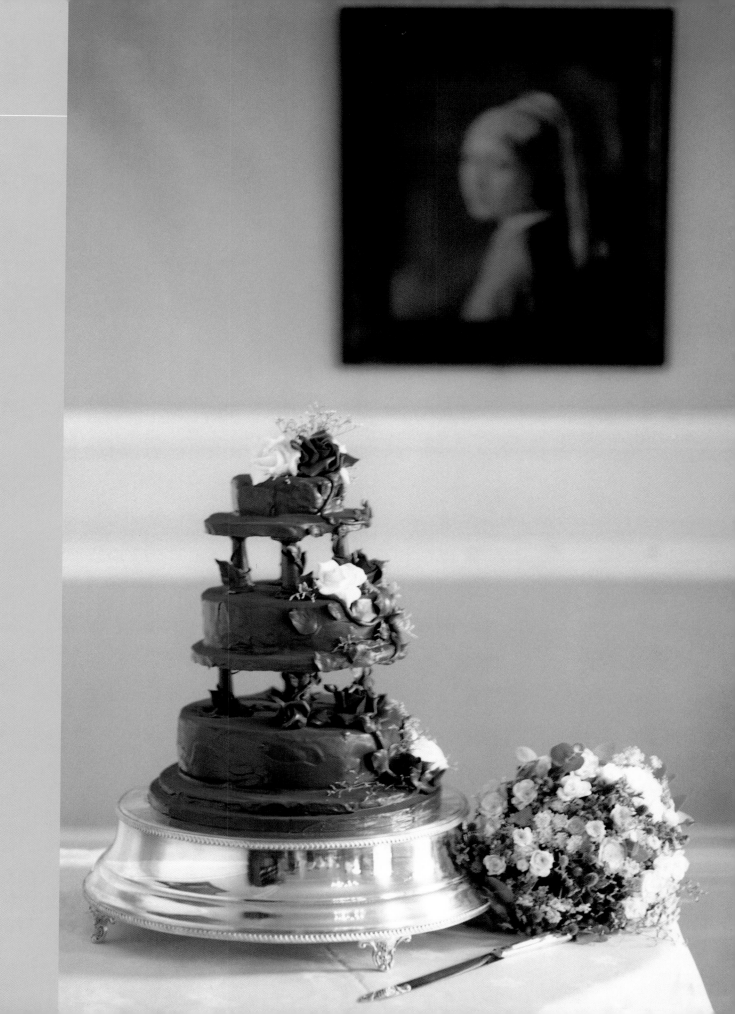

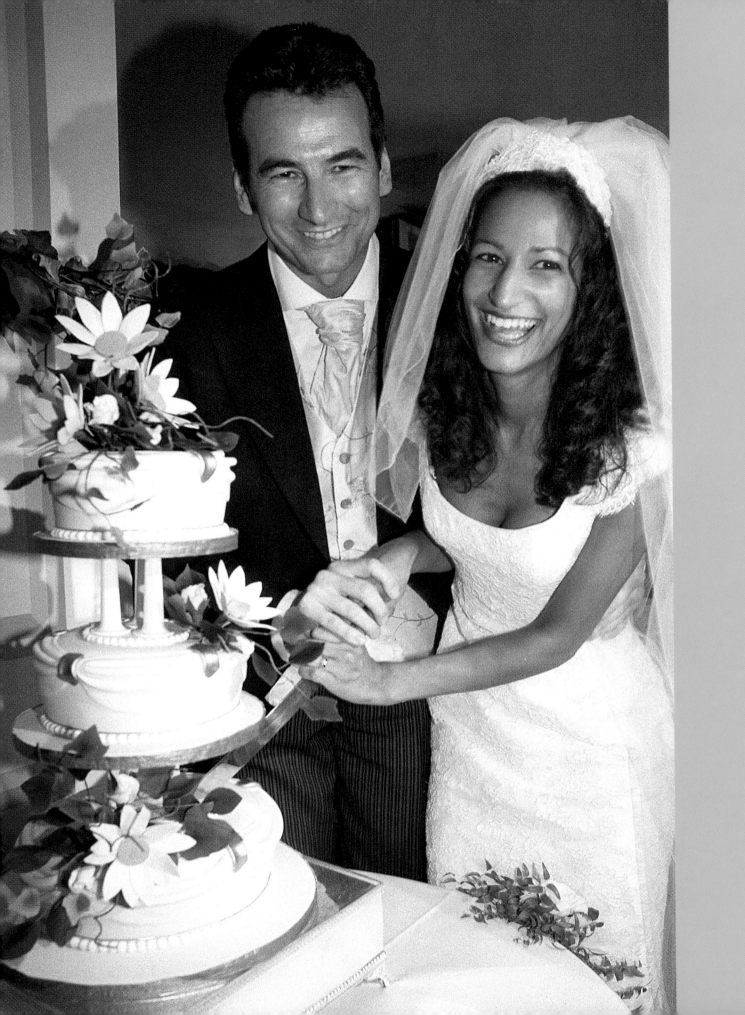

CAMERA	Nikon F4
LENS	28mm
FILM	Ilford HP5 400 ASA
FOCUS	Auto
FLASH	Yes (TTL metering)
CAMERA SETTINGS	Programme

< TECHNICAL INFO FOR MAIN PICTURE

LEFT & BELOW
These photographs of the collapsing cake were taken in the evening as the event happened. The room was very small, and guests were surrounding me, which is why I was working with the wide-angle lens. I saw the cake was starting to topple as they began to cut, and just kept clicking.

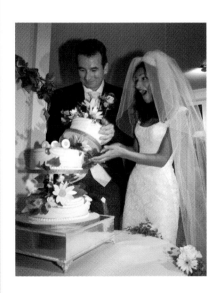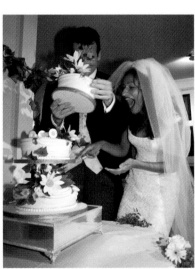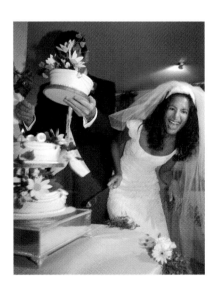

{ DISASTERS DO HAPPEN, BUT THEY DON'T HAVE TO RUIN YOUR DAY. CAUGHT ON CAMERA SUCH EVENTS ONLY ADD TO THE PERSONAL NATURE OF A WEDDING AND WILL PROBABLY BRING A SMILE TO YOUR FACES FOR MANY YEARS TO COME.

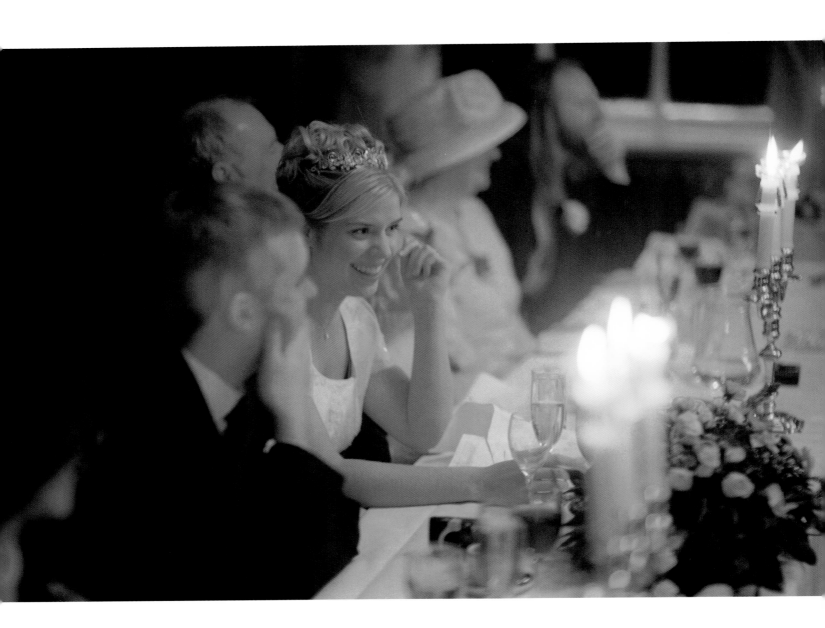

CAMERA	Nikon F4
LENS	85mm
FILM	Fuji Superia 400 ASA
FOCUS	Auto
FLASH	No
CAMERA SETTINGS	Auto/aperture priority f1.4 at 1/30sec

< **TECHNICAL INFO FOR MAIN PICTURE**

LEFT

During the speeches I spend more time looking for people's reactions to what's being said, rather than on the person making the speech. I am usually crouching in front of the top table, but rise at opportune moments (during laughter for example) to take a few shots. I keep out of shot of the professional video, as I feel it has priority at this stage of the wedding. For this photograph the subject was reasonably static, allowing me to use a slow shutter speed rather than flashlight to hold the glow and warmth of the candlelight.

RIGHT

The bride spots me on the prowl for pictures during the speeches.

BELOW

The bride and groom react to the best man's speech.

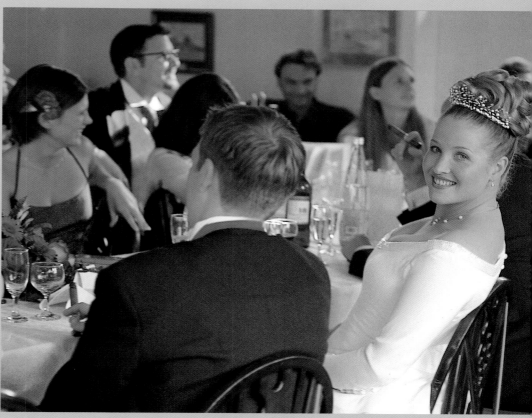

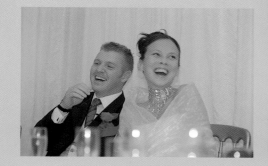

*THE*SPEECHES

> Autofocus means that you can work quite safely at a wide-angle lens aperture, which helps eliminate the need for flash in low-light situations.

>> If the speeches follow the meal, to avoid a silent pause when the final speech has finished, make sure an announcement is made as to what is to happen next. For instance, the cutting of the cake, or perhaps the bride and groom are to leave the room and the guests are to follow. Otherwise it is a good idea for the band or DJ to start some music. Sometimes the couple will move swiftly on to the dance floor for the first dance. This is a small point, but adds to the general flow of things.

CAMERA	Nikon F4
LENS	85mm
FILM	Ilford HP5 400 ASA
FOCUS	Auto
FLASH	No
CAMERA SETTINGS	Programme f1.4
TECHNICAL INFO FOR MAIN PICTURE	>

FAR RIGHT
The couple listen to the speech given by the bride's father. The speeches were made from a round table, which allowed me to move around and shoot between people, and made it easier to get the bride and bridegroom in the same frame in a good composition.

RIGHT
At the same wedding the bridegroom delivers his speech to the guests.

BELOW
The best man listens to the bridegroom's speech whilst contemplating his own speech which will follow imminently.

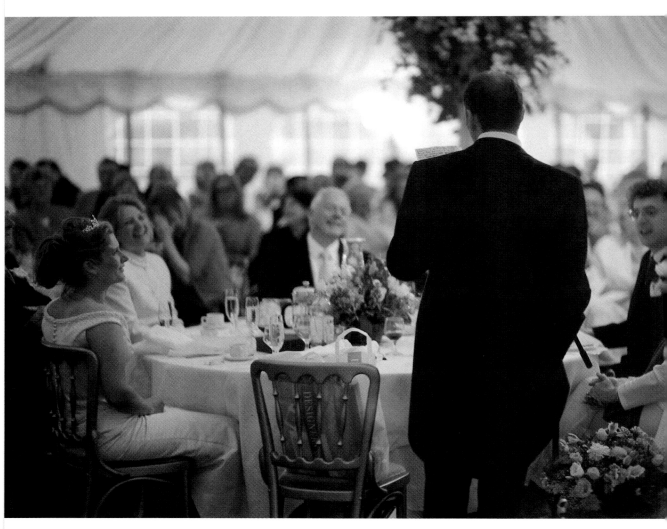

{ DURING THE SPEECHES I TEND TO CROUCH DOWN IN FRONT OF THE TOP TABLE. I LOOK FOR PEOPLE'S REACTIONS TO WHAT IS BEING SAID AND LET WHOEVER IS VIDEOING THE EVENT FOCUS ON WHOEVER IS GIVING THE SPEECH.

> Just before the speeches start, move any wine bottles or flowers that may obstruct your view of the couple during the speeches.

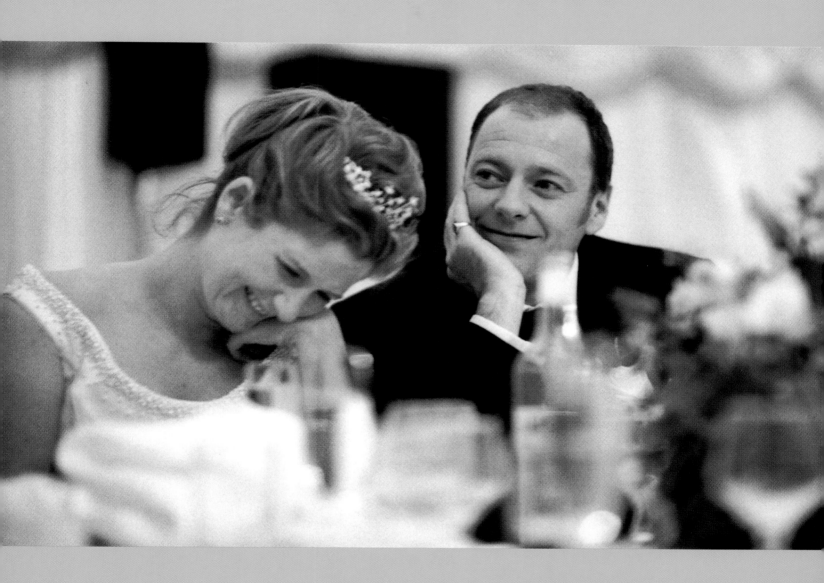

CAMERA	Nikon F5
LENS	85mm
FILM	Fuji Neopan 1600 ASA
FOCUS	Auto
FLASH	Yes (TTL)
CAMERA SETTINGS	Programme

TECHNICAL INFO FOR MAIN PICTURE >

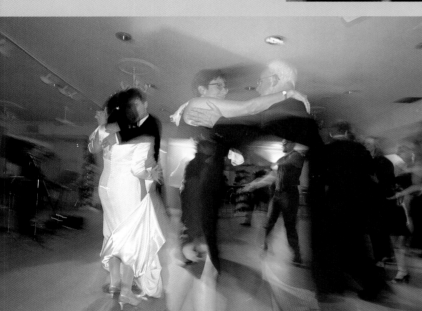

RIGHT
This photograph taken of the first dance is enhanced by a guest photographer's flashgun firing as he took a shot from exactly opposite me! The negative is overexposed, which produces the extra grainy effect when it is printed.

ABOVE LEFT
A high viewpoint was chosen for this shot, but no flash this time, as I relied on the DJ's disco lighting.

LEFT
The rear shutter sync button on the camera body made this photograph possible. The setting allows the camera to expose the film reading available light, and then fires a flash exposure just as the shutter closes, freezing things as they are at that moment. To get this effect involves trial and error, so it is worth taking a few shots just in case.

*THE*DANCING

> Check how long the DJ or band let the couple dance alone for before calling other couples on to the dance floor, so that you can pace yourself picture-wise. Sometimes it is after about 30 seconds, others let the happy couple command the dance floor for the whole song.

>> Let your photographer know if you have rehearsed a special first dance (a tango, for instance), so that he is ready to catch any swift manoeuvres you may perform.

PCPhoto
Save 73%

Start my subscription to PCPhoto today. Rush me 1 year (9 issues)
for just $11.97 and I save 73% off the newsstand price!

Name _____
(PLEASE PRINT)

Address _____

City/State/ZIP _____

E-mail _____

Your e-mail address will be used only to contact you regarding your subscription

SEND NO MONEY NOW! WE'LL GLADLY BILL YOU LATER.

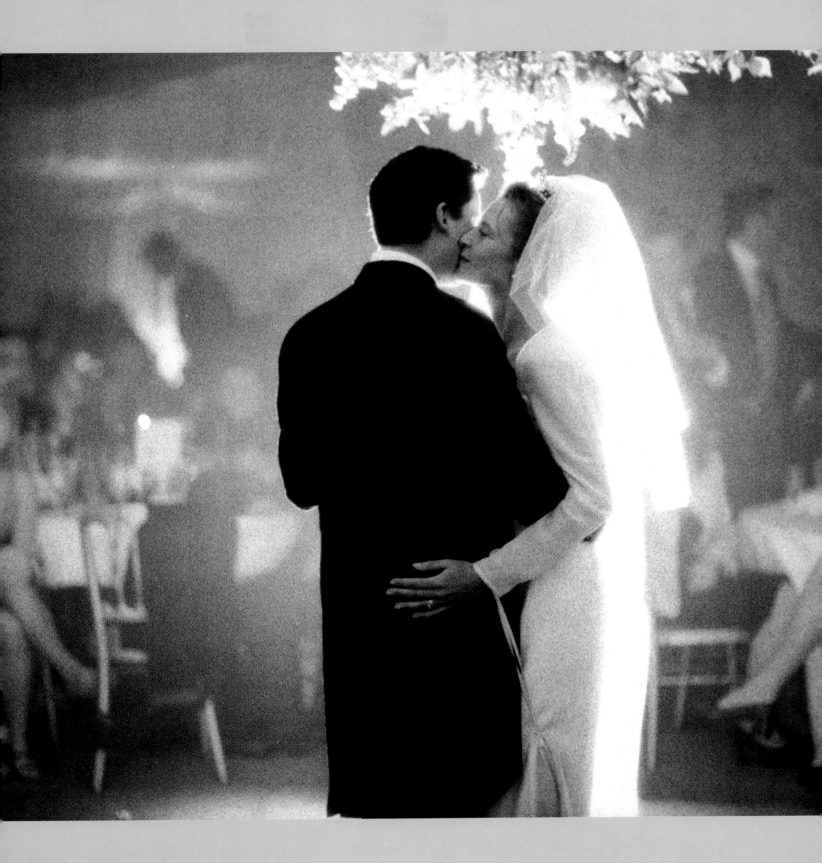

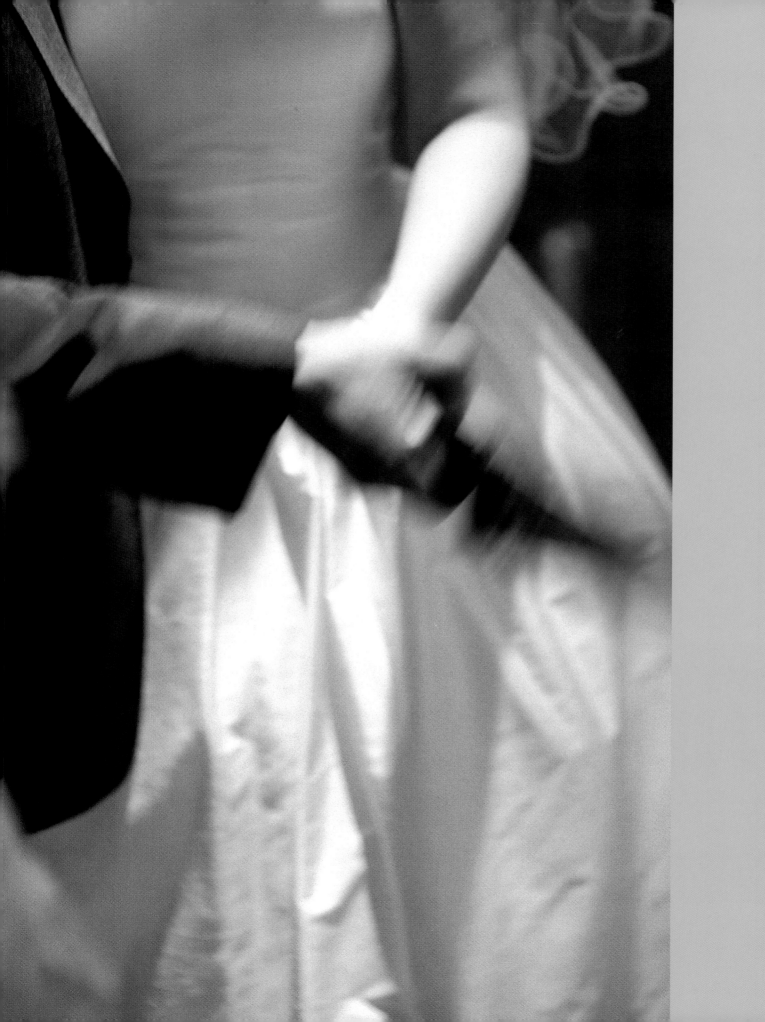

CAMERA	Nikon F5
LENS	85mm
FILM	Fuji Neopan 400 ASA
FOCUS	Auto
FLASH	No
CAMERA SETTINGS	Auto/aperture priority f1.4 at 1/8sec

‹ TECHNICAL INFO FOR MAIN PICTURE

LEFT & RIGHT
Close-ups of hands being
held, faces close together
and lips about to meet
are the type of thing I am
looking for when the couple
first take to the dance floor.
Once again I tend to work
in available light, whatever
the available lighting
conditions are, unless it is
pitch black of course, but
sometimes I cover my back
by using flash for a few
shots to avoid too much
motion blur.

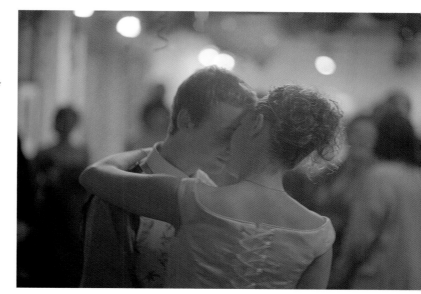

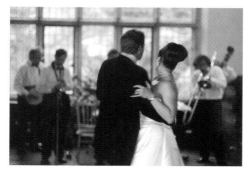

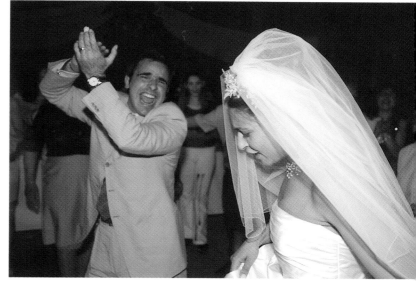

{ THE RECEPTION SHOULD BE PARTY TIME! MY ADVICE IS THAT IF YOU ARE HAVING A GREAT TIME, THEN YOUR PHOTOGRAPHER WILL TAKE GREAT PHOTOGRAPHS.

> I am not worried if I cannot see the bride's or bridegroom's faces during the first dance, it is the atmosphere of the event I am trying to catch on film.

> *WEDDING*ALBUMS

> THIS SECTION OF THE BOOK WILL GIVE BRIDE AND
PHOTOGRAPHER ALIKE AN INDICATION OF THE COVERAGE
A CONTEMPORARY WEDDING PHOTOGRAPHER CAN GIVE
A WEDDING. HERE YOU CAN VIEW THE MAIN EVENTS OF
A WEDDING DAY FROM BEGINNING TO END, CAPTURED IN
AN UNOBTRUSIVE, ROMANTIC AND FUN MANNER. THE
WEDDINGS ARE ALL VERY DIFFERENT, AS YOU WILL SEE,
AND THEY HAVE ALL BEEN PHOTOGRAPHED IN A VERY
UNIQUE, YET CONTEMPORARY FASHION. I HOPE THEY
INSPIRE YOU FOR THE FUTURE.

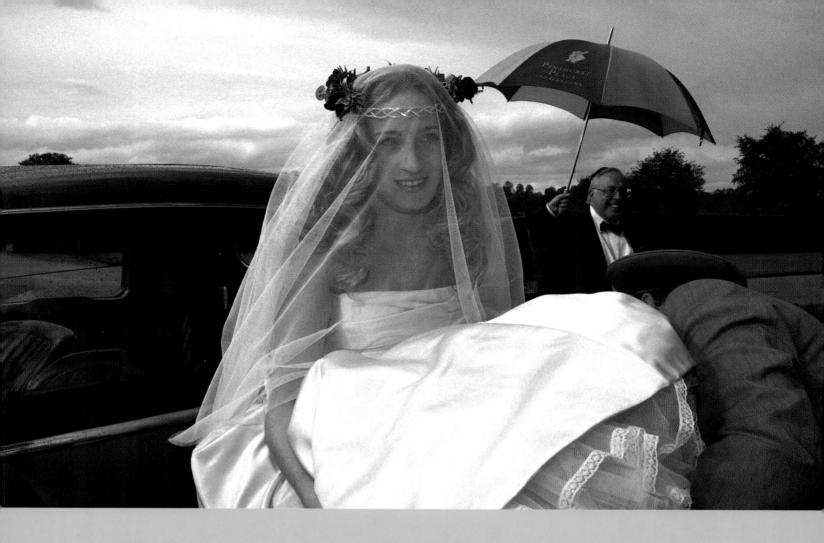

{ FOR GABBI AND I WHAT WAS IMPORTANT WHEN CHOOSING
A PHOTOGRAPHER WAS SELECTING SOMEONE WHO WOULD
CAPTURE EVERY ASPECT OF THE DAY INCLUDING THE
EMOTIONS. AS BRIDE AND GROOM THE DAY PASSES IN A
WHIRLWIND AND IS OVER FAR TOO QUICKLY. YOU MISS SO
MUCH. STEPHEN'S PHOTOGRAPHS FILLED IN THE GAPS
AND GAVE US A COMPLETE RECORD OF THIS INCREDIBLE DAY.

VENUE FOR WEDDING AND RECEPTION	Penshurst Place, Kent, UK
TIME OF YEAR	August
WEATHER CONDITIONS	Overcast with some light rain

Wedding albums **113**

MIRANDA
&GABBI

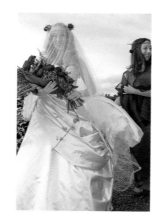

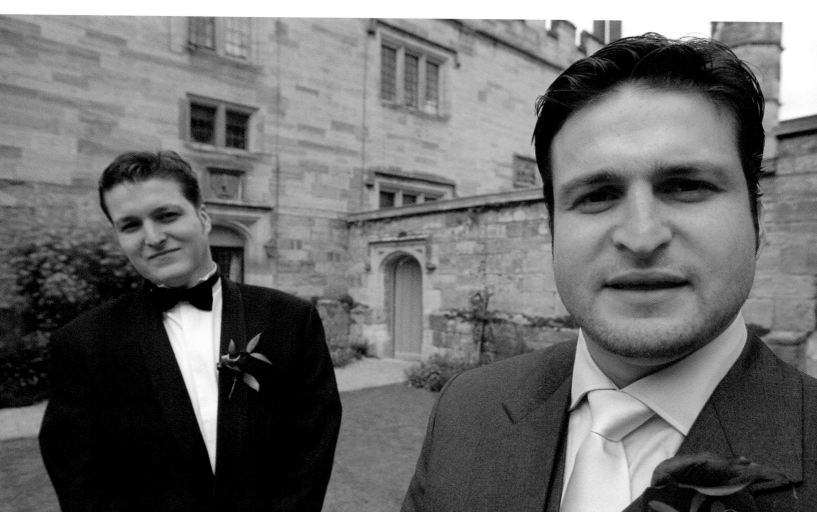

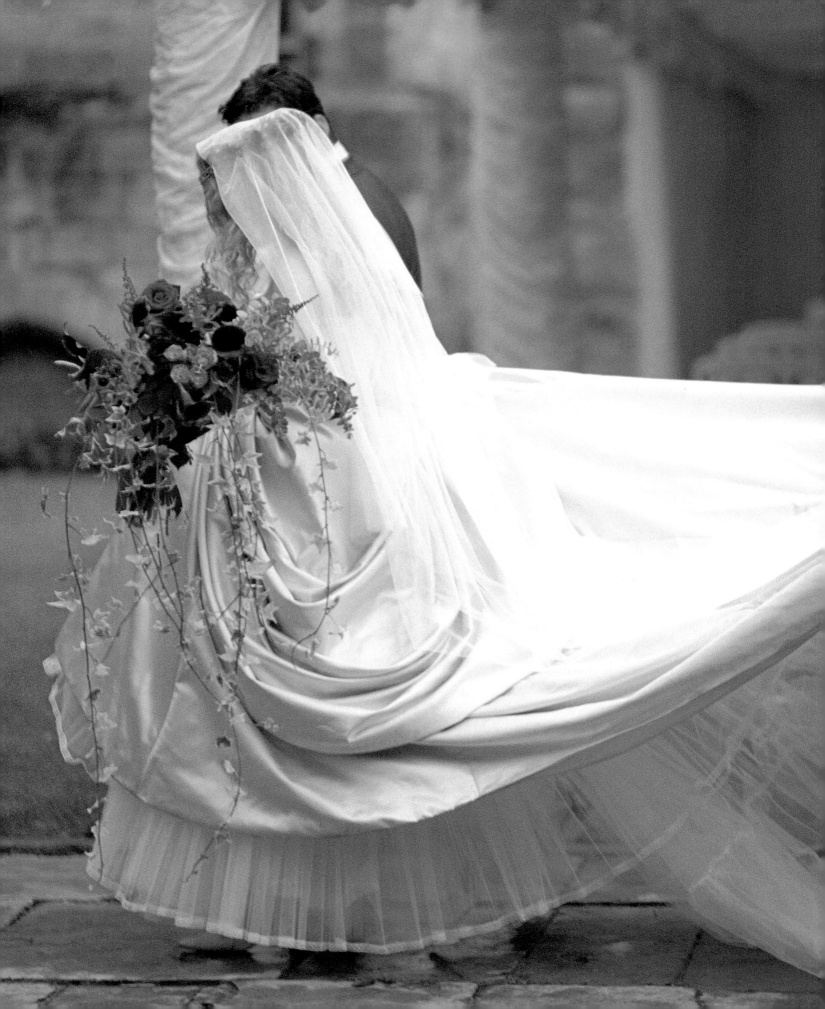

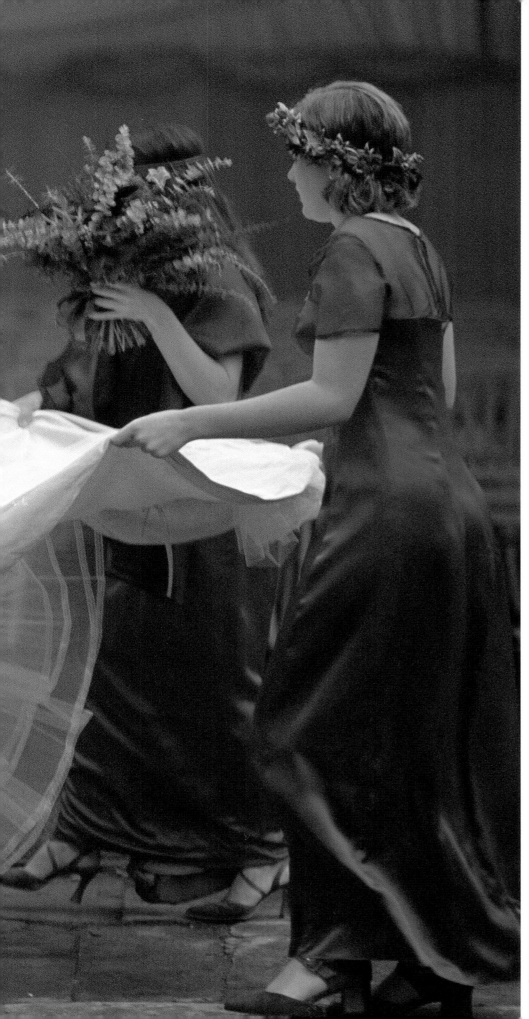

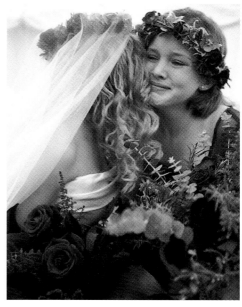

{ BLACK-AND-WHITE
PHOTOGRAPHY HAS
A TIMELESS, ELEGANT
QUALITY TO IT.
THE MEMORIES OF
OUR WEDDING ARE
EQUALLY TIMELESS.
THE BLACK-AND-WHITE
PHOTOGRAPHS ARE ALSO
EXTREMELY BEAUTIFUL
WHEN HAND-PRINTED
BY STEPHEN.

BELOW RIGHT & LEFT

The Jewish ceremony took place beneath a Chuppah (a special canopy) in the courtyard of the 16th-century venue. As the couple was surrounded by parents and close family it was hard to photograph the couple without being intrusive, I just had to take what I could working over people's shoulders and in-between them.

FAR LEFT

The shot of the whole banquet was taken from a gallery. I did not use flash, opting instead for a longer exposure, which meant I could hold the candlelight and blur the waiters that were moving from table to table.

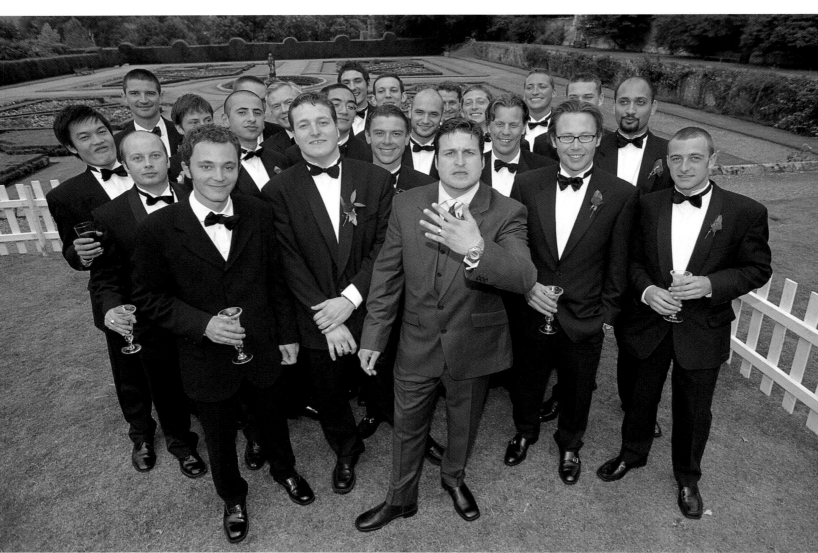

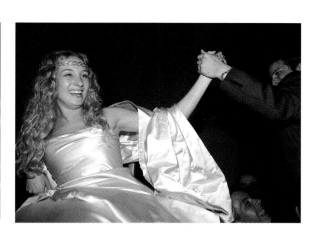
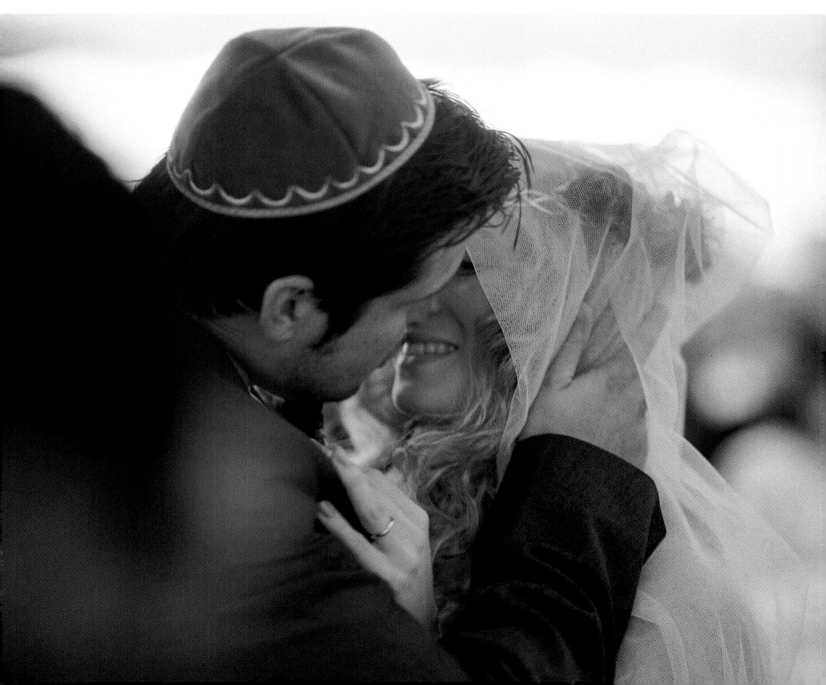

VENUE FOR RECEPTION	Briggens House Hotel, Standsted Abbotts, Essex, UK
TIME OF YEAR	August
WEATHER CONDITIONS	Hot sunshine

{ ONE REASON WE CHOSE A MORE MODERN STYLE OF PHOTOGRAPHY WAS THAT WE KNEW FAMILY AND FRIENDS WOULD NOT RESPOND TO LINE-UP PHOTOGRAPHS VERY WELL. THEY WOULD HAVE STOOD TO ATTENTION, AND WE WANTED TO REMEMBER THEM RELAXING AT OUR WEDDING. ALSO, WE WANTED NATURAL PHOTOGRAPHS THAT SHOWED PEOPLE REACTING TO ACTUAL EVENTS RATHER THAN ANYTHING STAGED.

FLEUR&RICHARD

LEFT
I have photographed many weddings and people still come up with wonderful ideas I have never seen before. The idea of decorating the porch to the church door with flowers, petals and candles created a wonderful ambience, which I am sure, in turn, helped me produce the photograph of the bride looking down as she enters the church.

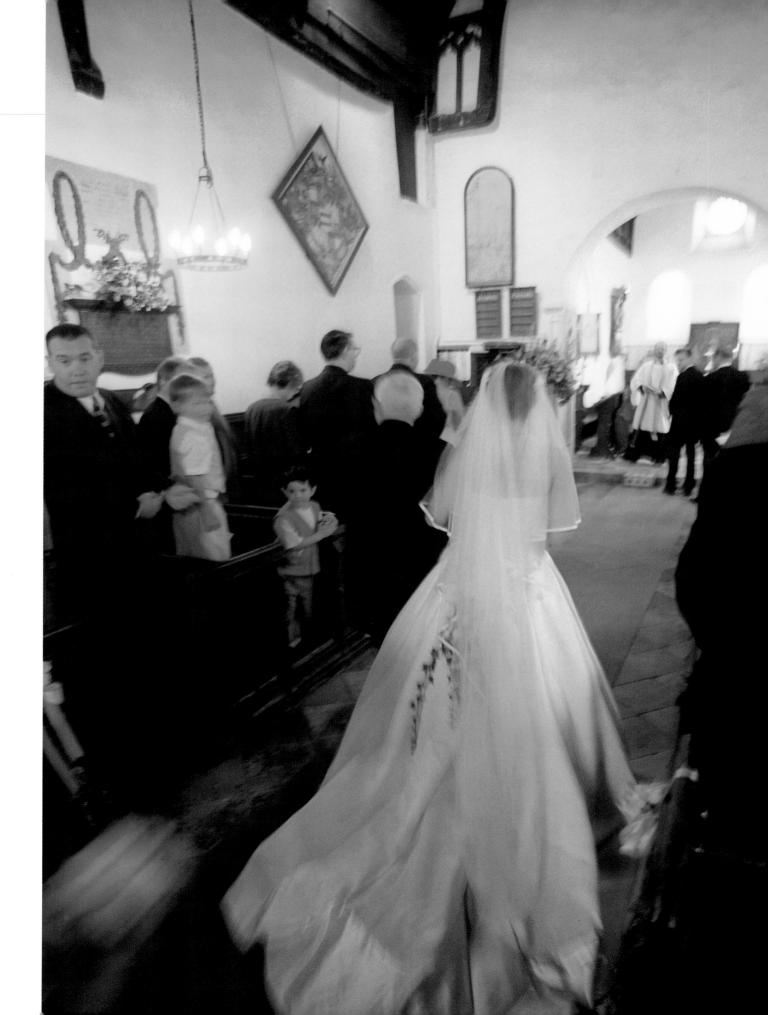

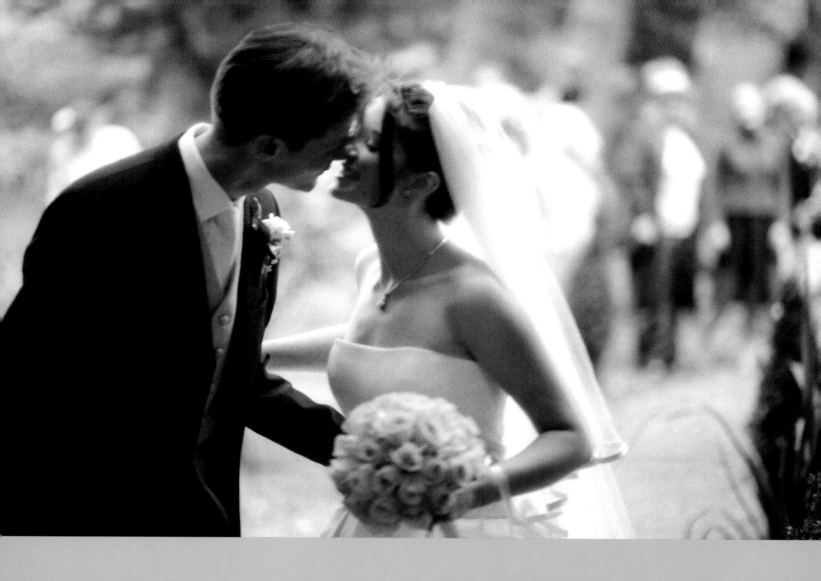

{ WE DIDN'T NOTICE THE PHOTOGRAPHER WAS TAKING PHOTOGRAPHS FOR 90 PER CENT OF THE DAY.

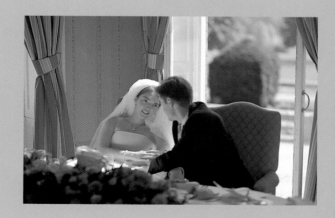

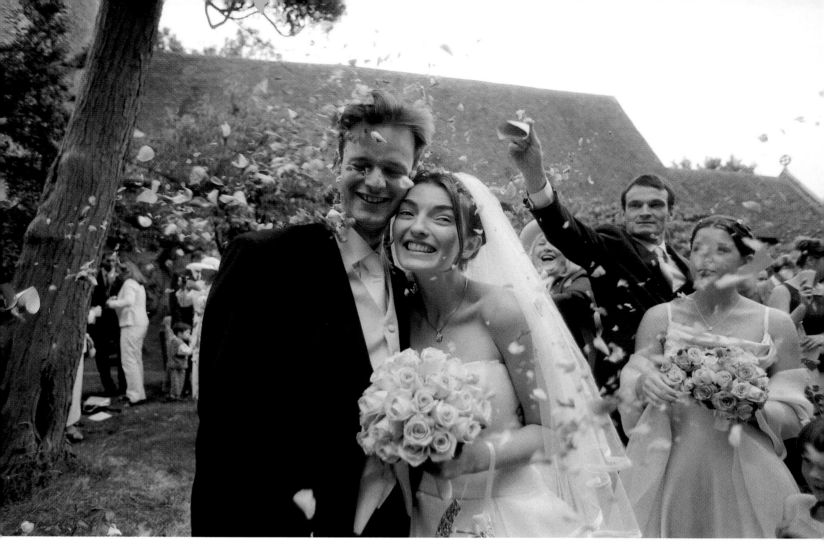

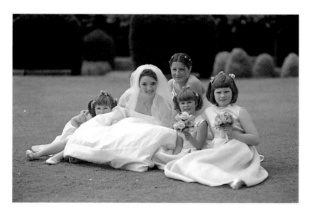

{ BLACK-AND-WHITE PHOTOGRAPHS ARE FAR MORE FLATTERING, AND FAR MORE ATMOSPHERIC.

VENUE FOR WEDDING AND RECEPTION	Fanhams Hall, Hertfordshire, UK
TIME OF YEAR	September
WEATHER CONDITIONS	Sunshine all day

{ MOST OF OUR WEDDING FOLLOWED THE TRADITIONAL PATTERN, BUT THE PHOTOGRAPHY WAS ONE THING WE DEFINITELY WANTED TO BE MODERN. WE WANTED OUR PHOTOS TO BE AS NATURAL AS POSSIBLE AND NOT JUST A LOAD OF PEOPLE STANDING IN ROWS THAT WOULDN'T TELL YOU VERY MUCH ABOUT THE WEDDING DAY ITSELF! AND HOPEFULLY OUR KIDS WILL THINK OUR WEDDING WAS COOL IN 20 YEARS' TIME TOO!

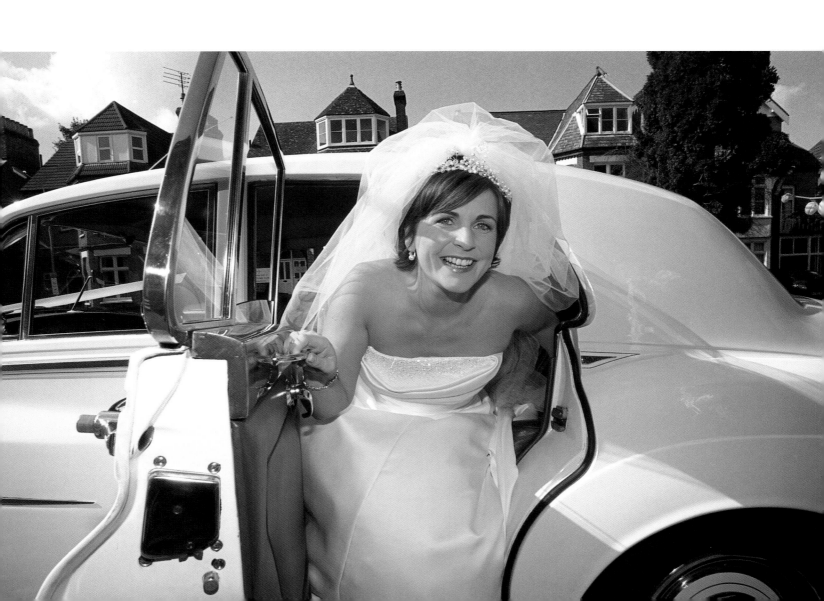

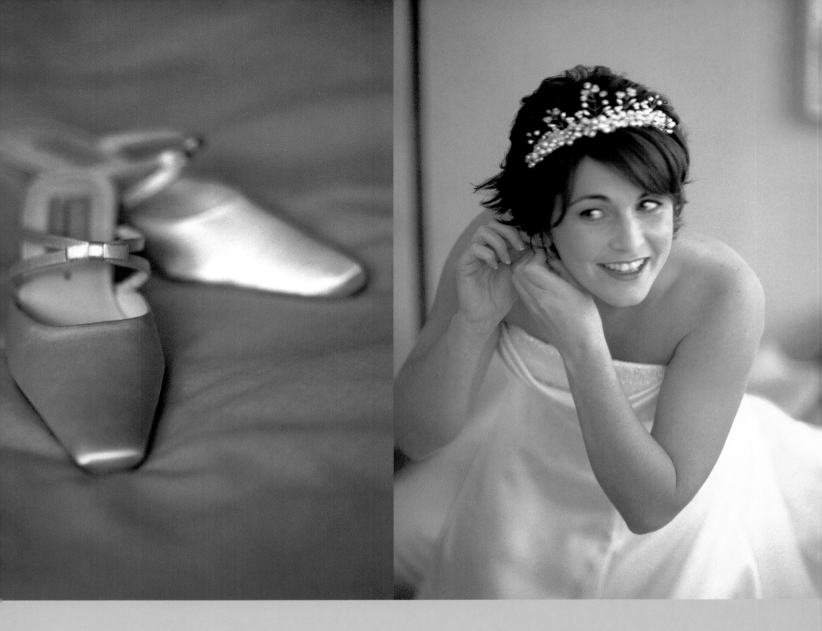

FRANCESCA&TONY

{ WE'VE ALWAYS LOVED BLACK-AND-WHITE PHOTOGRAPHY – IT JUST ADDS THAT LITTLE EXTRA SOMETHING TO THE MOOD OF THE PICTURE AND THIS IS ESPECIALLY TRUE OF OUR CEREMONY SHOTS. WE ALSO LOVE THE WAY BLACK AND WHITE MAKES THE PHOTOGRAPHY LOOK CLASSIC, EVEN WHEN THE SETTING IS MODERN.

BELOW
I was allowed to work through the ceremony for this wedding. I work with natural light during the service so as not to be intrusive. The black-and-white photographs of the couple in the church were caught just after the couple had signed the registry book. I was waiting in the aisle ready to move to the back to photograph the couple's exit, but I just managed to squat down so that the crucifix could be seen between the couple as they held hands and kissed.

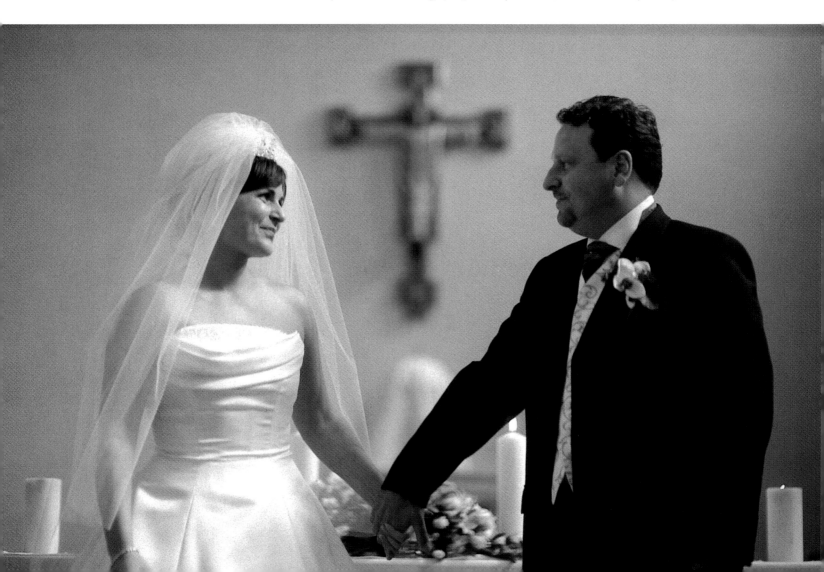

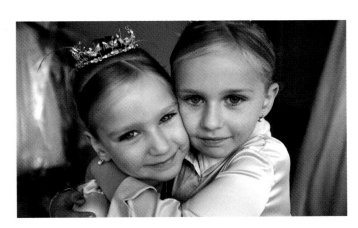

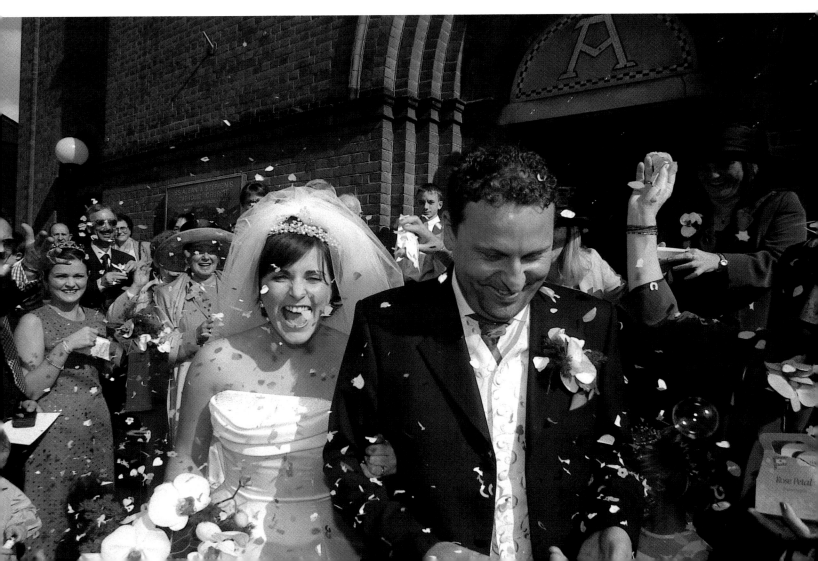

BELOW

I did take more family portraits than I usually do at this wedding, and for larger family pictures I made use of garden furniture that I found around the grounds.

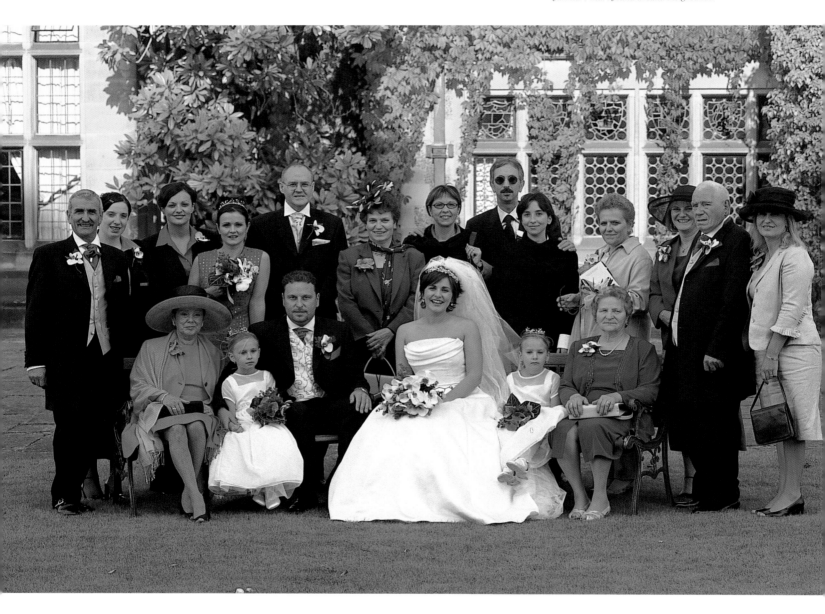

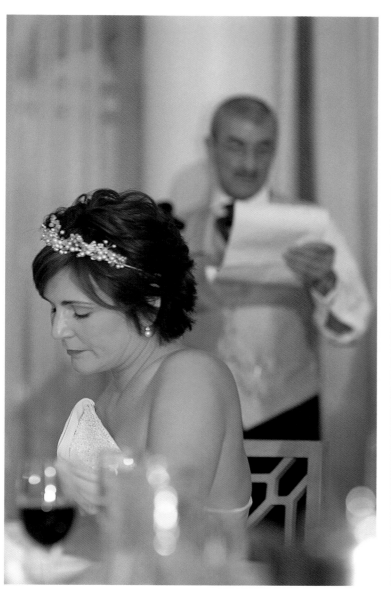

VENUE FOR WEDDING AND RECEPTION	Ham House, Richmond, UK
TIME OF YEAR	August
WEATHER CONDITIONS	Rain and sunshine

RIANDA&SEAMUS

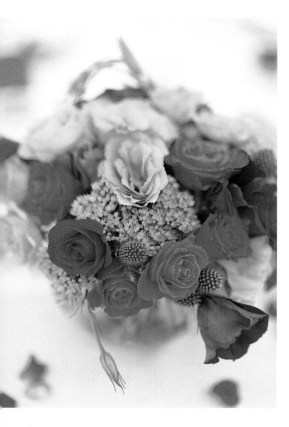 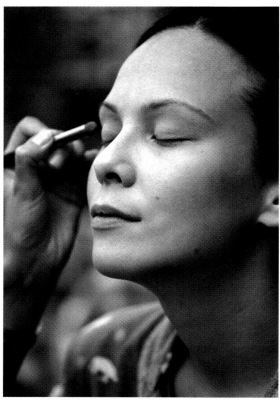 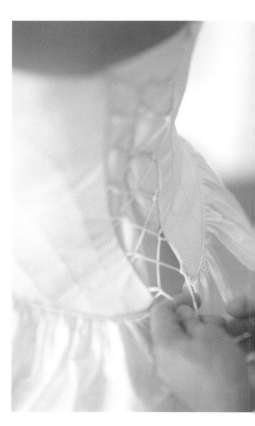

{ THE RESULTS WERE AN IMPRESSIVE VARIETY OF IMAGES THAT CAPTURED THE ESSENCE OF OUR WEDDING ENTIRELY AS WE REMEMBER IT. STEPHEN HAD BEEN BRILLIANTLY QUICK TO CATCH TINY, EVOCATIVE MOMENTS AND WITH THOUGHTFUL COMPOSITION, HE CREATED AN AMAZING SENSE OF MOVEMENT, ATMOSPHERE AND EMOTION – EVERY PICTURE EVOKES MEMORIES OF A PARTICULAR MOMENT IN GREAT CLARITY.

{ THERE WERE MANY CONTEMPORARY ELEMENTS TO OUR WEDDING, SO WE WANTED A STYLE OF PHOTOGRAPHY THAT WOULD BEST REFLECT OUR DAY OVERALL – BROWSING THROUGH A WIDE VARIETY OF WEBSITES AND MAGAZINES, IT WAS THE 'REPORTAGE' STYLE PHOTOGRAPHS THAT WERE MOST EYE-CATCHING AND INTERESTING.

ABOVE & BELOW
The ceremony room was quite dark and cramped; I had to use a wide-angle lens to keep the bride and bridegroom in the same frame. Flash photography was not permitted during the ceremony because of the valuable paintings and tapestries hanging on the walls.

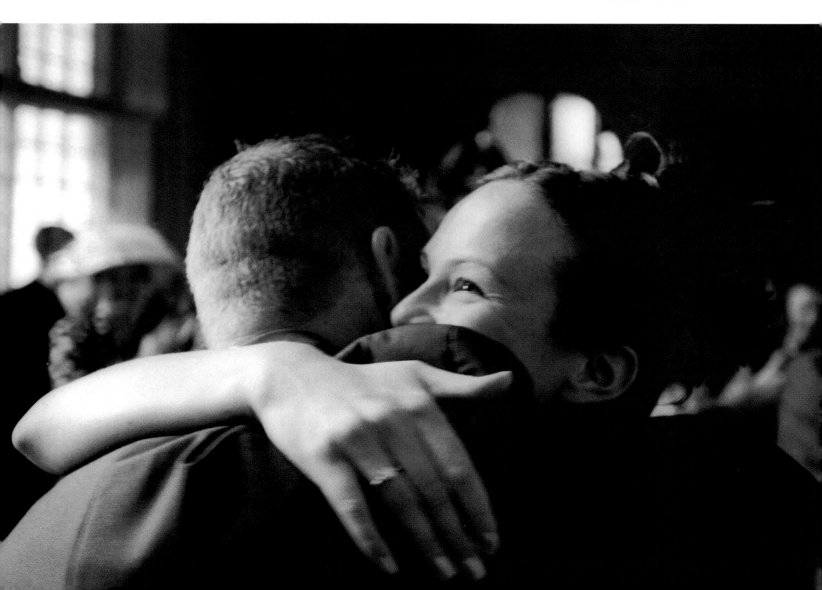

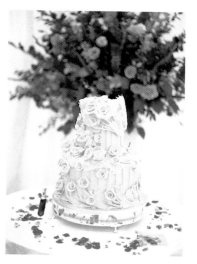
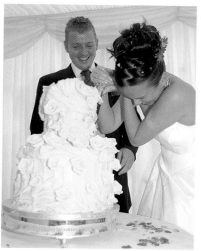
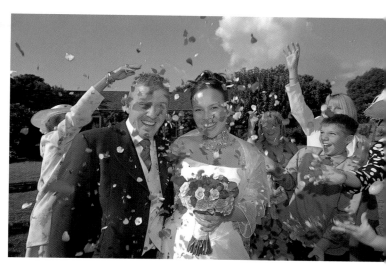

ABOVE & BELOW
The reception was held in a marquee in the venue gardens.

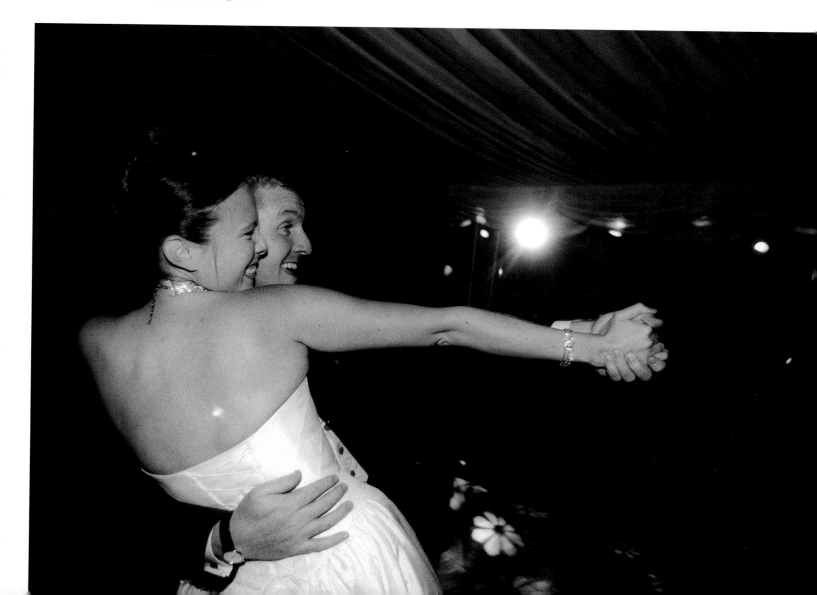

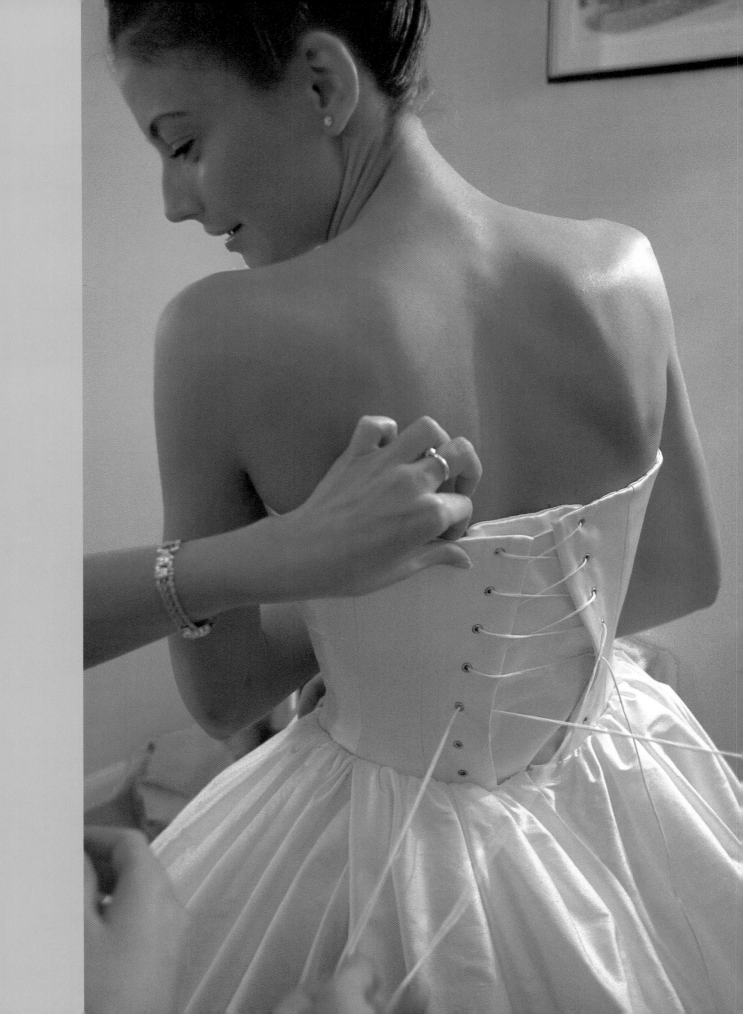

VENUE FOR WEDDING AND RECEPTION	Leez Priory, Essex, UK
TIME OF YEAR	May
WEATHER CONDITIONS	Rain all day

JAYNE & SIMEON

{ PEOPLE ALWAYS LOOK BETTER WHEN THEY ARE CAUGHT
UNAWARES RATHER THAN PUTTING ON A CHEESY GRIN!
THE PHOTOGRAPHS WERE VERY NATURAL AND RELAXED,
AND CAUGHT THE SPIRIT OF THE DAY PERFECTLY.

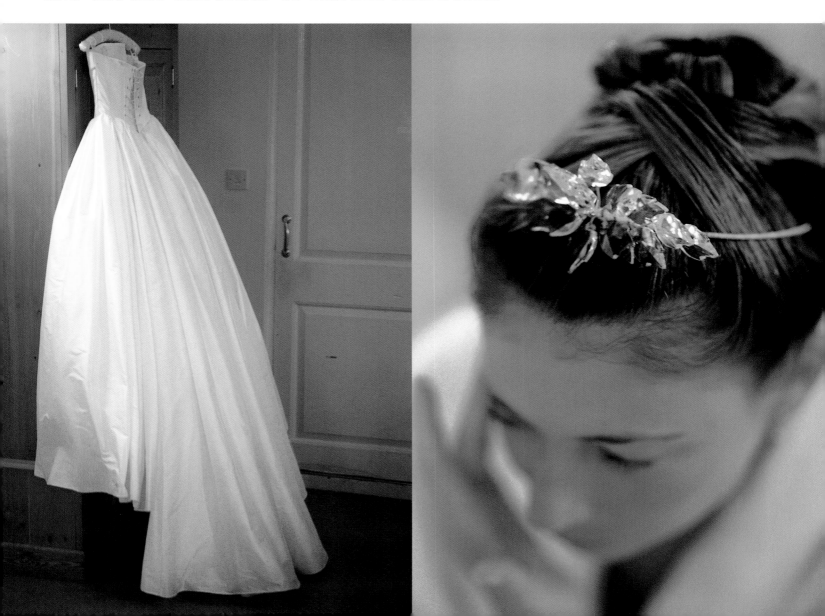

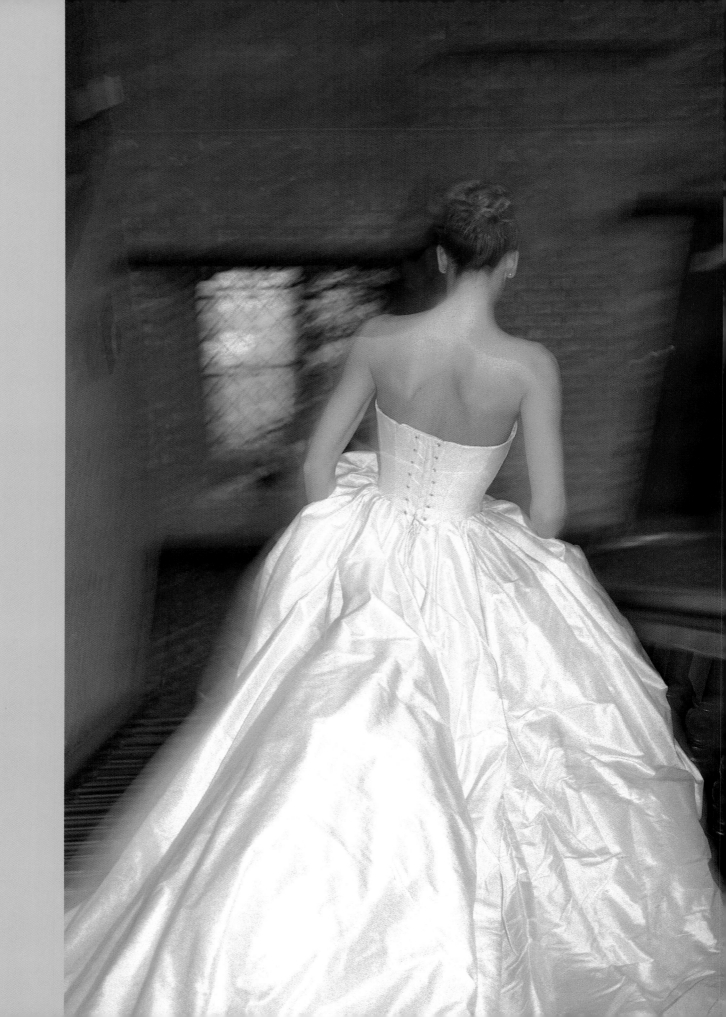

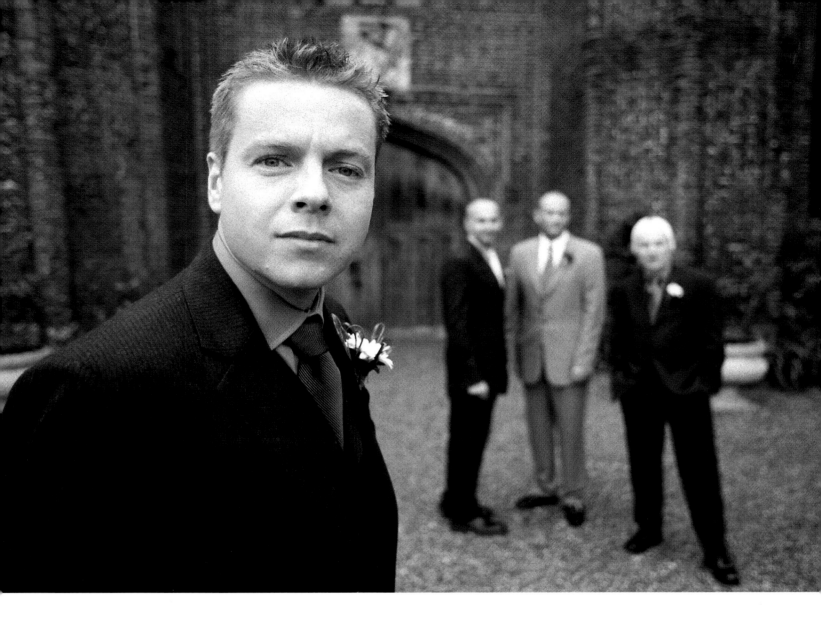

LEFT

The picture of the bride going downstairs, taken from behind, was not planned in advance, but I did see it coming. I switched the camera to rear curtain sync to keep some movement and background light in the picture.

{ I THINK BLACK-AND-WHITE PHOTOGRAPHS ARE VERY FLATTERING AND IT WAS NICE TO HAVE A SELECTION OF BLACK AND WHITE AND COLOUR TO CHOOSE FROM. A LOT OF MY FAVOURITE PHOTOS ARE IN BLACK AND WHITE, AND I FEEL THEY ARE SOMETIMES MORE DRAMATIC THAN COLOUR.

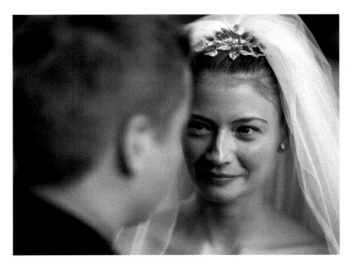

{ WE FELT MODERN STYLE PHOTOGRAPHY CAPTURED PEOPLE NATURALLY AND THEREFORE TOLD A BETTER STORY ABOUT THE DAY RATHER THAN THE TRADITIONAL STYLE WHICH IS A LOT MORE 'STAGED'.

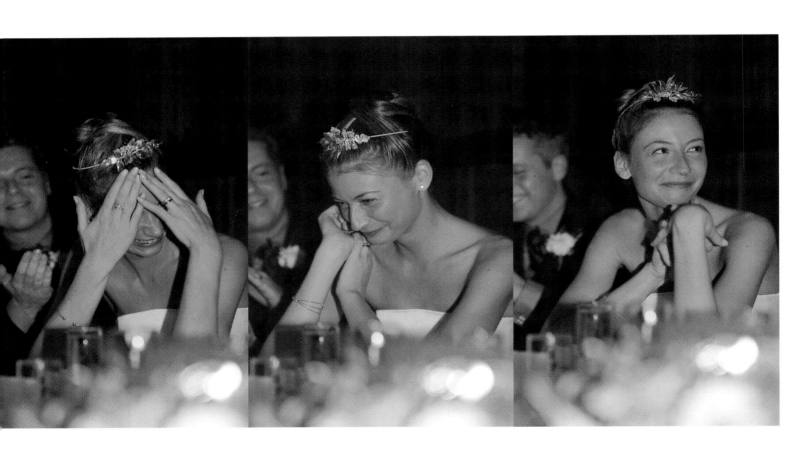

ABOVE

The photographs of the bride taken during her father's speech make an interesting visual story. It is also worth keeping an eye on the bridegroom during the best man's speech (and the bridegroom's mum come to that!).

RIGHT

For this wedding, my attitude – and luckily enough the couple's as well – was to ignore the weather and have a good time, so we nipped outside for some photographs, taking umbrellas, which add to the charm of the photography.

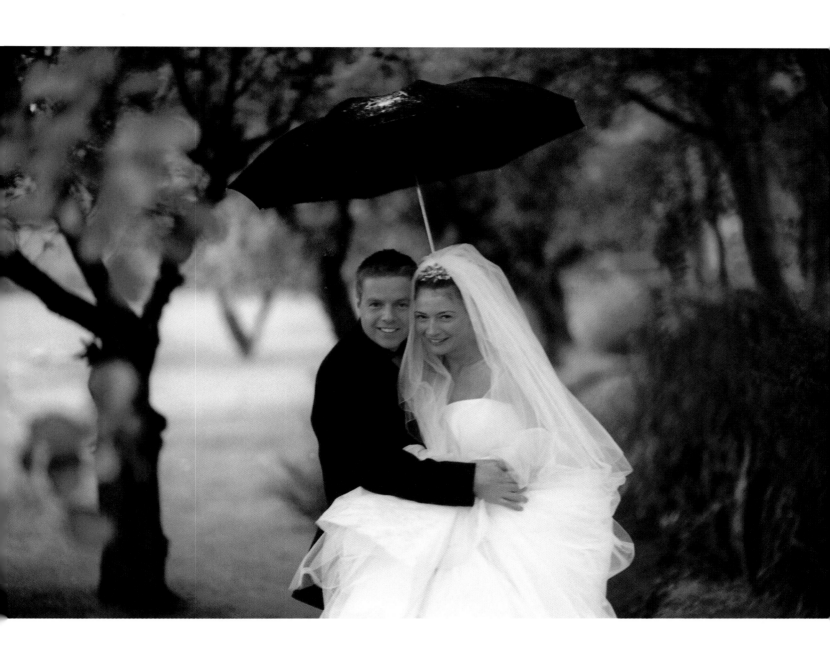

{ WHAT INITIALLY INSPIRED ME TO SEEK A PHOTOGRAPHER WITH A MORE MODERN APPROACH WAS MY DRESS. I WANTED A PHOTOGRAPHER THAT WOULD CAPTURE THE MOVEMENT AND FLOW THAT IT CREATED WHEN I MOVED.

HELEN&DOMINIC

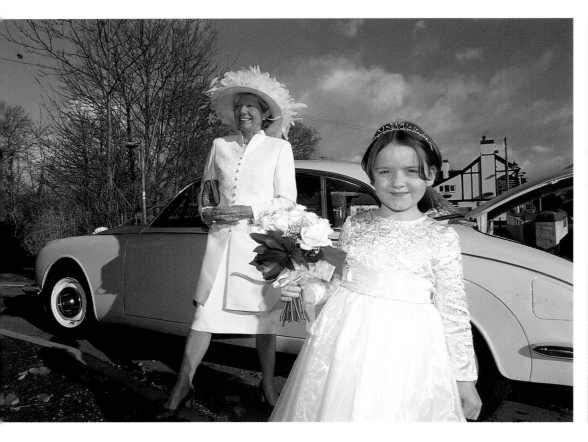

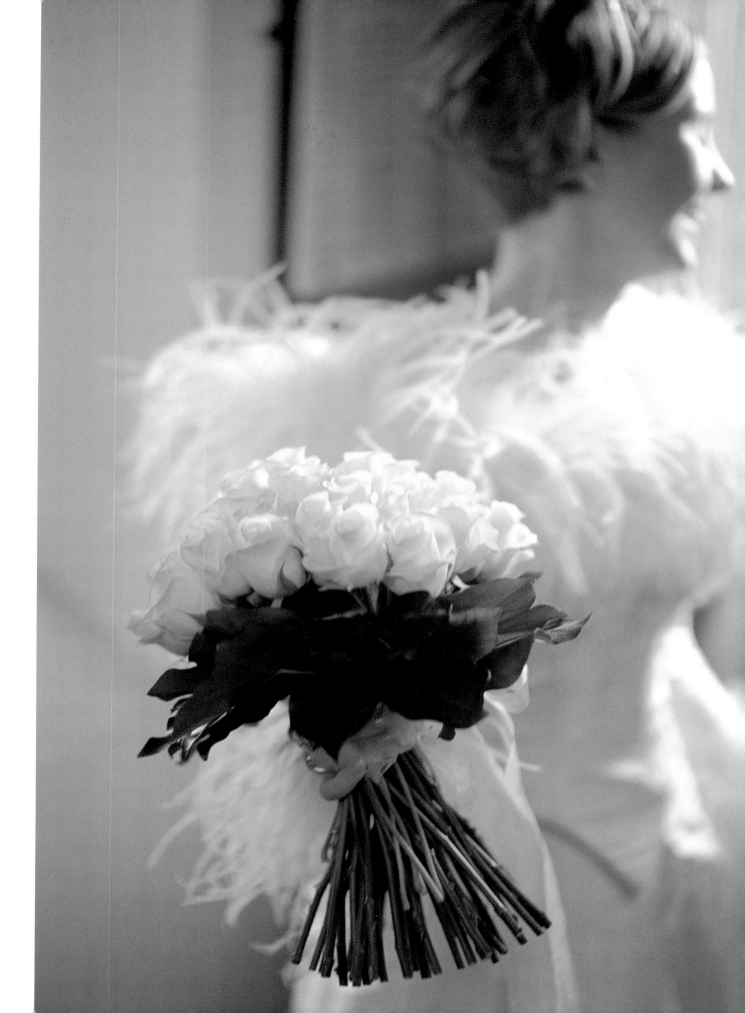

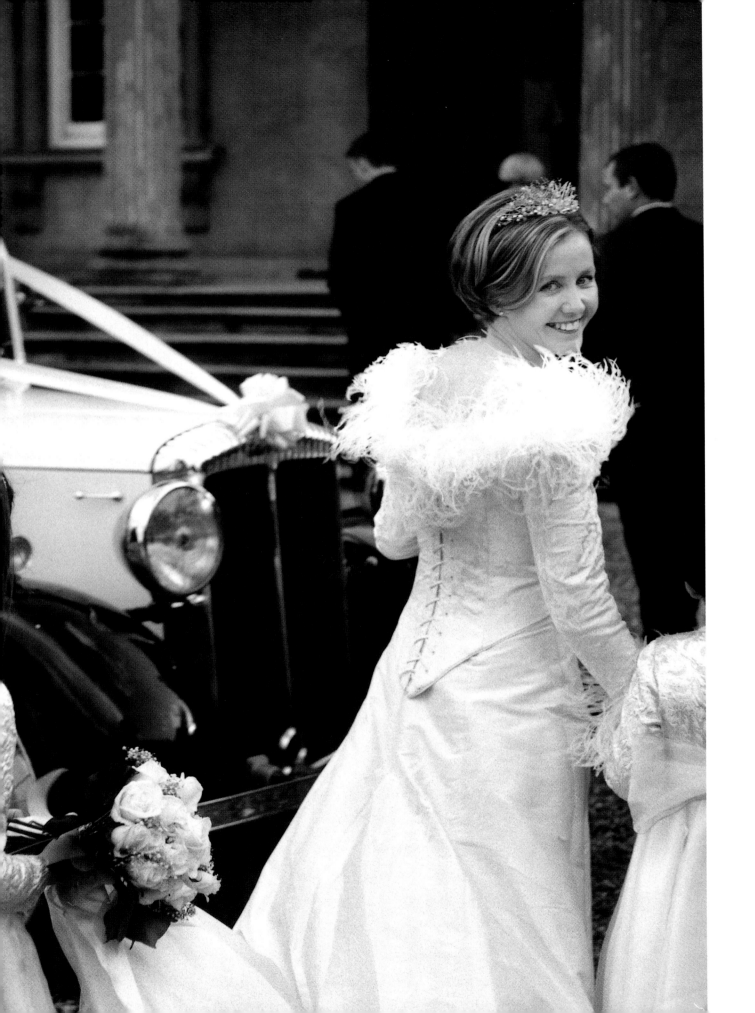

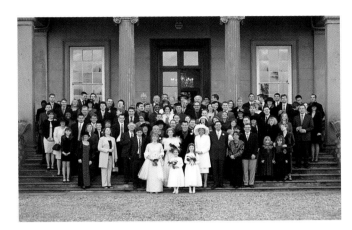

FAR LEFT
This was a very beautiful,
relaxed day. Sunset was
around 4.30pm, so I made
sure we took all the formal
photographs as soon as
we arrived at the reception
venue. This was taken on
the steps at the front of the
house, so those guests not
required for individual
pictures could go back
indoors to keep warm.

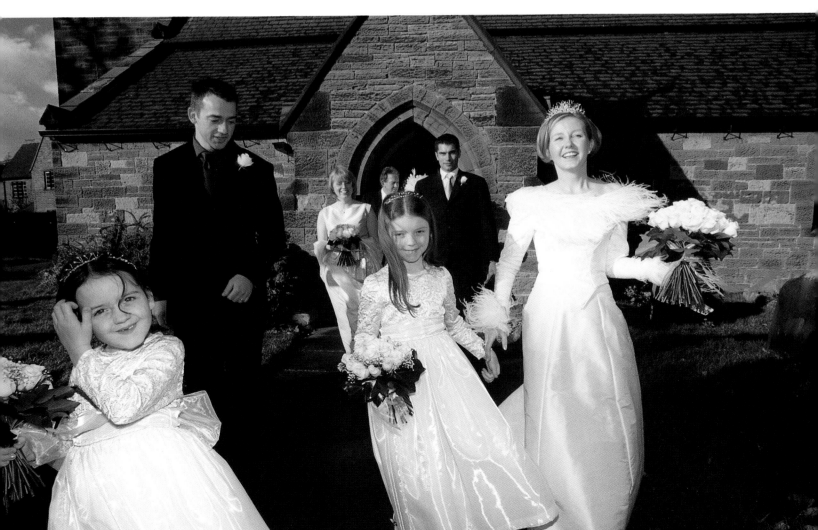

VENUE FOR WEDDING AND RECEPTION	Syon House and The Glass House, Syon Park, Isleworth, UK
TIME OF YEAR	September
WEATHER CONDITIONS	Rain, thunder and lightning, and sunshine (for a short while!)

MICHELLE
&SACHA

{ THE RESULTS WERE
FANTASTIC – THE BEST
PHOTOGRAPHS I HAVE
EVER HAD TAKEN OF ME!
ALSO, BY FAR THE BEST
WEDDING PHOTOGRAPHS
I HAVE EVER SEEN.
THEY REALLY CAPTURED
THE RELAXED, HAPPY
SPIRIT OF THE DAY,
REALLY NATURAL –
THE PERFECT RECORD.

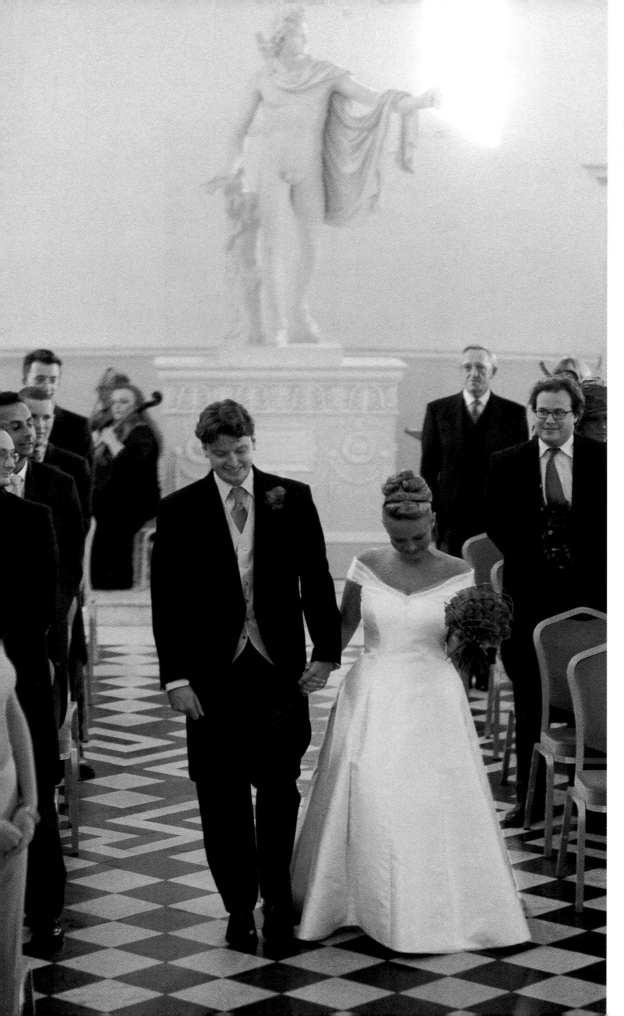

LEFT
The rain was not a problem really, as the locations were beautiful indoors as well as outside.

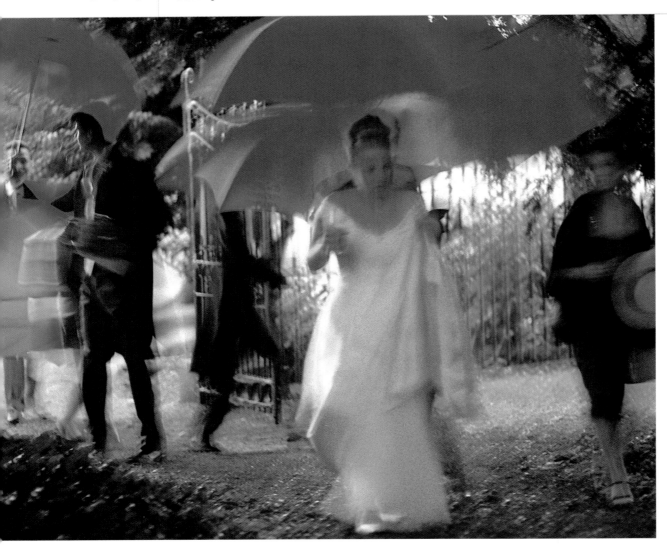

ABOVE

The picture of the guests walking from location to location, through the gardens, was taken at about 1/8sec exposure. I nearly didn't bother taking it as the light was so low, but the blues and greens looked so strong that I couldn't resist it, and the abstract result came out quite beautifully.

The danger for the photographer in passing this type of photograph to the client, is that they could quite easily criticise the picture, saying that it is out of focus, or has camera shake (which, in fact, it may well have). However, the majority of customers who book a contemporary wedding photographer will understand the photograph, and have educated themselves whilst reading various magazines that in the modern fashion and advertising image, this type of effect is used a great deal, so why shouldn't it be in wedding photography.

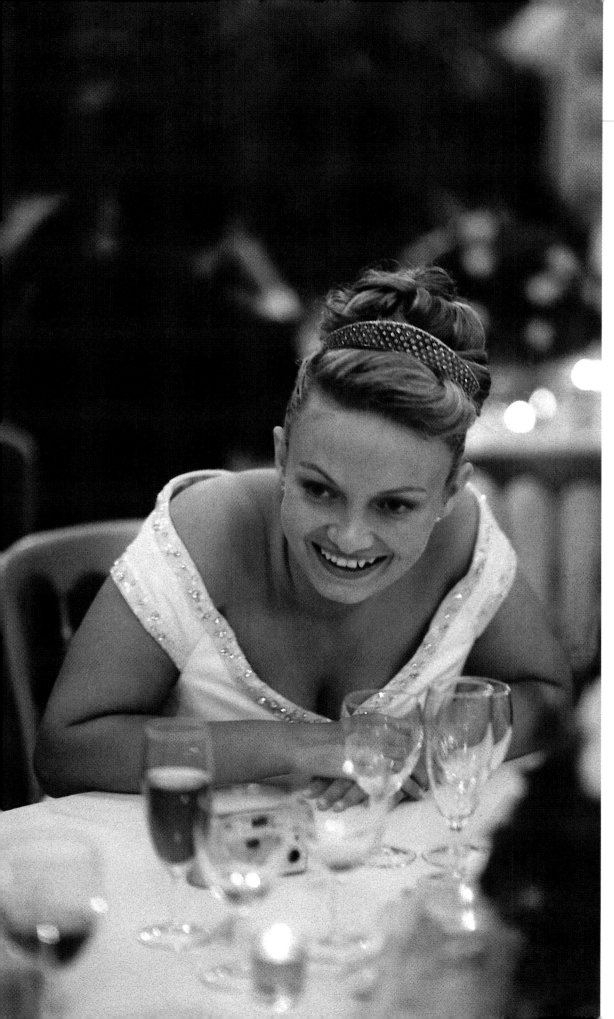

VENUE FOR RECEPTION	Kew Steam Museum, Richmond, UK
TIME OF YEAR	September
WEATHER CONDITIONS	Overcast with sunshine late in the day

AMANDA&MIKE

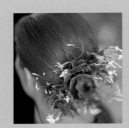 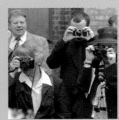

{ THE COUPLE HAD A GREAT DAY, AND JUST ALLOWED ME TO PHOTOGRAPH EVENTS AS THEY UNFOLDED.

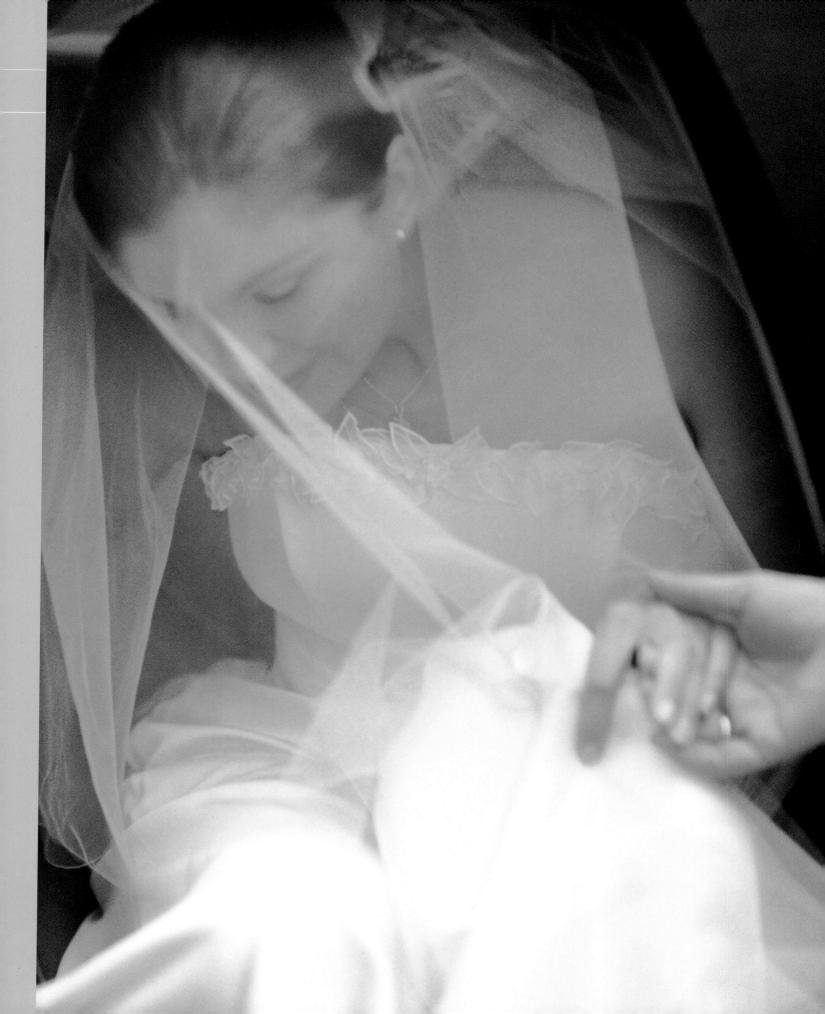

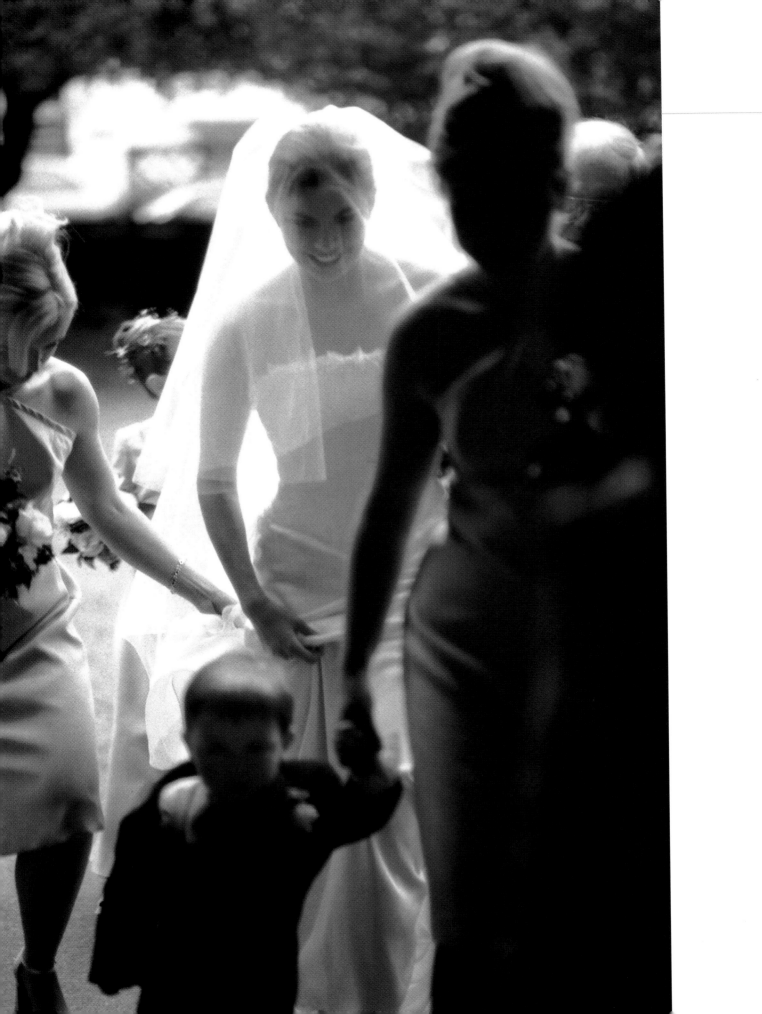

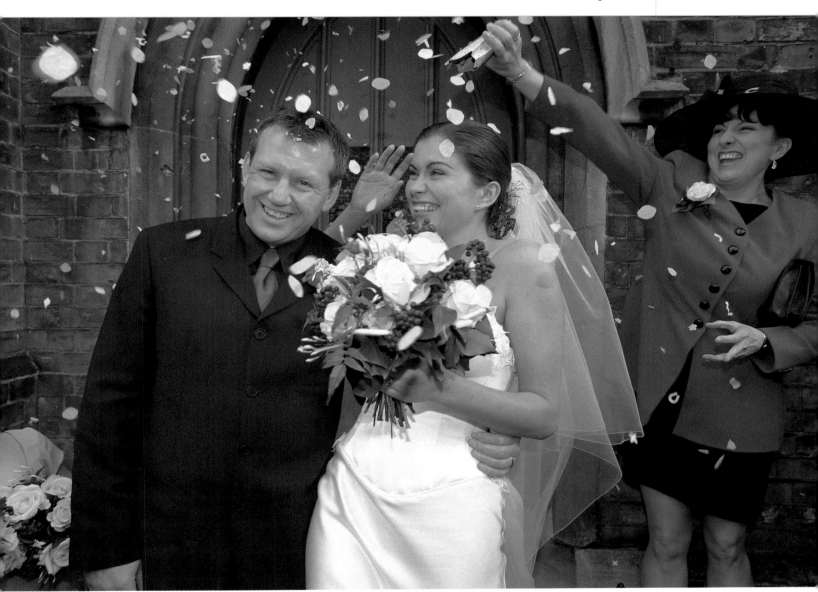

{ THE SUN DID NOT COME OUT UNTIL LATE IN THE DAY, BUT WE STEPPED OUTSIDE JUST BEFORE SUNSET FOR A FEW SHOTS ALONG AN OLD RAILWAY TRACK.

RIGHT

I was standing on a metal staircase as the bride and groom were circulating amongst the guests. I was waiting for them to head towards the patch of sunlight that I had spotted streaming through a rooftop window and called the bride's name as she reached the right spot.

BELOW

For the first dance photograph I made use of the video cameraman's light rather than use flash, and I chose a fast film (Fuji Neopan 1600 ASA).

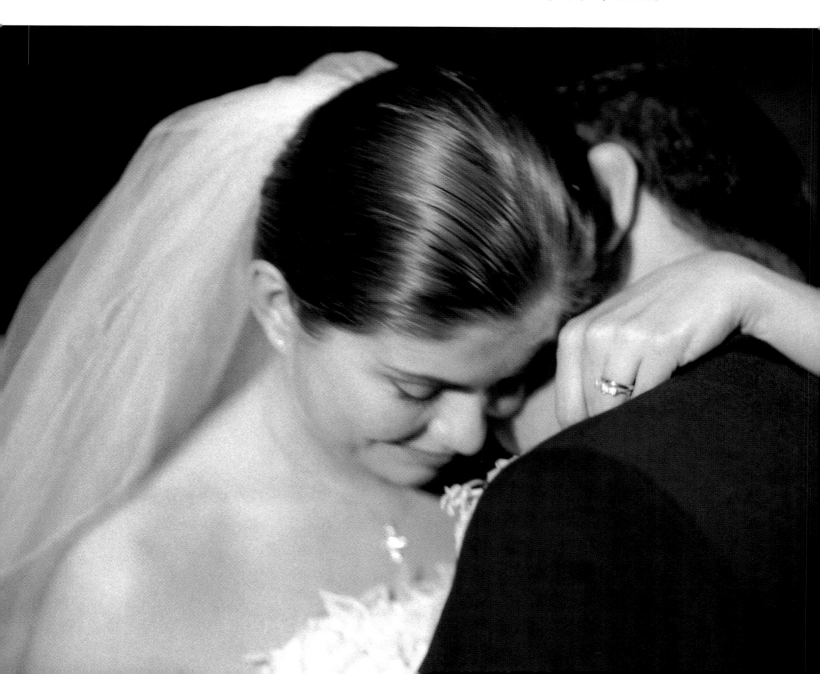

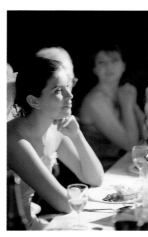
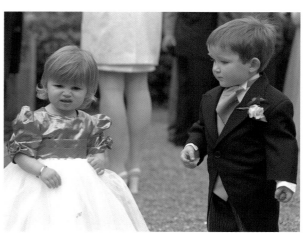
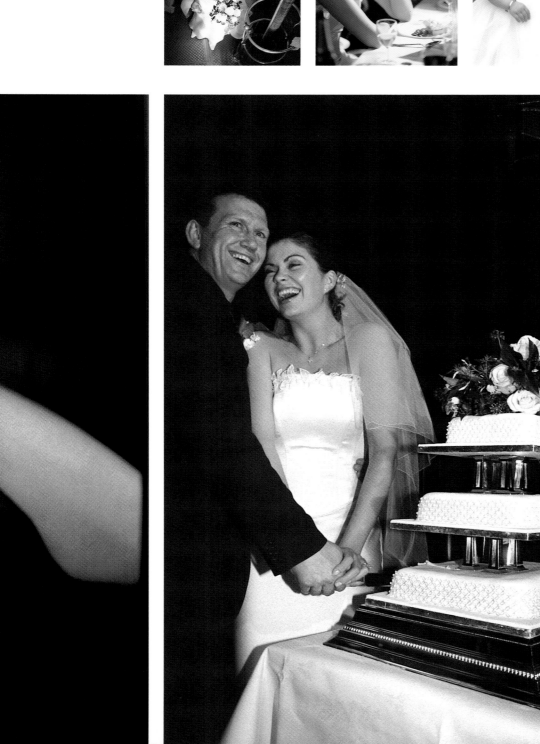

> PRESENTING*YOUR*IMAGES

THE INITIAL COLOUR PRINTS THAT THE COUPLE WILL CHOOSE ENLARGEMENTS FROM ARE KNOWN AS PROOF PRINTS.

> I find it best to supply good quality 6x4in or 7x5in colour prints as the initial prints, and build the cost into my pricing. If you supply inferior quality proofs it will put customers off rather than entice them to buy more. You may put a stamp or mark the photograph in some way to prevent people copying them without returning to the photographer to buy reprints, but, in reality, if someone is determined to copy your work there is really very little you can do about it.

 All I suggest is charging a higher fee for the day's work and not relying on the income generated from the follow-up reprint orders. The initial prints are usually presented to the bride and groom in small albums (preview/proof albums or books) which can be passed around friends and family for them to select the pictures they would like to buy.

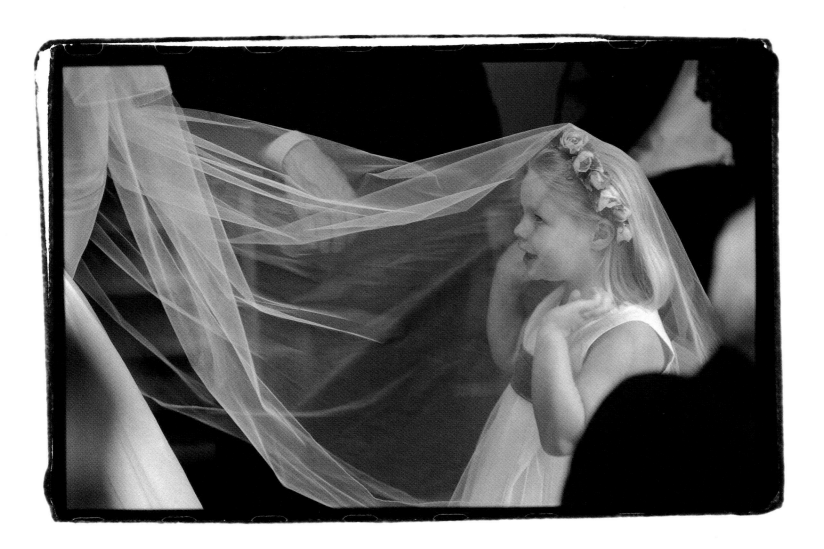

> The black-and-white proofs can also be supplied as prints, or sometimes supplied on a contact sheet, which is all of the photographs taken on a single roll of film supplied on a single sheet of paper.

Images that have been taken digitally will initially be presented in similar ways to the above, although they may be presented on a computer screen (or handed over on a disk) for the couple to choose the images that they would like enlarged.

All of the individual proof pictures are given a reference number by the photographer, which can be used for future print orders.

BORDERS

A photograph with a border often looks more contained and finished. A large border around a smaller image makes you concentrate harder to look at the image. A photograph without a border can give the impression that it is leaping off the page.

The size of the white border is determined in the darkroom during the printing stage with the settings on the masking frame, or printing easel. These are usually in 1/4-inch steps.

To obtain a thin black border, you or your printer may use a masking frame or printing easel designed specifically for this purpose.

An alternative to this is to file the negative carrier (the part of the enlarger the negative sits in when being printed) so that it is a little larger than the size of the negative. This will allow light to spill around the edge of the negative during the printing process, and thus fog (expose) the paper around the image to form a rough or fuzzy border. To tidy a rough border into a thin black outline, simply mask the light with your masking frame.

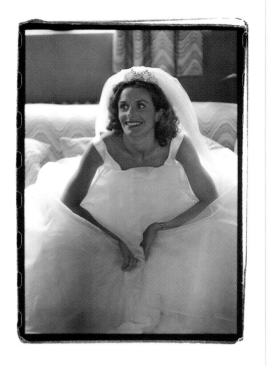

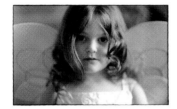

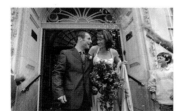

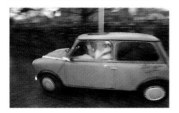

SEPIA

Sepia toning (a brown wash/tone given to a black-and-white image so as to create a nostalgic feel) can now easily be achieved with the help of a computer. The digital image or scanned negative can be toned with certain software and printed as a sepia image. The conventional way is to bleach a black-and-white image in the darkroom and then tone the image with chemicals. Also, certain black-and-white films designed to be processed with colour chemicals (Kodak TCN 400 or Ilford XP2) can produce sepia-toned prints, which is a frequently used technique among many wedding photographers.

It is worth remembering that an image taken the conventional way, and then scanned into a computer, becomes a digital image and can then be manipulated or treated in the same way as any image taken on a digital camera.

FINAL ALBUMS

There are many different designs of photographic albums to consider presenting your wedding photographs in. Apart from the usual stationers that sell wedding albums, do have a look in larger department stores where you can find some beautifully designed albums. Also, think about showing your prints in a photographer's portfolio, which you can purchase at any large photographic or art shop. Remember, the type of presentation album you choose does not have to be specifically aimed at the wedding market, once you open your mind to this you are not limited to a certain type of album.

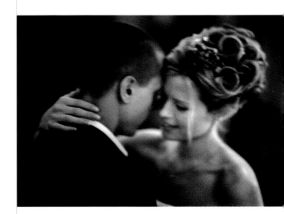

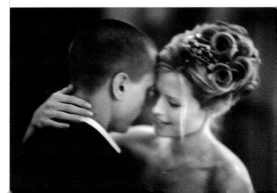

GLOSSARY

> This is a personal glossary, rather than a set of definitions as would appear in a dictionary. As a result, it contains personal thoughts and comments about the entries. It does not delve deeply into the technical mechanics of how or why things function as they do, but explains how to achieve certain results, and how many of the photographs in this book were arrived at.
> After all, you don't need to know what's going on under the bonnet of a car to be a good driver!

Aperture

The aperture setting on the lens selects the amount of light allowed through the lens. In doing so it determines the shutter speed and the depth-of-field for the photograph. The lower the number of the aperture setting (measured in f-stops) the more light is allowed on to the film. A lens is often known or referred to by its widest (lowest number) f-stop setting, for example, 85mm f1.4 or 80–200mm f2.8.

Aperture priority mode

With the camera set in the aperture priority mode, you can select the aperture for a photograph and the camera will automatically select the correct shutter speed.

ASA (European Equivalent ISO)

The American Standards Association is a given reference number to show how sensitive to light a film is. Films are made at varying levels of sensitivity to light; for a 35mm camera the range is between 50 ASA and 3200 ASA, with the low numbers representing less sensitive film and the high numbers, very sensitive films.

In general the higher number ASA films (fast films) usually print with a high amount of grain visible. The lower number ASA films (slow films) will print with a smooth/fine grain appearance, although high quality fast films are coming on to the market all the time. I have nothing against grain in photographs, and think it can add to a photograph. I tend to work with films between 100 and 1600 ASA, depending on the light situation and the mood I wish to create.

Most films are now DX coded (bar coded) meaning the camera is aware of the ASA number of the film automatically, so you do not have to adjust your camera unless you wish to push or pull the film.

Auto exposure

Automatic exposure is a term used when the camera is determining the exposure of the film automatically.

Auto focus

I use auto focus 95 per cent of the time. When the camera is set to automatically focus, it will focus on the selected area/subject as you press the shutter button half way down.

Backlight

Backlight is strong light that is behind the framed subject, usually causing the subject to appear as a silhouette. If you do not wish the subject to appear as a silhouette, then you can use fill-in flash, or overexpose the negative to hold some detail. Backlight is quite often a problem when photographing civil ceremonies in hotels etc. where you are only allowed to work from an allocated position. Spot metering is very useful in this type of situation.

Depth-of-field

The depth-of-field is the amount of distance behind and in front of the subject that will appear in focus on the photograph. A shallow or small depth-of-field makes the foreground and background of the subject appear out of focus, which helps direct the eye to the subject. This effect is achieved by selecting a wide aperture (low f-stop/number) setting on the lens or, as with many modern cameras on the control dial of the camera.

When using a low f-stop setting, you are allowing a lot of light to pass through the lens, making a faster shutter speed necessary, depending on the natural light available.

A high aperture setting on the lens will allow you to obtain a greater depth-of-field, holding the background and foreground in focus along with the subject. As you are allowing less light to travel through the lens with a high f-stop setting, a slower shutter speed is usually required.

Exposure

The exposure is the amount of time the film is exposed to light. An exposed film is a used film and an unexposed film is unused.

Exposure lock

This is a button on the camera that when pressed can be used to lock the exposure. I often use this in church when photographing the couple at the altar, as there is often a large stained glass window behind them causing strong backlight. Rather than switch to spot metering I choose to point the camera to a moderately lit area, hold the exposure lock button, and then re-frame and photograph the couple. This is not the most accurate way of gaining the correct exposure, but it is quick and practical, and it works fine for me.

Flashgun

The flashgun is a light, which is attached to the camera, and synchronised with the shutter, so that it fires as you take a photograph. It can be used to illuminate a dark scene, or to fill in shadows in daylight situations.

Lens

The lens is the glass through which light reflected from the subject, passes before passing through the camera shutter and exposing the film. I use single lens reflex cameras (SLR), which give me

the advantage of viewing the subject through the viewfinder, with the lens that will be used to expose the film.

The alternative is to use a rangefinder camera, where the viewfinder is independent from the lens that takes the photograph. The advantage of the latter, it is said, is that the camera can create a sharper negative/picture due to less internal movement of the camera mechanism occurring.

Light metering system

The two metering systems I use – matrix (about 99 per cent of the time) and spot metering – are built into the camera. Modern cameras will have numerous ways of measuring available light, and it is for you to choose your favourite. These are all ways of measuring the available light so that the correct film exposure is achieved.

Macro lens

A macro lens is a lens that will allow for extreme close-up photography. I tend to use this type of lens for beauty shots of the bride preparing and for photographing the flowers and details such as shoes, the rings, tiaras etc.

Manual focus

With manual focus you adjust the focus yourself by twisting a ring on the lens. Manual focus can be more reliable than auto focus in low-light conditions, as auto focus can have difficulties locking on to a subject.

Matrix metering

This is a sophisticated form of light metering/automatic exposure control, which measures brightness, contrast and even colour taken into account when the exposure is calculated.

Meter

See Light metering system.

Metering

See Light metering system.

Micro lens

See Macro lens.

Overexposure

This is when the film is exposed to too much light. I actually push all of my black-and-white

films by a small amount (1/2 a stop), as I prefer to print from a slightly stronger negative. Pushing the film a bit also helps compensate for the light reflected from a white wedding dress, which can often fool the metering system into underexposing the negative.

All my colour films are processed at normal exposure, although I do ask that they be printed on the darker/stronger side.

Programme mode

Modern cameras can determine the exposure of your photograph automatically in a variety of ways. With the camera set to the programme mode the camera will decide the aperture and the shutter speed for you. This can be very useful for capturing images on impulse, or grabbing events that occur out of the blue, and I often leave my cameras on this setting as I wander around during the drinks reception at a wedding.

Programme modes have become increasingly sophisticated, and are sub-divided into portrait, landscape, flexi-programme and various different situation modes. See your camera guidebook for the various modes your camera has.

Pulling

If you pull a film, you are rating it at a lower ASA than it has been designed for. For instance, you may be using 400 ASA film but due to strong light levels, or perhaps the desire to work with a smaller depth-of-field, set the camera/rate the film at 100 ASA.

Inform your processing laboratory and they will pull the film, leaving it in the developer for less time thus compensating for the overexposure of the film.

Fill-in flash

Balanced fill-in flash is when you make use of your flashgun to illuminate shaded areas of a photograph during daylight. It is particularly useful in strong sunlight, and not only illuminates the shaded areas (underneath the mother of the bride's hat, for example) but balances the foreground with the background of the photograph, for example helping to retain the strong blue hues of the sky and clouds. I find it particularly useful when working with a wide-angle lens, as it helps to add a strong, dramatic effect to a photograph.

Pushing

If you push a film, you are rating it at a higher ASA than it has been designed for. For instance, you may be using a 400 ASA film but due to low light levels set the camera/rate the film at 800 ASA.

Inform your processing laboratory and they will push the film, leaving it in the developer for a longer time thus compensating for the underexposure of the film.

Rear curtain sync

This is a setting on the flashgun or camera body (depending what system you are using) that extends the automatically controlled shutter speed, and turns available light into a stream of light that follows the illuminated subject. It allows you to hold more detail in the background in low-light conditions, and can create motion blur, which is especially effective when photographing the first dance.

Shutter speed

The shutter speed is the amount of time selected for the shutter to open and close, thus determining the amount of time the film is exposed to light.

Spot metering

Setting the camera to the spot metering setting allows you to take a light reading from a very specific part of your composition. Take the reading from a backlit face for example, hold down the exposure lock button and frame/focus your composition, and you are ready to photograph. For more details consult your camera guidebook.

Telephoto lens

On a standard 35mm camera, any lens with a focal length of 85mm or higher is known as a telephoto lens (the 85mm and 105mm lenses are also known as portrait lenses).

A telephoto lens brings the subject nearer to the camera than in reality. This is great for candid portrait photography, although people do tend to step in your way, as they are unaware you are working. With a telephoto lens the depth generally becomes shallower, which can create beautiful hazy backgrounds in your photographs.

TTL

This stands for 'through the lens' and is a term used when describing light metering methods.

Rather than the light being measured independently with a hand-held meter, the camera measures the light as it passes through the camera lens. This is essential for the type of wedding photography in this book, as it is very fast and reliable.

Underexposure

This is when the film is exposed to too little light, making the final print appear dark.

Viewfinder

The viewfinder is the part of the camera you look through to see the image you are photographing. It may also show you information about the various camera settings that you have chosen, below or to the side of the image.

Wide-angle lens

On a standard 35mm camera, a standard lens (lens that will not make the subject appear any nearer, or further away) has a focal length of 50mm. Any lens with a focal length under 50mm is a wide-angle lens.

A wide-angle lens makes the subject appear further away from the camera than it is in reality, and allows a greater area surrounding the subject to be contained in the picture.

It is very useful in small rooms, or if you cannot get any distance between yourself and the subject. It can also create a very dramatic effect, and when first used is very difficult to put down.

Zoom lens

A zoom lens can cover a wide range of focal lengths. You can choose the focal length of the lens within a set range (i.e. 20–35mm or 80–200mm) usually by turning a ring on the lens itself.

The advantage of a zoom lens is that you do not have to keep changing the lens on the camera, and you do not have to carry a large selection of lenses. It will also save you legwork, as you can increase and decrease the distance between you and your chosen subject.

The disadvantage of zoom lenses is that they are usually slower (do not have such a wide aperture) than telephoto/wide-angle lenses.

USEFUL **WEBSITES**

WWW.CONFETTI.CO.UK
WWW.GWP-UK.CO.UK
WWW.THEKNOT.COM
WWW.WEDDINGDEPOT.COM
WWW.COOLWHITE.COM
WWW.WEDUK.COM
WWW.WEDDING-SERVICES.CO.UK
WWW.WEBWEDDING.CO.UK
WWW.BRIDE2B.CO.UK
WWW.HITCHED.CO.UK
WWW.GETSPLICED.COM
WWW.ONLYWEDDINGS.LTD.UK
WWW.PARTYCO.CO.UK
WWW.WEDDINGTIPS.COM
WWW.WEDDINGGUIDEUK.COM
WWW.ULTIMATEWEDDING.COM
WWW.BESTWEDDINGSITES.COM

WEBSITES

AS ALREADY MENTIONED, ONE OF THE ADVANTAGES OF DISPLAYING AND VIEWING WEDDING PHOTOGRAPHS ON A WEBSITE IS THAT BOTH PARTIES CAN SAVE VALUABLE TIME. THE CUSTOMER SAVES THE TIME OF WASTED TRIPS TO VIEW PHOTOGRAPHS IT TURNS OUT THEY DO NOT LIKE, AND THE PHOTOGRAPHER SAVES TIME BY NOT DISPLAYING WORK TO UNINTERESTED CUSTOMERS.

> As a photographer you should always display your best work on a website. The site should be fast to operate, using small file sizes for photographs, so that they appear on the customer's computer screen in less than five seconds.

If you are building your own website, the design should not be complex. Avoid flashing or turning logos, and when building your site stay away from free music/animation downloads as they will give your site an amateurish appearance and add considerably to download times. If you are having your site built by a professional this will not be a problem.

Read contemporary magazines and study their design, image layout and typefaces. Incorporate these ideas into your own site to give your work a modern feel.

> > To find wedding photographers' websites on the World Wide Web, simply type 'wedding photography' into any search engine (Lycos, Yahoo! etc.) and hundreds of photographers' sites will be listed. You can narrow down the field by searching for something more specific such as 'reportage wedding photography' or 'informal/formal wedding photography'. You may also add an area that you wish to restrict your search to, 'candid wedding photography Manchester' for example. Otherwise you may decide to use one of the more general wedding/directory sites to help in your search, such as the ones listed above.